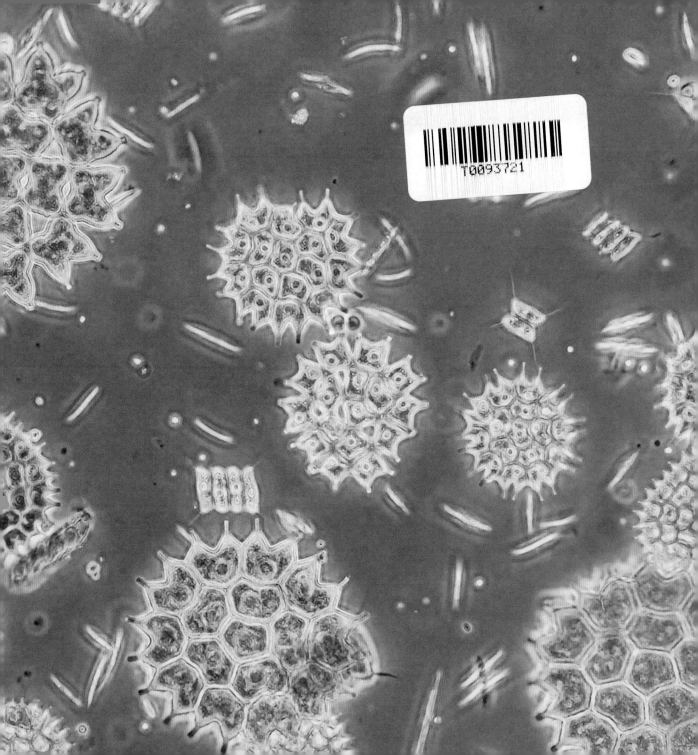

The Hidden Beauty

of the Microscopic World

The
Hidden Beauty
of the Microscopic World

What the tiniest forms of life can tell us about existence
and our place in the universe

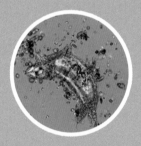

JAMES WEISS

WATKINS
Sharing Wisdom Since 1893

To
Dr Adam Muszyński, who introduced me to microbes,
Dr Anna Karnkowska, who was kind enough to answer my email,
Professor Bozena Zakryś, who has always been
a great mentor and an inspiration,
Monika Wolińska, who kept me sane through all,
Ella Chappell, who made this book real.

The Hidden Beauty of the Microscopic World
James Weiss

First published in the UK and USA in 2021 by
Watkins, an imprint of Watkins Media Limited
Unit 11, Shepperton House,
83–93 Shepperton Road
London N1 3DF

enquiries@watkinspublishing.com

MANAGING EDITOR: Ella Chappell
PROOFREADER: Joanne Osborn
HEAD OF DESIGN: Glen Wilkins
DESIGNER: Luise Roberts
PRODUCTION: Uzma Taj

A CIP record for this book is available from the British Library

ISBN: 978-1-78678-449-0 (Hardback)
ISBN: 978-1-78678-463-6 (eBook)

10 9 8 7 6 5 4 3 2

Typeset in Raleway and Span
Printed in Turkey.

www.watkinspublishing.com

ENDPAPERS: *Pediastrum.*

PAGE 2: *Stentor polymorphus* detail.

OPPOSITE: Tardigrade.

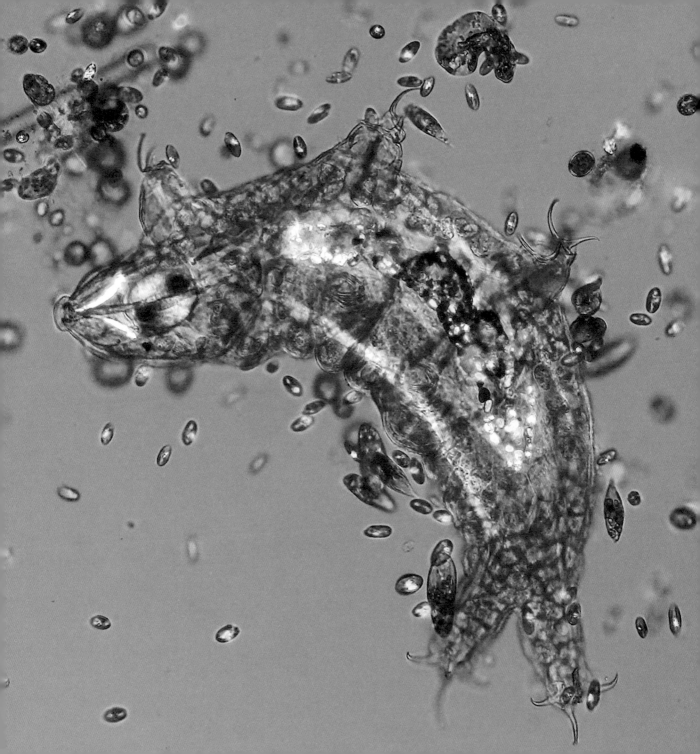

contents

Welcome to the microscopic world! 9

part one
prokaryotes 21

part two
unicellular eukaryotes 59

part three
multicellular eukaryotes 183

OPPOSITE: Diatoms. **ABOVE (FROM LEFT TO RIGHT):** *Daphnid*, euglenids, *Chroococcus*.

Welcome **to the microscopic world!**

Everyone knows that oxygen is one of the most basic elements required for life on Earth. But did you know that we owe at least 20 per cent of the oxygen that is generated on Earth to some hidden organisms? If you didn't, you're certainly not alone. In fact, as a species we spent the last 300,000 years not knowing about these organisms at all! It seems we knew more about the universe outside our own atmosphere before we saw our first microbe under the microscope. These creatures were kept away from the curious minds of humanity until we mastered lens-making, only a couple of centuries ago.

However, even once armed with the right lenses, our arrogance as humans causes us to overlook the complexity and the beauty of the "less significant" life around us.

My favourite example of this is the way we underestimated our ape relatives. One day in October 1960, primatologist and my favourite human being, Jane Goodall, watched a chimpanzee poke pieces of grass into a termite mound to "fish" for termites. It was the first observation of an animal altering objects to use as a tool in the wild. Goodall sent a telegram to her mentor, Louis Leakey, describing her discoveries, and Louis responded with his famous quote: "Now we must redefine 'tool', redefine 'Man', or accept chimpanzees as humans."

The act of looking at the life around us, and allowing ourselves to truly see what that life was capable of, was so revolutionary that it forced us to change not only our core concepts but our understanding of ourselves. I believe the same thing can be done by truly seeing microbes. It is time for us to change the common negative opinion of the microscopic world.

Estimations say that there are a trillion species of microbes on Earth and only a handful of them can have adverse effects on us. A trillion different species! That's a lot of microbes to discover, observe and take care of, and that's a lot of happiness for me, and I hope you too.

A little bit about me

The first time I gazed into the microworld, I was on a college course. We had been tasked with counting the number of microorganisms

present in a treatment plant wastewater sample. The very first thing I saw through the microscope looked like a round, yellow gem. I couldn't make sense of it. Was it alive? Or just something on the slide? Then I saw another figure coming out of it, moving slowly. It looked like a blob emerging from the gem. I became intrigued to find out more about this little guy; I asked my professor to take a look at it. After checking, he told me what I had found was an amoeba, which builds a shell from dissolved inorganic matter it finds in the water, then lives in that shell. He told me that the shell would have been transparent when it was first built, before becoming a yellowish-brown colour due to iron that leaks into the shell from the water. It may not be like a moment from a Hugh Grant movie, but that was it! I was in love with the microscopic world. I loved the way this new world made me puzzled and confused, and all these emotions encouraged me to dive deeper and deeper.

My excitement to explore the microworld during that lab course grew and grew, until only two hours per week just wasn't enough for me. That's when I decided to buy my own microscope. I wanted to explore without any restrictions, even though I was completely broke, in a foreign country, with no job and I had tuition to pay. I had recently moved to Warsaw in Poland. The move would come to have its up and downs, but it led me to where I am now – following my passion for pond scum!

I was doing nothing but checking out microscopes online. I finally convinced myself to get one as a Christmas gift to myself and I ordered my first microscope. It was the cheapest one I could find with a binocular head, meaning that I would be able to see with both eyes.

When I think back on it now, I can say that it was the best purchase of my life.

This new microscope unexpectedly changed everything for me. I started learning all I could about microbes. It felt like I was studying life forms from a different planet. I was going out for samples almost every day and coming back home with a bunch of jars full of water from ponds.

The biggest lesson I learnt from this time is that it always pays off to follow your curiosity. In this book I intend to show you that there is beauty hidden everywhere and it doesn't require years of education to find it or thousands of dollars of equipment; the hidden beauty is for everyone who is curious enough to seek and who is determined to learn. I hope that I can inspire you to find it in your own way, too, whether through a microscope or in other ways that spark your curiosity and excitement.

Along the way I'll introduce you to some of my heroes in the field of microbiology, from long-gone scientists and naturalists whose dedication led me to some amazing encounters, to current experts in the field who became mentors and treasured figures in my life. If you're totally new to the realm of microorganisms, I hope you find something here that will lead you down a path to your own discoveries.

We have only just begun to discover this world, and it will be a lifelong journey for me, full of mysterious stories. I do not know where this journey will take me, but I am sure my enthusiasm will lead the way.

What on earth is taxonomy?

I often refer to the "domain", "genus" or "species" of an organism. These terms can be a bit confusing at first, but they are part of the system of taxonomy, which is how scientists categorize organisms.

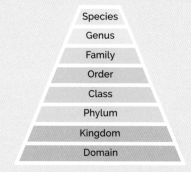

The species name is the way to refer to the narrowest taxonomic unit; for example *Escherichia coli* (*E. coli*) is one of many species in the genus *Escherichia*, and the genus *Escherichia* is under the family *Enterobacteriaceae*, and the list goes on with more hard to pronounce Latin names, until we reach the domain Bacteria.

How I collect samples

Microscopic life depends on water. Therefore, all of the organisms you'll meet in this book will be aquatic. They live in any type of permanent and temporary water bodies: oceans, rivers, lakes, ponds, puddles, even on a thin layer of water on humid soil. Some of them are single-celled organisms, which are, as you probably already guessed from their name, composed of only one cell, nothing more. They behave in a surprisingly complex way; they hunt, avoid predators, form colonies and some of them even show simple learning behaviour. Another group is multicellular organisms. Just like humans, they have organs and systems, and often they have cute little eyes – but, as you will find as you read this book, it is sometimes hard to tell the difference between multicellulars and unicellulars. Some multicellular organisms are much smaller than their unicellular neighbours; they are constantly bullied and eaten by the "less developed" unicellular groups. The way nature is able to make things in all sizes and shapes never ceases to amaze me.

Finding these creatures is not as hard as you would expect; they live everywhere.

As species vary from one environment to another, it is highly likely that you will find something different in a pond, for instance, compared with the sea. That's one of the most exciting parts of looking for microorganisms: there are unlimited options for collecting samples and there is always a chance that something new will be in the sample to investigate. Even if there is not a new organism, there will be a new interaction to observe among the common ones.

Some reported organisms have yet to be found again. Some are only found in a particular location. For instance, Stentor loricata, *a big, self-pigmented green unicellular, which builds a shell or "lorica" for itself and lives inside of it to avoid predators, is a species so far only reported from a stream in New Zealand.*

There is one theory which says that microorganisms are cosmopolitan, meaning that there is a chance of finding every organism worldwide. If this theory is true, organisms reported only from certain places such as Stentor loricata *may be living in your city but perhaps have not been found yet because not many people collect samples, so the chances of someone stumbling upon these*

organisms are really low. This also, as you can guess, makes my daily life quite exciting, not just because I could find an organism new to me, but because even with organisms that are common, there is always something new to see.

The way nature is able to make things in all sizes and shapes never ceases to amaze me.

For instance, I was able to record "mating behaviour" of a certain tardigrade species and even managed to record a "ménage à trois" of this species. I'm the first person in human history to film this weird and funny moment (see page 239).

The number of organisms in a sample of water is determined by the available food. Shallow ponds where leaves and other plant matter accumulate and decompose are wonderful places to look for life. Usually there is a thin layer of sediment on the decomposing leaves in the water that harbours microbes. I use a big syringe or a turkey baster to suck this layer up and transfer it into a container, as well as to scare the bejesus out of anyone who

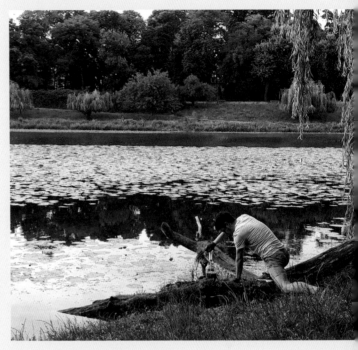

Sampling at my local pond.

crosses my path while I am holding a giant syringe. When the conditions are right, some water bodies can produce an excessive amount of algae; these often change the colour of the water to greenish and hold many different algae consumers, making the sample extra interesting and rich in species.

The other tool I use is a plankton net. These are made out of fabric with a specific

mesh size to meet the user's needs. Fabric forming a conical structure is wrapped around a metal ring, which can be dragged to allow water to pass through it while keeping organisms that are bigger than the mesh size trapped and concentrated inside the cone of fabric. The net I use has a 20-micron mesh size, so I can collect everything bigger than 20 microns by dragging the net through hundreds of litres of water. A micron is 1/1,000th of a millimetre, so this fabric is made precisely, which explains why the nets are expensive! These samples are extremely concentrated, and the dissolved oxygen in the water is used by the organisms reasonably quickly as these microorganisms "breathe" it like us, so they need to be checked under the microscope right away. That's why when I collect water with the plankton net, I zoom back home on a rental electric scooter.

Even dry soil can yield exciting results. Microorganisms that rely on precipitation have evolved in a way to survive drying up. When water becomes scarce, these organisms form something known as "protective cysts", then wait in a dormant state until it rains again. The wet–dry cycles can be daily or even seasonal; these organisms can be active during the early

morning dew and then form cysts when the dew evaporates in the day, dormant and waiting until the next morning. I sample soil by collecting just the top layer, up to 5cm in depth. A good sample should contain "plant litter", or the "humus layer" of the soil, to provide nutrients for the microorganisms, but because I mostly collect my samples in urban areas, one or two candy wrappers slip in too. That's another reason not to litter. After the sample has been air-dried, it can be stored for years with no significant reduction in species numbers over time. I transfer the soil samples into Petri dishes and rewet them with spring water in a way that avoids flooding the soil. After 48 hours, samples are ready to be checked under the microscope.

Water samples need to be kept in glass containers; plastic should not be used to start cultures due to the toxic effects it can have on some of the microorganisms. That's why at some point I had over 400 glass jars of various sizes, and I am sure the lady in the local store where I buy my jars thinks I am a pickle-making lunatic. There are a couple of techniques that can be used to increase the number of organisms in the samples. One of the most frequently used methods is to add high-fat milk into recently collected water; 3–4 drops per litre of water is sufficient to boost the growth of microorganisms. The milk provides the required nutrients for bacterial growth, which then feeds and helps grow the larger organism populace. In a day or two, the sample turns cloudy because of the increased mass of microbes. Long-lasting cultures can be set in this way by adding more milk into the sample when the cloudiness of the water seems to decrease. This is the technique I use for my Stentor coeruleus culture, which I photographed for this book. By using this method I have maintained the culture for about a year now. Another method I use for culturing is known as "hay infusion": a simple

and effective method. All that it requires is to boil some Timothy hay in spring water, which, after cooling, can be added into the prepared sample. The easiest way to get hay is to check the pet food section of your supermarket as it is sold as rabbit food.

Collecting and caring for microorganisms requires creativity and innovation. Even though I always thought selfie sticks were unnecessary for me, I bought one and turned it into an extendable sampling stick that I can easily carry in my backpack. Converting everyday items into tools for collecting and observing microbes is one of the most exciting parts of working with microorganisms. After drinking a couple of cups of black coffee, I start seeing a use in everything for this purpose.

Before putting a sample under the microscope, a microscope slide must be prepared. A slide is a clean piece of glass of a fixed size and thickness. A pipette is used to place a drop of sample onto a microscope slide, which is then covered by another piece of glass, called a coverslip, to create an even water layer between the glass pieces. I usually prepare my slides to include quite a bit of sediment and some debris so the weight of the coverslip is

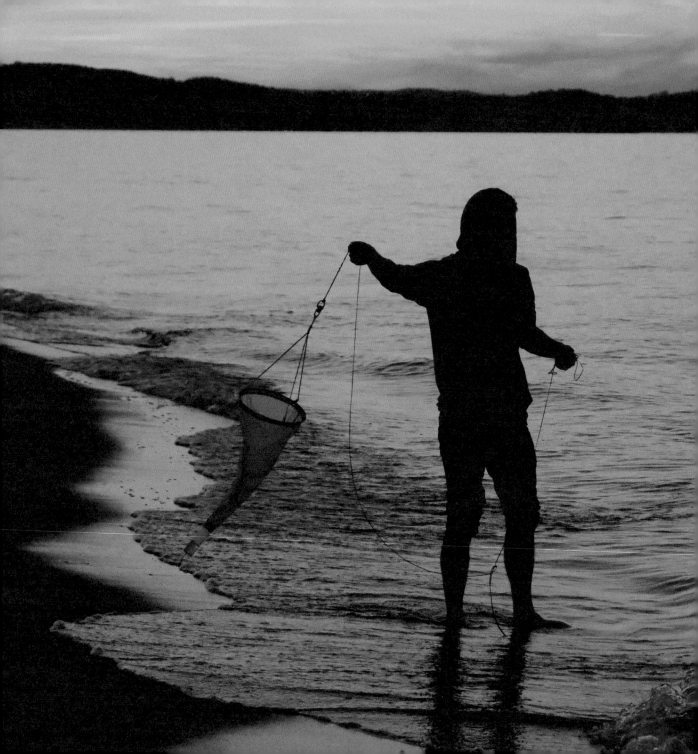

supported and doesn't crush my precious pond buddies. I often put the prepared slides into air-tight plastic boxes with wet tissue at the bottom. Wet tissue keeps the humidity high in the box and stops the slides drying up; in this way I can keep the prepared slides alive for months! Over time, these tiny spaces between the glass pieces are turned into perfect habitats for microorganisms. After only a couple of days, bacteria form a biofilm on the glass, providing a food source and surface for many other organisms to live and thrive on.

Immediately after a slide is prepared, the eight-legged chubby residents of the microscopic world, water bears, are not able to get a good grip on the glass with their claws. But once the bacteria have formed a biofilm on the glass, these clumsy animals are able to walk on the biofilm and this turns them into agile, grazing machines and lets you see how they behave in their natural habitat.

Sampling from the Baltic Sea using my plankton net.

Some terminology

As I introduce you to the microorganisms in this book, I will explain how they live in easy-to-understand terms, but here are a few key terms that you might need to know before you begin reading if you are a complete beginner.

Aerobic – used to describe something that involves oxygen

Anaerobic – used to describe something that does not involve oxygen

Chloroplast – an organelle in a cell that is often green-coloured due to the presence of chlorophyll in it. Chloroplasts carry out photosynthesis to create energy for a cell in the form of sugar

Cytoplasm – the jelly-like substance that fills a cell

Eukaryotes – organisms that contain organelles and a nucleus

Mitochondria – organelles that produce chemical energy for the organism. This is why mitochondria are generally called the powerhouses of the cell

Mucilage – a sticky fluid or secretion

Nucleus – an organelle that contains the organism's DNA and also functions, in simple terms, like the brain of the cell

Photosynthesis – a chemical reaction that harnesses the power of sunlight to turn carbon dioxide and water into oxygen and sugar

Prokaryotes – an organism made up of a single cell which does not have organelles or a nucleus

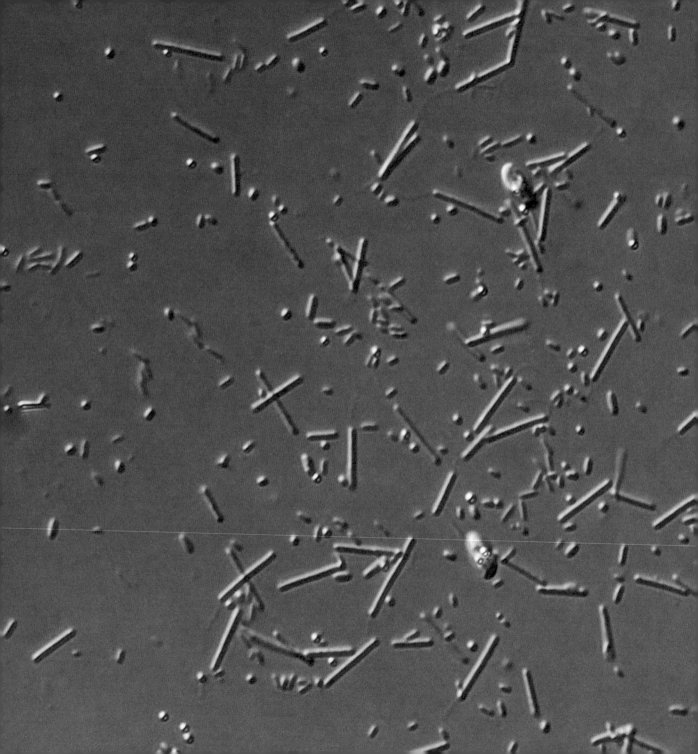

part one
prokaryotes

The simplest life forms one can observe under the microscope are certainly the prokaryotes. These are microorganisms with no nuclei or any other membrane-bound organelle such as mitochondria and chloroplasts. Prokaryotes were the first life form to appear on the Earth billions of years ago. They continued to change and evolve; some formed simple multicellularity and then changed their mind and evolved back to being single-celled again, which goes to show that simplicity often pays off.

Prokaryotic organisms are categorized in two domains: Bacteria and Archaea. We are very much familiar with bacteria; they are all around us, on us and even inside us. Archaea are less well-known, even though they are quite abundant like the members of the domain Bacteria. Archaea are similar to bacteria in terms of structure, but they are evolutionarily distinct from bacteria, so archaea get their own domain of life. Bacteria and archaea grow by binary fission, which means one cell divides to create two cells, and later these two cells divide into four cells, and the four cells

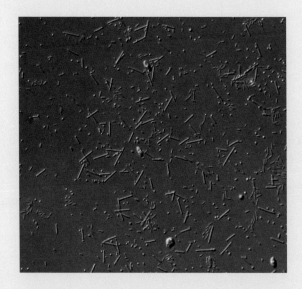

ABOVE AND PREVIOUS PAGE: A variety of bacteria.

divide to create eight and so on. To give you an idea of scale, common inhabitants of our intestines, *Escherichia coli*, can divide into 2 every 20 minutes. This exponential growth can result in millions of new cells from a single *Escherichia coli* cell after only a day! However, luckily for us, many factors influence the growth rate and not every *Escherichia coli* continues dividing every 20 minutes, otherwise the mass of the *Escherichia coli* would exceed the mass of Earth in a couple of days!

Archaea are obligate anaerobes, meaning that they cannot survive the atmospheric concentration of oxygen and they have to live in oxygen-free environments. It's almost impossible to differentiate archaeans from bacteria without using fluorescent microscopy techniques, so you won't see any in this book, but they are there. They like to live in extreme habitats, such as the boiling springs of Yellowstone, the extremely low pH conditions of acid mine drainages and inside most anaerobic single-celled microorganisms, as well as a little less extreme habitats like human guts.

Metopus is one of these single-celled organisms that harbours methanogenic archaea in its cell. Both the *Metopus* and the archaea benefit from this relationship. The methanogens utilize hydrogen to generate the smelly gas methane, but we don't yet

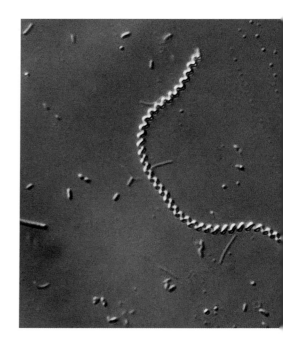

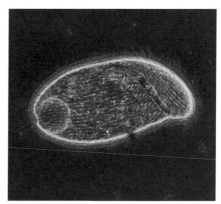

ABOVE: *Metopus*, 170 microns.

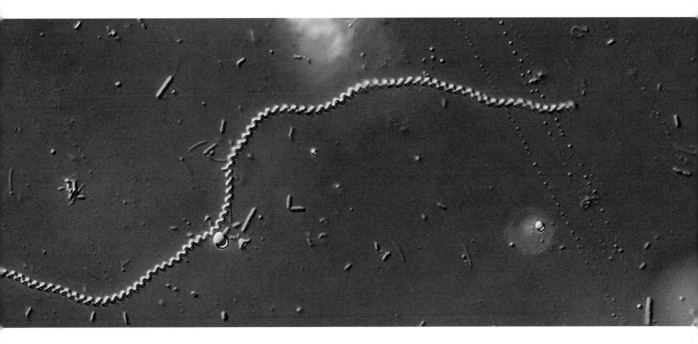

fully understand what benefits the *Metopus* gains from these methanogenic archaea inside its cell. All we know is that when *Metopus* have these endosymbionts they grow faster! Even though I cannot show you the archaeans inside the *Metopus* precisely, they are in the photo for sure!

The size and shape of bacteria varies quite a lot. Most species are so small it makes them hard to distinguish even under high magnification, but some bacteria are quite big, especially the ones from the order Spirochaetales. These are spiral-shaped bacteria. A couple of species in this taxonomic order are pathogens to humans and can cause diseases like syphilis and Lyme disease, but the majority

of the Spirochaetales have nothing to do with humans. Some of the spiral-shaped bacteria I found were quite big, sometimes even bigger than the microscopic animals with thousands of cells in their body. Like this giant bacterium (shown on the previous page): it's most likely a spirochete. It's fast and big; a whopping 150 microns in length (that's 0.15mm). I almost always find them in my mud samples. They are probably part of the sulphur cycle in the environment. The cell is coiled tightly, not segmented as it appears in the photo, and able to move with a corkscrew motion. Spirochetes use this type of motion inside the mud and sediment to find more suitable conditions for themselves. The spirochetes can move in this way thanks to something quite interesting: They have flagella, which is a hair-like appendage between the cell's inner and outer membranes. These flagella cover the whole length of the bacterium, like spaghetti inside its package, and let the bacterium move in its characteristic corkscrew motion.

LEFT: Rod-shaped bacteria, 5–10 microns.

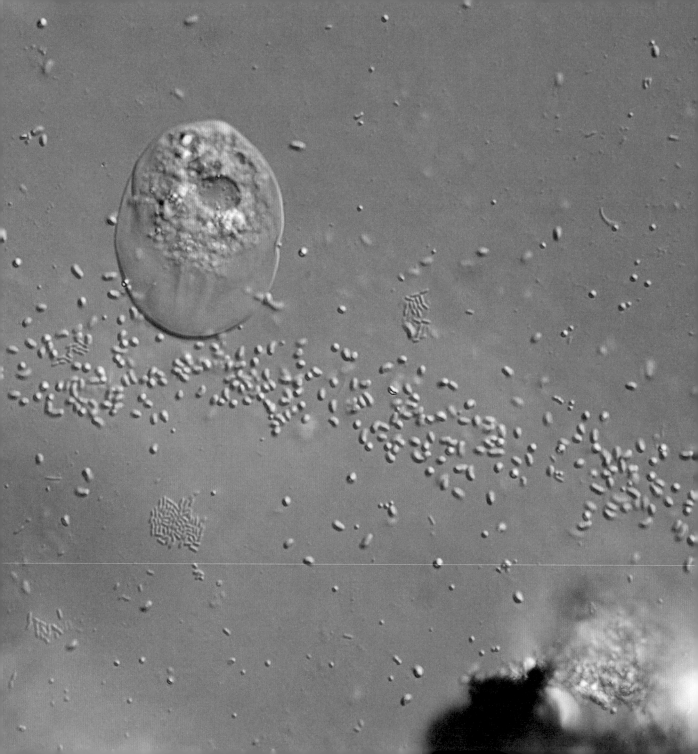

Life in syrup

Every microorganism shows some motility in its life cycle. Even the ones that are not actively moving and prefer a sedentary lifestyle move in a way during cell division, or during the process called "cyclosis", where the organelles of the organism move, or when they need to eat something. The more active microorganisms are usually quite fast. They dart from one direction to another, turn and twist, zoom around. It all looks a bit unreal, and I guess that is because it is unreal when compared with reality at a human level. The physics of the water at the microscopic level, and in particular the inertia experienced within it, is completely different from what we would ever experience.

I might need to explain what inertia is here. Inertia is a force that keeps stationary objects at rest and moving objects in motion at constant velocity. Here's an everyday analogy to explain it. Think about seatbelts. They exist because of inertial forces. If a car is driving at 80kph but then makes a sudden stop, the driver continues to move at 80kph, and the only thing to stop them from hitting the dashboard at that speed is the seatbelt.

Microorganisms live in a viscous world and they are always surrounded by a sticky coat of the surrounding water, which changes their relationship with inertia. Physicists express this by saying that these organisms live at low "Reynolds numbers". Reynolds number (Re) is quite a complicated mathematical calculation that is determined by various factors such as density, velocity and viscosity. But, in the end, if the Re number is smaller than 1, then viscous forces predominate in that environment. If the Re number is bigger than 1, then inertial forces

are more important. This is all another way to say that the size of the creatures living in the microscopic world means that they move very differently in water to the way that, say, a person swimming would. If a swimming human were to be used as a realistic model of a *Paramecium*, a unicellular organism, the person would have to swim in something like glycerol.

This means that it's as if the microorganisms are swimming inside a substance as thick as corn syrup, and the inertial forces that apply to you in your everyday life don't have any power in the microscopic world. Think back to the seatbelt analogy: if I were a microbe somehow managing to drive a tiny microbe car, I wouldn't need a seatbelt because the inertial forces have almost no role at this size. So, if I drive my microscopic car and crash it into a *Paramecium*, I, as the driver, would stop moving at once too, needing no seatbelt.

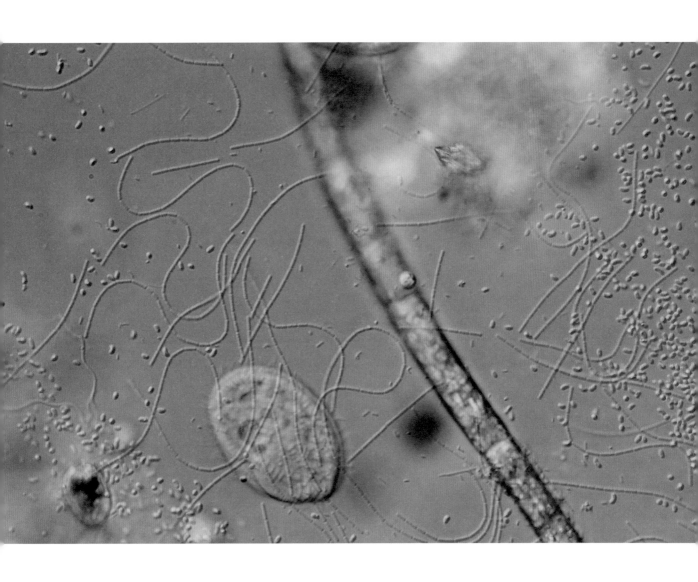

ABOVE AND OVERLEAF: Ciliate, bacteria and alga. Width of the image is 300 microns.

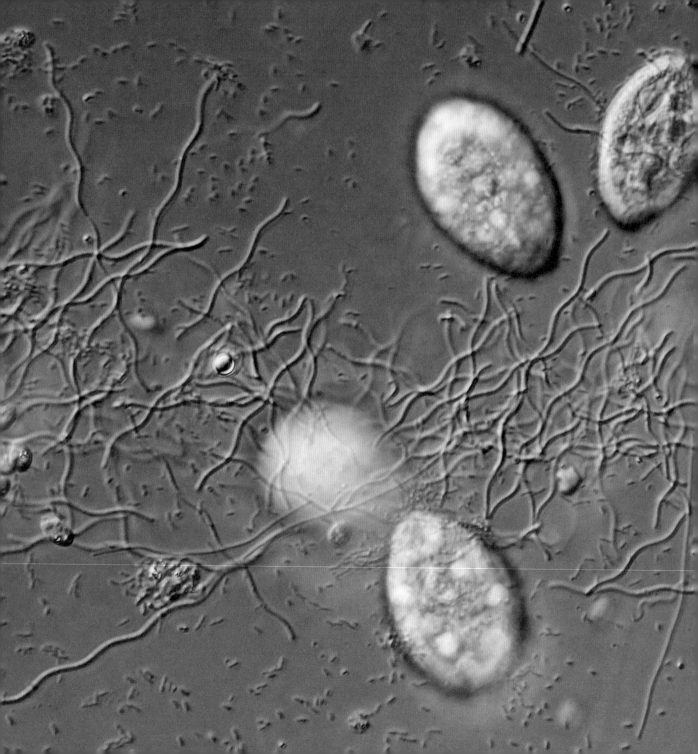

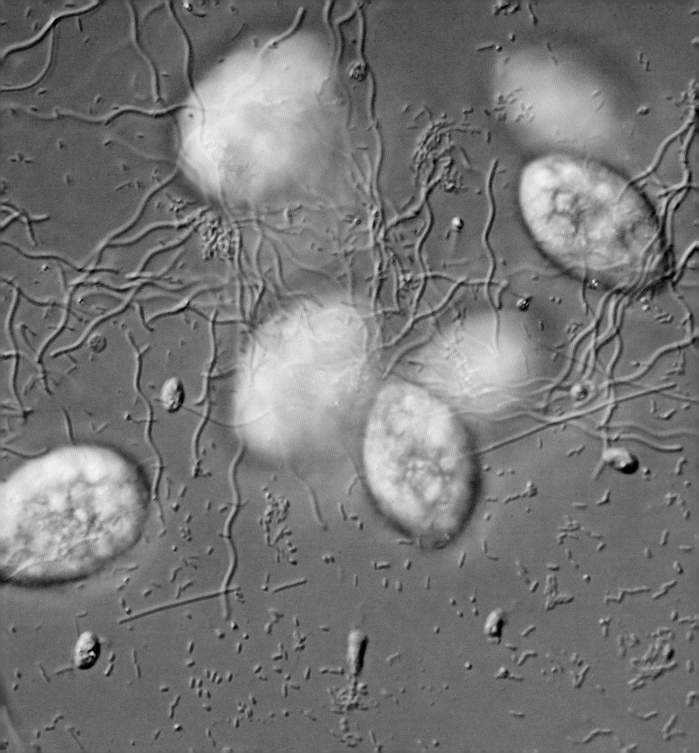

Bacterial parasites of *Paramecium* –
life within life

Bacterial infections are not limited to multicellular organisms like you and me. Bacteria can infect, harm and even kill some single-celled organisms. There are peculiar interactions between bacteria and single-celled eukaryotes; for instance, the *Paramecium* species may be a host for about 60 species of bacteria. These are called bacterial endocytobionts and they don't necessarily harm the host. However, some of these endocytobionts can be parasitic too. After I got my first microscope and started to dive into the microcosmos, I read a paper about some parasitic bacteria in *Paramecium*. It was mind-blowingly interesting, but I never thought I would see some infected *Paramecium* with my own eyes.

Paramecia are one of the most common organisms I find, and after years of seeing them on my slides, they kind of became a little uninteresting. And, honestly, they even became a bit annoying! Imagine you're finding a perfect composition for a photo or a video and then an overly excited *Paramecium* comes along and destroys your precious photo. They were the smallest photobombers I have ever had to deal with. I was even often separating them with a micropipette from the drop of water under a low magnification before covering the drop with a coverslip. Although one time, three years into using my microscope,

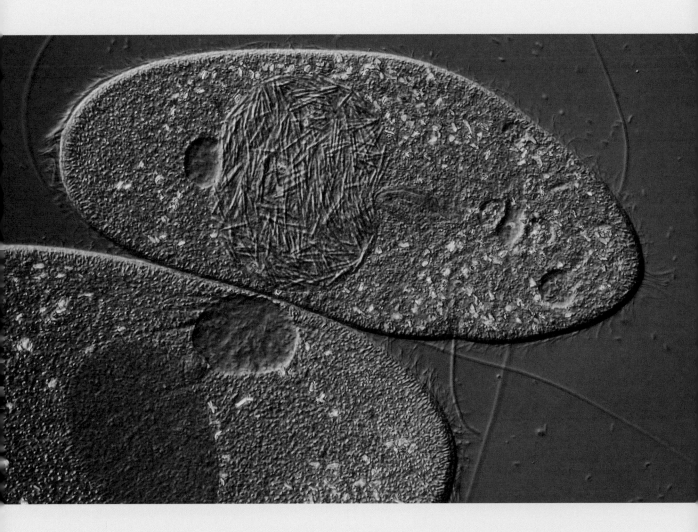

ABOVE: *Paramecium* with an infected nucleus (above), *Paramecium* with a healthy nucleus (below), 180 microns.

I spotted some strange structures inside a *Paramecium* that was zooming around on my slide. I couldn't believe my eyes: these were the parasitic bacteria I read about years ago!

The bacteria I was seeing belonged to a genus called *Holospora* and they were infecting the nuclei of the *Paramecium*. These bacteria were first reported in 1890 by the bacteriologist Sir Waldemar Mordechai Wolff Haffkine in a laboratory aquarium in France. The origin of the infected *Paramecia* were never found, and they haven't been reported in France since 1890. I couldn't find much information about the aquarium where Haffkine first reported the *Holospora*, but I bet it was an aquarium where they dumped old samples to have something to show to students later. I have a similar one at home where I put my old samples rather than flushing them down the drain.

Paramecium is part of a diverse group of microorganisms called ciliates, which we will cover extensively in part two. However, it's important to note that *Paramecia* and other ciliates have two types of nuclei: one is called the macronucleus, which basically maintains the metabolism of the cell, and the other is called the micronucleus, which holds the germline genetic material for the next generation of *Paramecia*. Haffkine found three

different species of the bacteria that were infecting *Paramecia* in the aquarium. He named them *Holospora obtusa*, which targeted the macronucleus, and *H. undulata* and *H. elegans*, which were parasites of *Paramecium*'s micronucleus. Since Haffkine's work, seven other *Holospora* species have been described.

 Holospora species target specific nuclei of a specific *Paramecium* species. For instance, *Holospora obtusa* only infects *Paramecium caudatum*'s macronucleus, while *Holospora undulata* only infects the micronucleus of *Paramecium caudatum*. *Holospora* cannot grow outside the cell, and they show two different forms during their life cycle: a reproductive form and an infectious form. The bacteria find their way into the cell when the *Paramecium* is eating. When the infectious form of *Holospora* is taken into the *Paramecium*, it's wrapped in a membrane with a bunch of other food particles and bacteria, but the *Holospora* does something that other bacteria inside the food vacuole cannot. It saves itself from being digested, leaves the food vacuole and uses *Paramecium*'s own cell network to travel in cytoplasm and find its way to the nucleus it targets. Once it has penetrated the nucleus and started the formation of reproductive forms, it divides inside the nucleus. When the host lives in favourable conditions, these reproductive forms of *Holospora* stay in this stage, but when the *Paramecium* starves, the bacteria change into their infectious form. This allows them to return into the environment and infect more cells in two different ways.

 The first way occurs during the cell division of the *Paramecium*: the infectious forms are "collected" between connecting pieces of the dividing nucleus and wrapped with the nuclear membrane. Later, the *Paramecium* expels these infectious forms through the cell anus (yep,

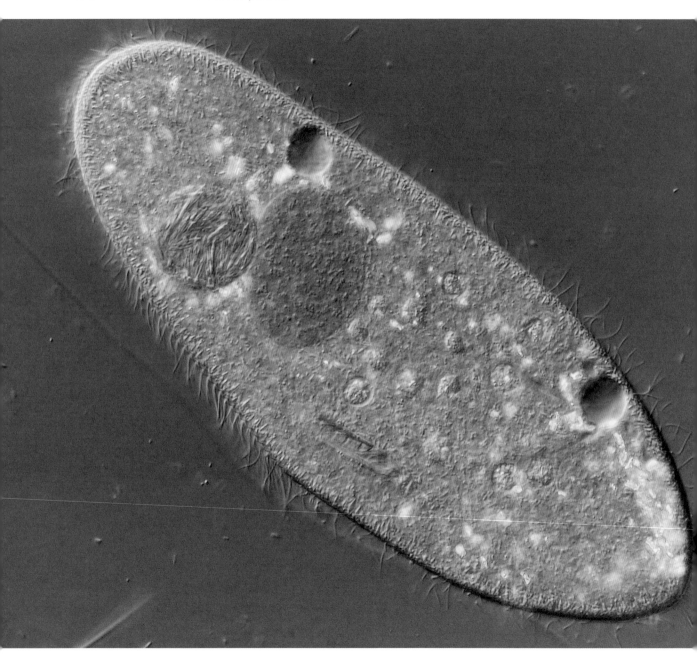

that's a thing) into the environment. The second way for infectious forms to leave the cell is actually how I found them in my sample: The infectious forms fill the whole nucleus, and once the nucleus is overrun by the bacteria, the *Paramecium* cannot grow or maintain the cell and dies, scattering the bacteria back into the environment.

I collected some of the *Paramecia* from my sample and cultured them in a jar. My culture looks quite "healthy", so I add a drop of milk into the culture from time to time to create some food for the *Paramecia*. I believe there are two species of *Holospora* infecting my *Paramecia*. Out of every 100 cells of *Paramecia,* I see 3 or 4 individuals with their macronucleus full of *Holospora*. After over a month of observations, I've seen four cells with infected micronucleus so far. It's absolutely fascinating to find something so remarkable, and I'm hoping to keep the bacteria alive in my culture for further investigation. I'm not expecting a groundbreaking discovery, but they will surely keep me busy for some time! I hope to keep the bacteria alive until I am able to upgrade my microscope with a flourescent light so I can stain the bacteria with some specific dyes that shine under the flourescent light and give me more details about the bacteria. Specifically, I want to observe the bacterium using *Paramecium*'s own cell structures to locate and migrate to the specific nuclei it targets!

OPPOSITE:
Paramecium with infected micronucleus, 180 microns.

Beggiatoa and *Achromatium* – **bacterial giants**

There is one genus of bacteria I can spot in ponds without even needing a microscope. *Beggiatoa* are filamentous sulphur bacteria and they move by gliding on sediment. Sometimes, so many of these filaments gather on decomposing organic matter, like fallen leaves, that they form a white mat which can clearly be seen with the naked eye! *Beggiatoa* are able to oxidize hydrogen sulphide to sulphur, which they deposit in their cells as sulphur inclusions. The sulphur inclusions appear as tiny black spots inside the filaments. I really love watching *Beggiatoa* glide; they move quite fast, and with all the black sulphur inclusions in the filaments, they look amazing!

RIGHT:
Achromatium,
40 microns.

OPPOSITE:
Beggiatoa
filaments.

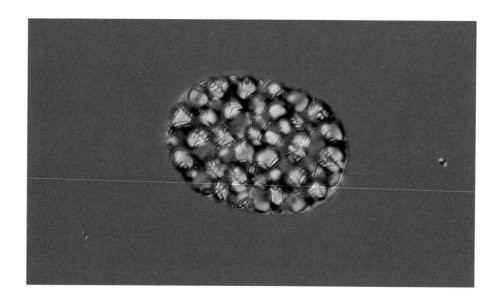

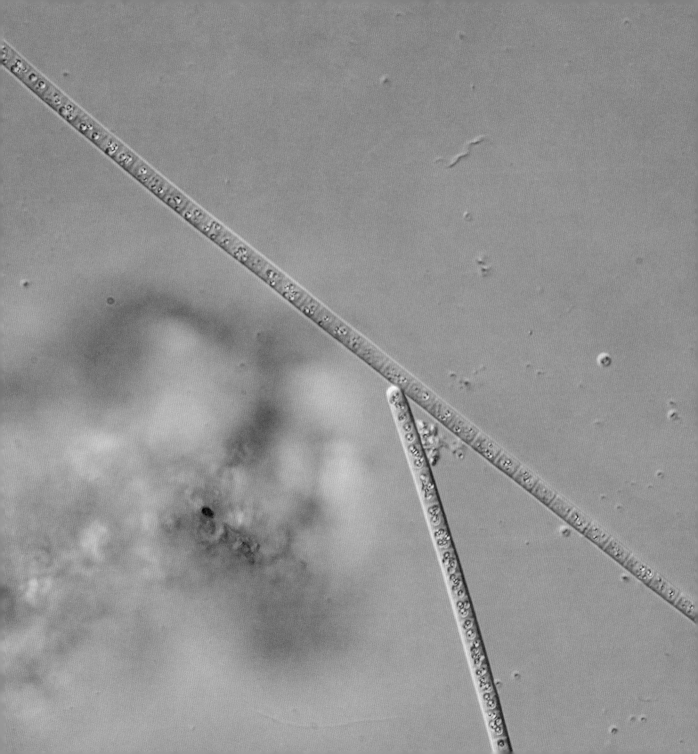

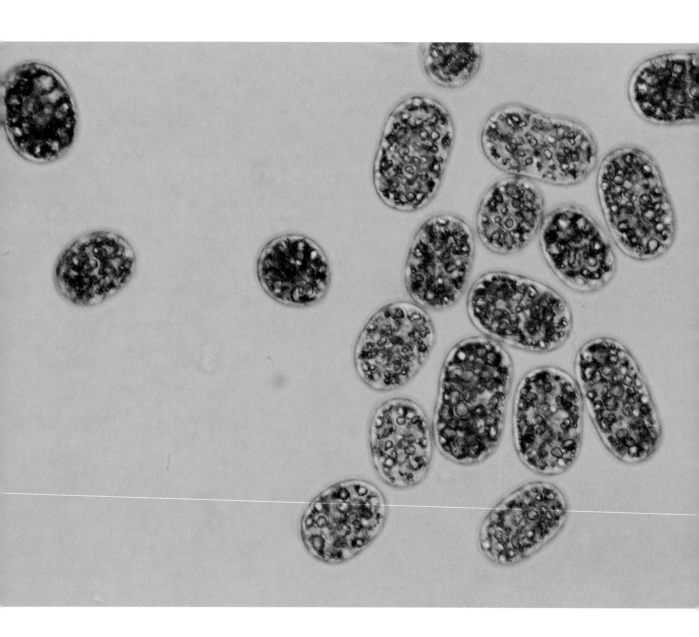

One day I decided to collect mud from the pond in a nearby park to see what I could find. The sample was full of a giant bacteria called *Achromatium*. These are pretty unique bacteria that can accumulate high amounts of calcite, a mineral that is the main constituent of limestone and marble, in their cell, and they can be even larger than 100 microns, which is quite big if you consider most bacteria are under 5 microns in size. Scientists are still trying to understand why *Achromatium* accumulates calcite. It's proposed that the bacteria regulate their buoyancy with the calcite accumulations. They might be using the calcite as a source of carbon dioxide or as a buffer for pH changes. Even though it was first discovered in 1892, *Achromatium* still cannot be cultured in the lab, which makes studying the organism very difficult, and this is a great example to show how little we know about microbes.

LEFT: *Achromatium.*

Cyanobacteria – **the game changer**

Life was very different on Earth 2.5 billion years ago; single-celled organisms were evolving for at least a billion years under oxygen-free conditions. Then something changed around 2.4 billion years ago, and oxygen started to build up in the atmosphere. This was one of the most important events that ever happened on Earth, which led to the evolution of life as we know it, but it also wiped out most of the life forms that evolved to live in oxygen-free conditions. This was known as the "Great Oxygenation Event", and it was an annihilation of many bacteria species but a happy ending for us oxygen-breathers!

The increase in the atmospheric oxygen was caused by a biological mechanism we are all familiar with today: photosynthesis. Around 3 billion years ago, a group of prokaryotic organisms known as "cyanobacteria" appeared with a certain skill: they started to use the water and carbon dioxide and sunlight's energy to produce food for themselves, and the waste product of this recipe was oxygen. However, levels of oxygen didn't increase in the atmosphere for about half a billion years. We don't know why the Great Oxygenation Event didn't occur earlier, as the cyanobacteria were producing oxygen long before the event. One explanation is that the generated oxygen was reacting with some chemicals in the atmosphere, and another explanation is that something about the cyanobacteria changed

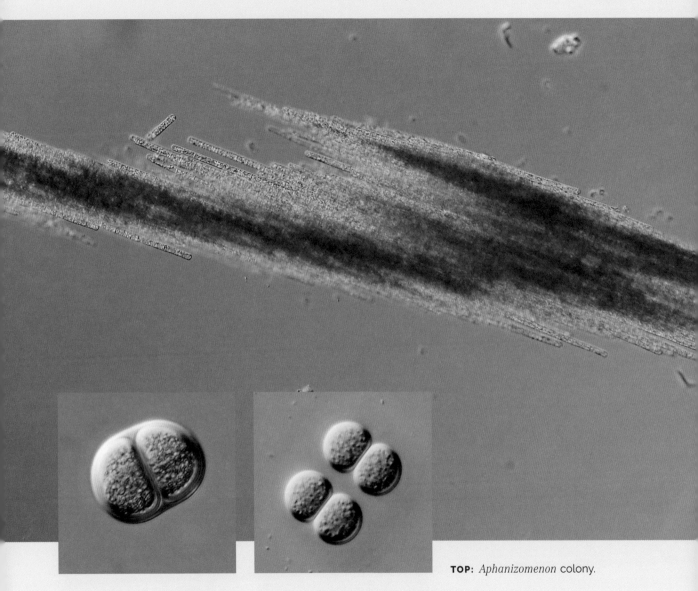

TOP: *Aphanizomenon* colony.

ABOVE: *Chroococcus*, 20 microns.

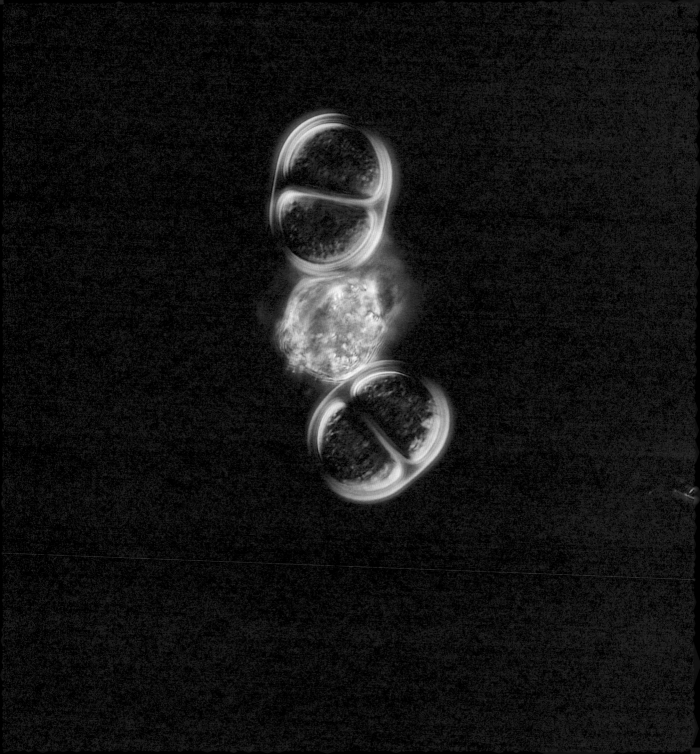

2.4 billion years ago, and that triggered the increase of oxygen in the atmosphere. That change could have, in fact, been the evolution of multicellularity in cyanobacteria.

Cyanobacteria show multicellularity in a remarkable way today. They form long chains of attached cells, and in some species, the cells on the chains have work division; there are heterocyst cells for harvesting nitrogen into useful forms for the bacteria, and thick akinetes cells for surviving environmental stresses. The multicellularity might be the game changer of the cyanobacteria's success in early Earth history. By looking at fossil records and through studies that look at the evolutionary history of species, it seems the multicellularity in cyanobacteria evolved approximately 2.5 billion years ago, just before the Great Oxygenation Event, and that this might have triggered the rise of oxygen.

The multicellular cyanobacteria were better adapted to the environmental conditions than the unicellular ones: they can form long chains that slowly move toward well-lit areas so they can use the sunlight's energy for photosynthesis more efficiently. Also, instead of staying horizontal, they can turn vertically in the water to avoid the harmful UV light that comes from the sun when the light intensity increases. Long chains can attach to rock surfaces better and don't get washed away by the currents. All these advantages of being multicellular might have given a boost to the cyanobacteria population on Earth right before the Great Oxygenation Event.

Cyanobacteria were not only probably responsible for the oxygen in the atmosphere; they were also the origin of the sunlight-utilizing organelles in algae and plant cells, known as "plastids", such as the

OPPOSITE:
Chroococcus,
20 microns.

chloroplasts. This is called the endosymbiotic theory, which has been well supported by much evidence since it was officially proposed by the prominent biologist Lynn Margulis in her book *Symbiosis in Cell Evolution* in 1981. While Margulis was doing research on the origins of eukaryotic cells, she realized that there were similarities between organelles inside eukaryotes (see page 58) and prokaryotes, and she thought that this could be explained by endosymbiosis, a process by which an eukaryotic cell consumed an aerobic prokaryote and, instead of digesting it, let the aerobic prokaryote live inside it, which later led to the formation of mitochondria.

Something similar happened when an eukaryote consumed a cyanobacterium and let it continue doing photosynthesis in its cytoplasm, which meant the whole eukaryote could benefit from photosynthesis. Mitochondria and chloroplasts in eukaryotic cells have their own DNA and they can only be reproduced by cell division, which also supports the theory.

ABOVE: *Oscillatoria.*

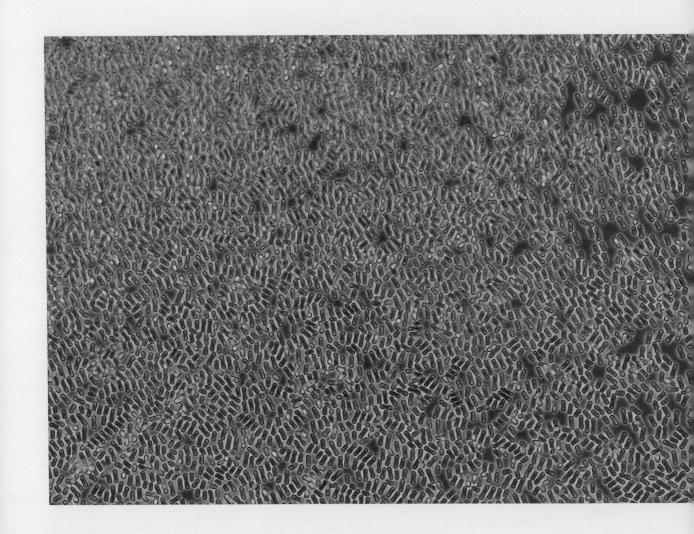

ABOVE: Tiny cyanobacteria, 5 microns.

Nostoc – **shooting stars fallen to Earth**

Nostoc is a genus of multicellular cyanobacteria with specialized cells. *Nostoc* cells are arranged like tiny little beads forming long chains of filaments that are grouped together in a gelatinous mass. These masses are often round, and they can be as big as a golf ball, containing tens of thousands of cells. *Nostoc* colonies are found worldwide both in aquatic and terrestrial environments, especially after heavy rain. The colonies swell on the soil and appear as if they came out of nowhere; that's why they are sometimes called star jelly or witch's jelly.

I accidentally cultured *Nostoc* at home. I was keeping my prepared slides in a big plastic box with wet cotton balls for humidity so the slides wouldn't dry up, and after leaving them neglected for a couple of months on my windowsill, I decided to take a look at the slides in the box, but when I opened the box I saw many bead-like dark green things on the wet cotton and I realized that I had cultured *Nostoc*! A quick check under the microscope confirmed it and made me realize that the *Nostoc* cells initially came from a slide I had put in the box. I must've touched the wet slide on the cotton and transmitted the *Nostoc* cells into the box where they had been growing for months!

Like other cyanobacteria, *Nostoc* uses photosynthesis to produce food for itself. It can also transfer gaseous nitrogen in the atmosphere

OPPOSITE:
Nostoc,
100 microns.

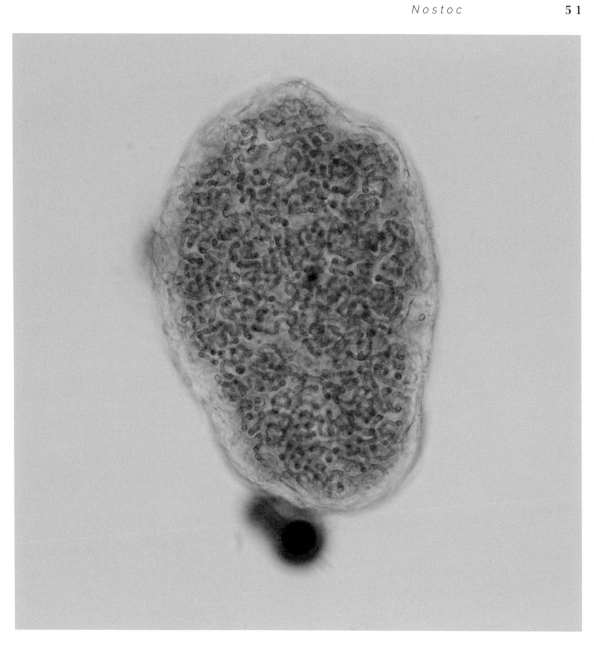

into compounds that can be used by the cells to make the more complex molecules that it needs to function. The most remarkable thing is that nitrogen-fixing enzymes don't work in the presence of oxygen, so *Nostoc* forms specialized cells called heterocysts. The heterocysts have thick walls that are impermeable to oxygen, and this provides the required oxygen-free environment for the operation of the nitrogen-fixing enzymes. Therefore, *Nostoc* cells take nitrogen from the air and put it into the environment, and then these nutrients can be used by the plants! In many ways, a simple organism contributes so much to the life we see around us.

OPPOSITE: *Nostoc*, 3,000 microns.

Dolichospermum – **microscopic blooms**

Dolichospermum inhabits freshwater habitats. It is a planktonic cyanobacteria, meaning that it hangs in the water and goes wherever the current takes it. *Dolichospermum* has the same ability as *Nostoc*; it converts nitrogen into ammonia in its specialized cells, the heterocysts. You can see the heterocysts in the photo opposite as darker spherical cells, but unlike *Nostoc, Dolichospermum* produces neurotoxins that occasionally cause problems in freshwater habitats.

Normally, *Dolichospermum* is harmless and part of a balanced ecosystem, but sometimes these cyanobacteria cause blooms. During blooms the number of *Dolichospermum* in the water increases incredibly, changing the colour of the water and causing a strange odour. Blooms happen mostly because of something called eutrophication. Eutrophication is an enrichment of water by nutrient salts caused by humans. Every time we use fertilizers, they are washed by rain into rivers, streams, lakes or ponds, entering the water cycle. Or we cause eutrophication by dumping nutrient-rich wastewater in lakes and rivers. This happens particularly often in developing parts of the world where this is not regulated and wastewater is mostly discharged into the environment. Even when there are regulations in developed countries to prevent dumping wastewater, illegal discharges still happen. The nutrients in the water create a perfect growing habitat for toxin-producing algae like *Dolichospermum*. The algae reproduce and create more biomass by using all the available nutrients in the water, and cause blooms. The blooms kill wild animals, like fish and birds, or our unfortunate pets who jumped into the toxic water to play fetch.

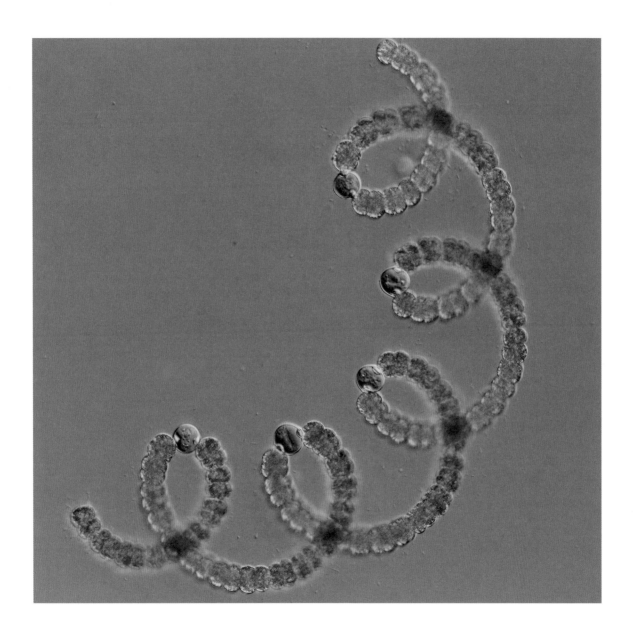

Foundations of life

I hope this rather short introduction to prokaryotes has helped to demonstrate that even the simplest life on Earth is actually not simple at all. Without the beautiful, brilliant and often smelly cyanobacteria, we wouldn't have any of the wonderful leafy plants that live on Earth today, let alone the breathable air. We often think about the balance at play in animal habitats, but even messing with the balance of invisible life can have planet-altering consequences. Life is formed as building blocks, one on top of another, and the prokaryotes form the foundations of life; without them the more complex life would never have appeared. Prokaryotes play an enormous environmental role everywhere. In the case of everyday human life, even after using antibiotics to kill the bacteria that harm us, we have to take live bacteria as probiotic pills to bring back the balance of lost helpful bacterial habitants.

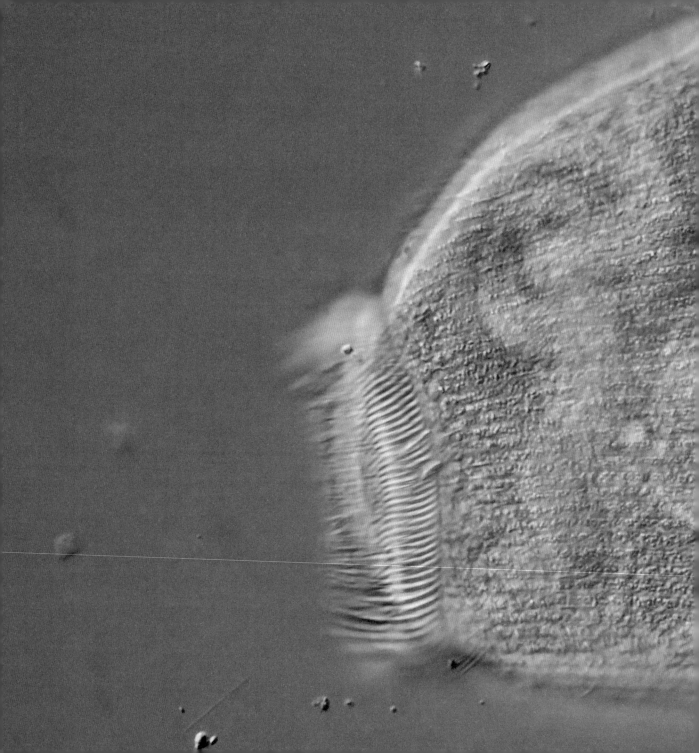

part two
unicellular eukaryotes

About a billion years after the appearance of the prokaryotes, a new type of cell emerged on Earth known as the "eukaryotic cell", which eventually formed all the plants, animals and fungi we know today. The first eukaryotes were not multicellular but unicellular. We still have single-celled eukaryotes on Earth, and they are called protists. These single-celled eukaryotes are different from their single-celled prokaryote neighbours in many ways.

Eukaryotic cells are usually bigger in size and volume than prokaryotes, although not always, and their DNA is separated from the rest of the cell by a porous membrane. The eukaryotes have specialized compartments in their cells that are wrapped in a membrane. These include special things like lysosomes, for digestion, endoplasmic reticulum, a folded and layered structure involved in making proteins, the Golgi body, which transports and stores proteins, and mitochondria, popularly known as the "powerhouse of the cell" because they convert carbohydrates into energy to power the cell. With all these add-ons, the eukaryotic cells can accomplish more and show simple behaviours.

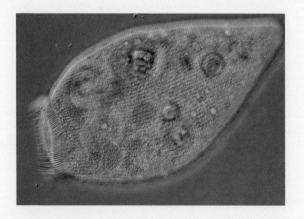

ABOVE AND PREVIOUS PAGE: *Stentor*, 400 microns.

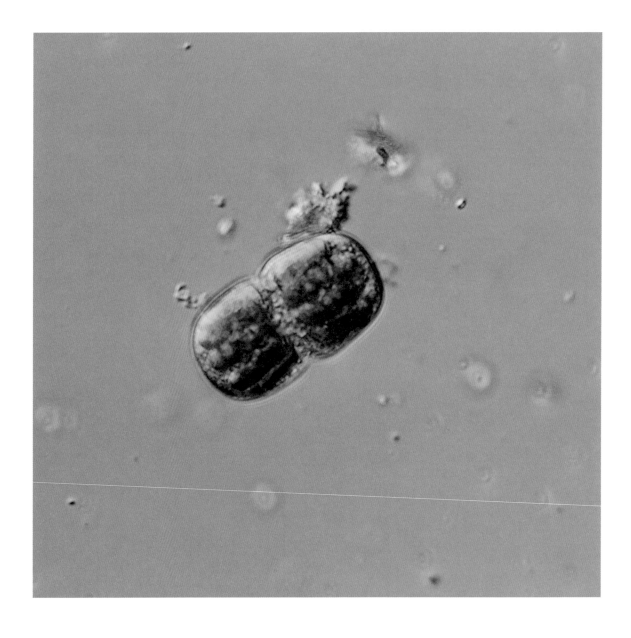

Desmids –
the power of symmetry

The first organism I recognized through my own microscope was a eukaryote. The microscope finally arrived after the Christmas holidays. I had ordered it to arrive at the office of my then-girlfriend, and so I received an excited call: "Your microscope is here!" I took a bus to get there, took the box under my arm and started to return home. But I couldn't wait to get started straight away. On the way back I stopped to collect samples from a puddle right in front of my house, the box still stuck under my arm. It was raining heavily for some time in Warsaw, and everything was drenched – perfect sampling conditions – I couldn't resist!

I found something really beautiful. It took me two whole days to identify what I saw. When I think of it now, I realize how easy it actually was. (There is certainly a learning curve when it comes to microscopy and microbes.) It was a desmid with a mouthful of a name: *Actinotaenium*. I didn't know much about identification at that time; all I did was google the word "green algae" and look at the images that came up. After a day of looking, I figured out the thing I was looking at was a member of a group called the desmids. They all have magnificent symmetry. Then I googled the word "desmid" and looked at the images Google had to offer, and finally I found it. I felt like I had won a battle!

Despite it being the first species I saw, I wouldn't find any more desmids again for many months. Yet over time I have found some other desmid species, and their beauty blows my mind. Desmids show the most striking symmetry of all the microorganisms, and I think they are

OPPOSITE:
Actinotaenium,
30 microns.

one of the most beautiful things this world has ever seen. I find desmids in ponds and even in puddles, like the one that was in front of my house. There are 5,000 species of these beauties. Most are unicellular, but some species can form long, chained colonies to avoid predators. The majority of desmids are composed of two half-cells that show perfect symmetry to each other. There is a chloroplast in each, covering the half-cell and giving it its beautiful green colour and also turning these nature's wonders into solar-powered biological machines. Where the half-cells meet, there is a spherical cell nucleus. This point where the half-cells connect is called the isthmus. I love saying this word out loud. It reminds me of the first sentence of *Moby Dick* by Herman Melville: "Call me Ishmael."

Photos are not enough to emphasize the beauty of the desmids. Most desmids have mysterious crystals in them, and these crystals interact with polarized light, shining like tiny fireflies in the night sky. And they dance too; these crystals are in constant motion as they vibrate, roll and rotate by themselves. This motion is caused by one of the most fundamental rules of our universe. To explain it, let's get back to basics. We all know everything is made up of atoms, and atoms come together to form molecules such as water molecules. Desmids live in water and they are surrounded by water molecules. The water molecules are constantly moving because of the heat energy they have; as long as the temperature is higher than absolute zero

OPPOSITE:
Micrasterias,
300 microns.

BELOW:
Micrasterias,
200 microns.

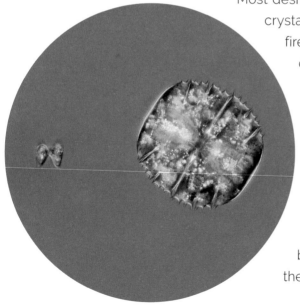

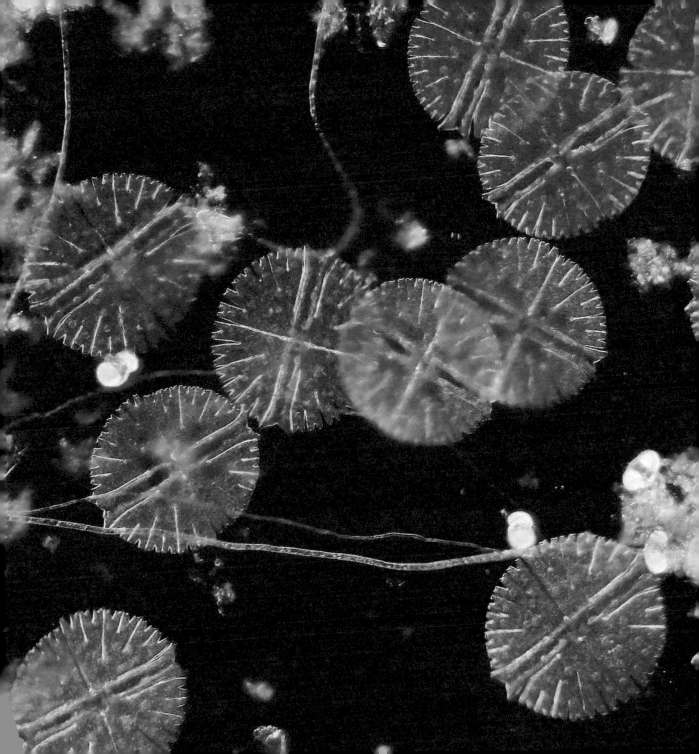

(–273.15°C or –459.67°F), they will continue to move, the higher the temperature, the faster the motion. When these molecules randomly move, they are occasionally bumping into the crystals in the desmids, and because the crystals are extremely small, you can see the molecules causing them to move erratically. We don't know the function of these crystals in desmids. They actually don't need to have a function or purpose; sometimes things are just there. But that doesn't mean we cannot use them for our own purposes. For instance, a crescent-shaped desmid containing such crystals got the attention of scientists because of its ability to be able to collect a radioactive isotope called Strontium-90 in the tips of its cell.

This crescent-shaped desmid is called *Closterium*, and it usually collects mostly barium crystals and has nothing to do with strontium, but under certain circumstances it can also collect strontium. Because the strontium is close to barium in size and properties, it gets crystallized and enriched in *Closterium* tips alongside barium. Strontium is dangerous for us because it has similar properties and atomic size to calcium, and if you

RIGHT: *Closterium*, 240 microns.

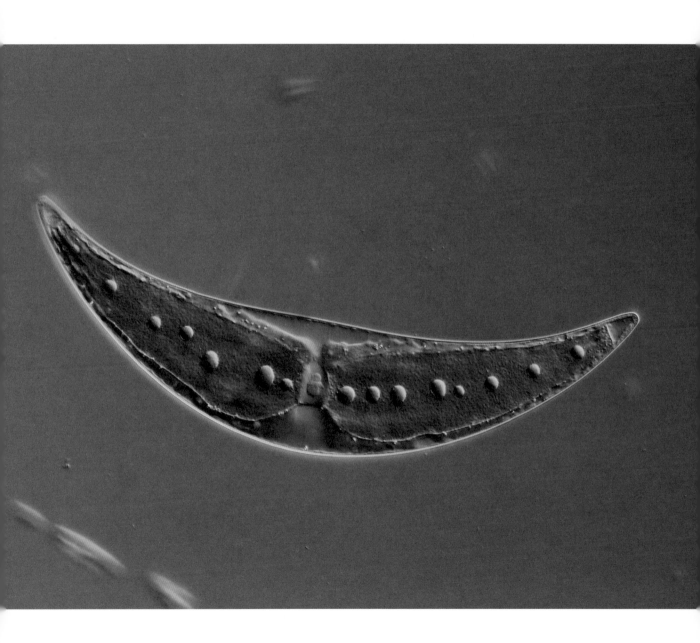

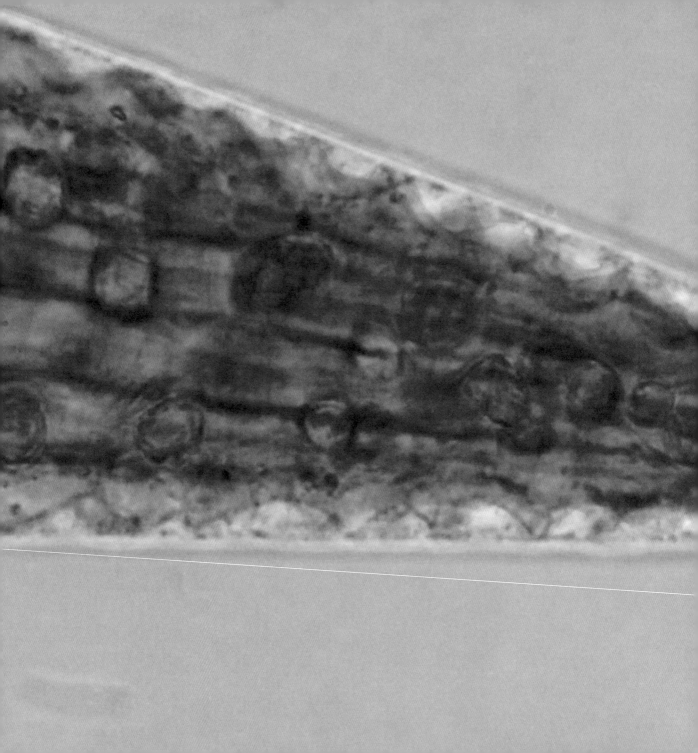

come into contact with it from contaminated water, your body cannot tell the difference and it can become stored in bones and bone marrow just like calcium. Any emitted radiation from strontium would eventually cause cancer. It is possible to enhance the strontium uptake of the *Closterium* by culturing the algae in the contaminated water and then removing it with a meshed fabric. This is a handy way to deal with a radioactive spill like the one that happened in Fukushima in 2011. So desmids, these seemingly simple algae, not only have a powerful symmetry, but they can also be used to clean up an environment after a radioactive disaster, a task that would harm human beings.

After I got my microscope, I started to record videos right away. I had a mirrorless camera, a Canon EOS M10, and I was able to record through the eyepiece of the microscope by getting my camera really close to the lens. At first I held the camera in my hand. This didn't work too well as I didn't have a surgeon's steady hands or the camera port on my microscope to actually attach my camera to it. So I bought a tripod and put my camera on the tripod. At that time I was sharing a small room with

LEFT: *Closterium* tip showing the crystals inside. Each crystal is 2 microns wide.

my girlfriend in a shared flat with four others. Yes, six people in a flat. In the tiny shared space I had to keep my microscope on a breakfast-in-bed tray on the ground, and I marked on the floor with a permanent marker three circles: one for each tripod leg. When I saw something interesting enough to record, I would fetch my camera on the tripod and place the legs on the circles to capture the whole view through the microscope. At the time I was uploading some of the videos on YouTube to show Dr Adam, the man who introduced me to microbes, so he could tell me his opinion about my findings. These videos weren't being watched by anyone else but me, but I was still uploading once or twice a week.

However, things were about to change. This was the loneliest period of my life. I had almost no friends, wasn't able to speak Polish, and things with my girlfriend weren't going well. I spent my time checking my microscope, and going to the National Museum every Tuesday because it was free. I even bought an annual ticket to Warsaw Zoo, even though I believed it was a prison for the poor animals, but I was lonely and depressed and once again I was trying to find solace in nature and art. One Friday I was out sampling when I got a text from my girlfriend. I think everyone knows how it feels to see a huge, unexpected text from someone. It was all bad news. Our relationship was over. She moved out the next week while I was at a coffee shop with the only friend I had in Warsaw.

It was a tough time. For about two weeks I didn't check my microscope, didn't do much at all. It was a sudden change and I even believed for a few weeks that I could never be a happy person, that I was damaged beyond repair. Yet in the end, this change led to

something wonderful. I went to see a therapist. I had decided I didn't want to be depressed any more. Life came back to me, along with my appetite. I started running, dating and uploading videos about microbes to Instagram every day. For a long time, I hadn't been sure about the whole Instagram thing – I thought it was a platform only for Kardashians! – but my friend convinced me that it was worth sharing my discoveries there. I uploaded ten clips in one day and then forgot about the whole account for a week. But when I checked my account, I saw 50 people following me and really enjoying my posts! It was so wonderful to see people interested in my pond buddies, and I decided to upload daily. I got a new job shortly after I started my Instagram. I was working from nine to five and commuting for over an hour, so I started to read scientific papers on the bus. I was coming home and checking my microscope, preparing videos for YouTube and Instagram. I believe I didn't sleep longer than four hours each night during the week for almost a year – social media was a place where I was able to list my findings, like a microbe diary. I would come home from work, check my microscope, record a bunch of interesting things, identify and read papers about them and prepare an informative post for social media. I continued my sessions with my therapist while doing this every day, and once I got to talk with a professional and understood myself better, things got easier. Through finding my community online, finding my passion, and seeking help, I learnt so much about myself. Like everyone else I have ups and downs, but I am not depressed any more.

Green euglenids –
serendipitous meetings

I had to do something about my growing passion and get more into this field, but it wasn't an easy thing to do. I studied engineering for almost ten years in three different countries, and what I wanted to do was pure science. I wanted to become a protistologist (not a proctologist, as autocorrect seems to think I mean; I have no special interest in butts!). I wanted to learn everything about the single-celled eukaryotes known as the "protists". They were, in my opinion, way more interesting than the prokaryotes. I had an idea. If I could become a member of the International Society of Protistologists (ISOP), I would be able to contact them to get some insights about changing my career to protistology. So, with a small payment, I became a member of the society. I sent an email to them, explaining that I am dying to learn more about everything protists, and I got a reply. It was a really nice email, telling me to contact another member of the ISOP in Warsaw, Dr Anna, who is working on a group of gorgeous protists known as "green euglenids". I was thrilled! I sent her an email, hoping that she would answer me.

OPPOSITE: *Euglenaria*, 50–70 microns.

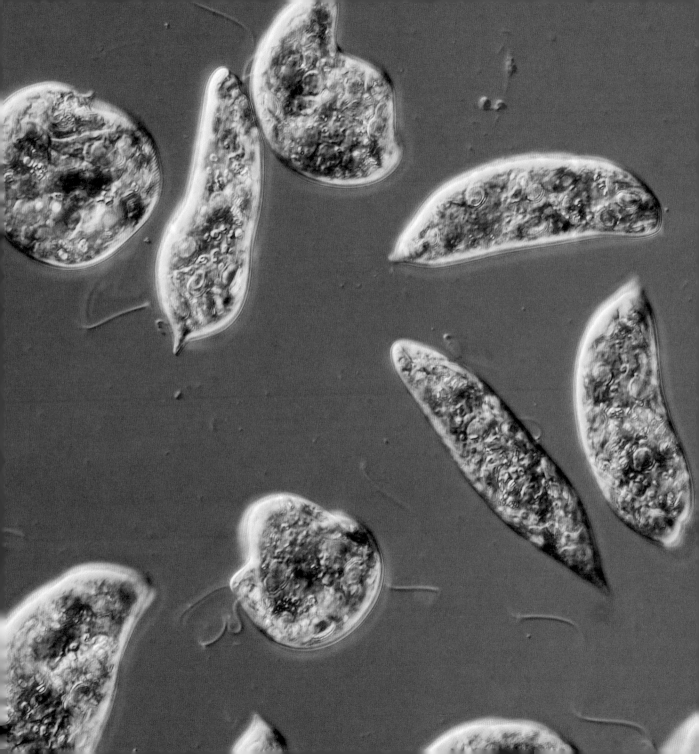

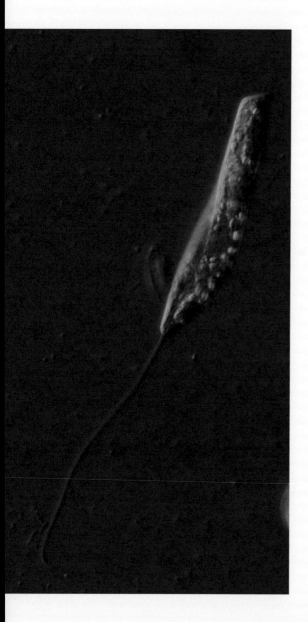

Green euglenids are tiny organisms that get their green colour from the photosynthetic pigment chlorophyll, just like the desmids. Green euglenids turn carbon dioxide and water into sugar and oxygen by using sunlight, but they can also get nutrients from the environment by engulfing some smaller organisms or food particles or even letting smaller molecules pass through their cell membrane into their cytoplasm via osmosis.

There are non-photosynthetic euglenids too, like *Peranema*. At least a billion years ago, a colourless euglenid swallowed an alga through its cell mouth, and, instead of digesting it, it adopted its chloroplast and turned itself into a green sunlight-powered cell! Even though its chloroplasts were acquired from an algal cell, a number of changes have taken place since then. For instance, green algae produce starch that is stored in the chloroplasts to save some energy for later use, but photosynthetic euglenids produce another carbohydrate called paramylon, and these paramylons are in the cytoplasm, not in chloroplasts. The number and the shape of paramylons in a cell differ from species to species, or even from individual to individual of the

LEFT: *Peranema,* 75 microns.

same species. Paramylon bodies get thinner when the organisms start using their stored energy in times of need, like the dark nights of winter.

The green euglenids are able to sense the intensity of light with photoreceptors located right under the beautiful red spot on the cell, known as an "eyespot" or "stigma". The eyespot itself is not photosensitive but is used in light-sensing in a genius way. Under the eyespot there is a part that is called the flagellar swelling. The flagellar swelling is composed of closely stacked membranes containing hundreds of thousands of photoreceptive proteins. The euglenids rotate when they swim, and the red eyespot periodically blocks some portion of the light that hits the photoreceptive proteins, so each time the light is blocked by the eyespot, the euglenid calculates the direction of the light and sends a signal to the whip-like flagellum (the hair-like appendage I mentioned in part one) to change its beating pattern in order to alter the euglenid's swimming direction.

Sometimes, after collecting samples, I place the jars in front of a desk lamp. Most of the organisms with light-sensing ability in the sample swim toward

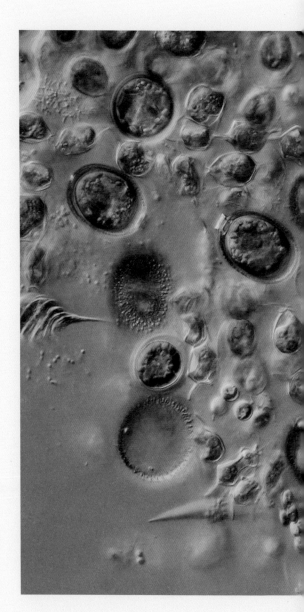

RIGHT: Euglenids and green algae.

the light and form a thin green layer on the surface after only a couple of hours. The green euglenids usually have two whip-like flagella, which beat to move the cell in the water, but often only a single flagellum is visible. The euglenids also have a very peculiar cell surface known as the "pellicle". The pellicle is organized as a series of strips. In some genera of euglenids, like in *Euglena*, these strips slide past each other actively and let the organism change its shape and even move around this way. This type of motion is known as "euglenoid movement" or "metaboly". Species that have fewer strips tend to be more rigid, and species with more strips tend to be highly metabolic and wiggle around. The wiggly ones were the euglenids Dr Anna was working on, and I was so excited about them.

Later that week I received an email back from Dr Anna, who invited me to visit her at the biology faculty. When we met I could immediately tell I was talking to someone very intelligent. (Maybe I even had a bit of an academic crush on her because of the knowledge she has about microbes!) She told me that she receives emails like mine often, but she googled my name and found some of my videos and she said she was impressed by them and decided to meet me! She was happy to include me in the lab and just needed to run it by her boss.

The week after, I met her boss, Professor Bozena. Bozena has been working on microbes for over 40 years, and she had so much knowledge about them. She quickly became a special person to me – an important mentor. I often went to visit her in her office and we spoke about microorganisms for hours. She is an unparalleled expert in using the microscope and taking microphotographs. She has a collection of gorgeous microphotographs, the likes of which I have never seen

before. They are such precisely arranged compositions, showing so many details of the cells. As well as sharing my passion for capturing microorganisms, she has a story like mine too. She became fascinated by the beauty of microorganisms during a high-school biology class. And she wanted to pursue this as her career, but at that time it was extremely hard to get into university because her parents didn't have the right connections. Desperate to find a way in, she went to the National Academy of Sciences in Warsaw and told them that she wanted to work on microorganisms, and a scientist there gave her a *Paramecium* culture. Professor Bozena wanted to see how *Paramecium* responded to some specific chemicals. She added some simple chemicals into the water and documented her observations. In the end, she submitted her study to the National Biology Olympiad. As she told me this story, she said, "The paper I wrote was this thick." And she showed something like an inch between her fingers. After Professor Bozena won the Olympiad, her place was ready in biology studies. I have learnt so much from her over the past two years. Whenever I find a green euglenid I cannot identify, I send her an email and ask for help.

One day after a sampling trip, I found a peculiar looking green euglenid under the microscope.

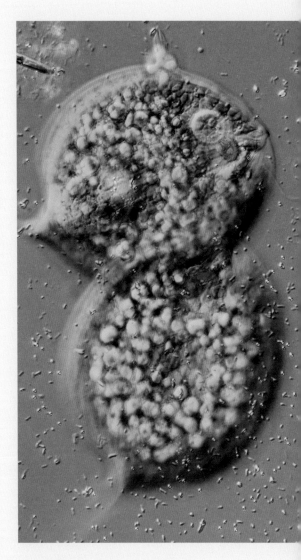

ABOVE AND OVERLEAF: *Phacus gigas*, 120 microns.

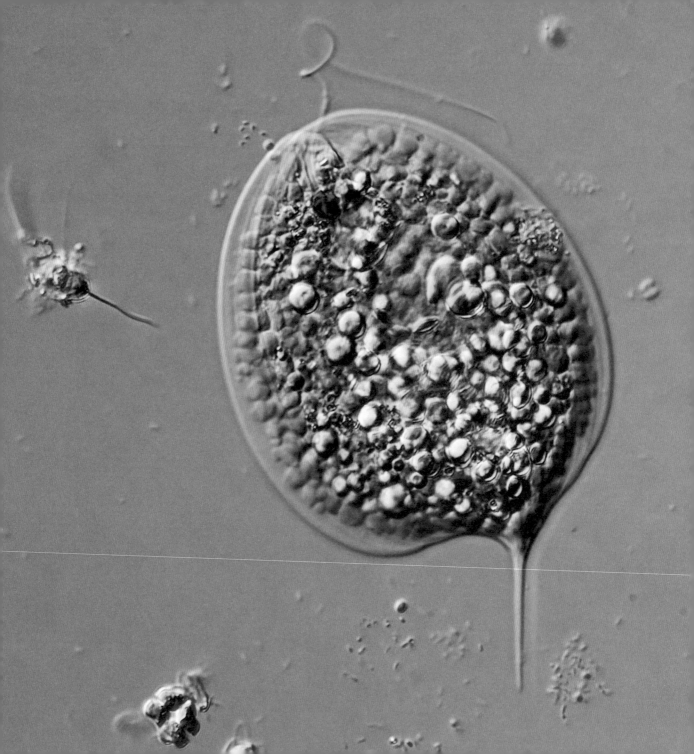

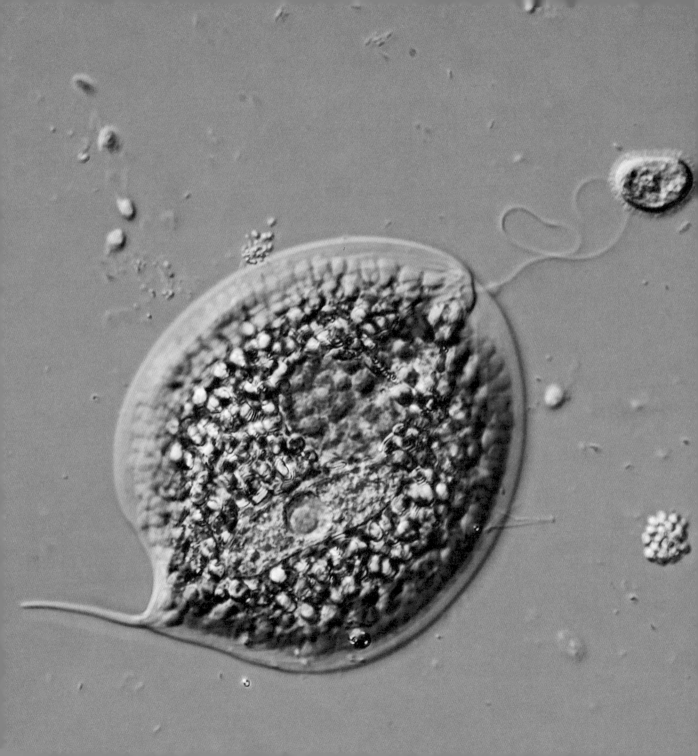

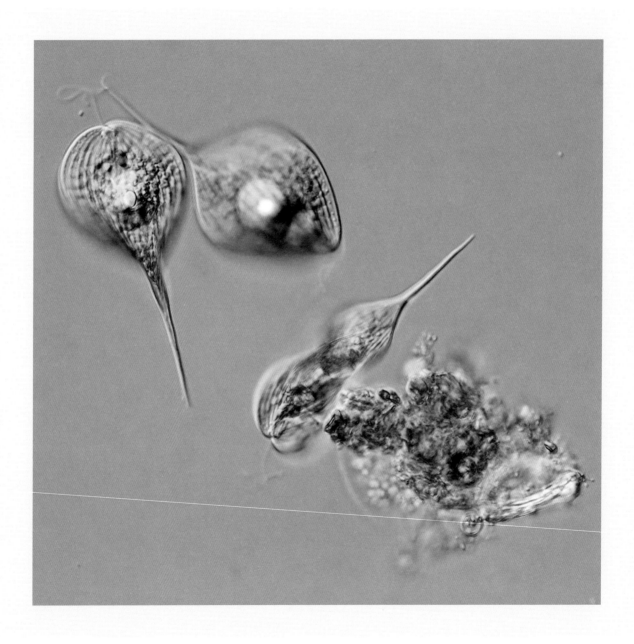

I believed it was a *Phacus* but wasn't sure what species of *Phacus* it was. So I wrote an email, attached a short clip of the cell swimming in a corkscrew motion, and sent it to Professor Bozena. She, of course, knew what it was immediately. She surprised me by telling me that she was the one who named that species as *Phacus smulkowskianus* in 1986! Decades later I had found my own mentor's species; it felt really meaningful, and I was keen to learn more about the origin of the name. And so she told me the story behind the name "smulkowskianus".

Before the internet age, Professor Bozena said, it was hard to get information on microorganisms. At the time, Poland was part of the Soviet Union, and they were separated from the rest of the world by the Iron Curtain. When Professor Bozena needed a scientific paper, she had to contact the author of the paper via post. She had to write a letter and wait weeks for the author to answer. She also had to contact libraries all over the world, referencing the names of the papers so that they could make a copy and send them to her. To make matters worse, these papers were written in many languages. Professor Bozena adds, although the description of the species were always written in Latin as a rule, describing the size, length, chloroplasts' shape, sample location, etc., the rest of the paper was often written in a language she didn't know. However, her husband's uncle, Janusz Smulkowski, was able to speak nine different languages, six of which he taught himself. Janusz would help her to translate the papers when she finally received them, so that she could fully understand all the valuable information. Janusz Smulkowski died shortly before Professor Bozena discovered this species, and she dedicated the beautiful organism to his memory.

ABOVE:
Phacus smulkowskianus, 40 microns.

OPPOSITE:
Phacus convexus, 70 microns.

Diatoms – **glass artists**

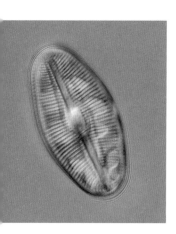

ABOVE AND OPPOSITE: Diatoms.

There are trillions and trillions of tiny golden cells everywhere there is water. They are not usually visible to the naked eye, but sometimes their number increases so much that they paint the oceans and become visible from space. They are called diatoms, or the jewels of the sea.

When I asked Professor Bozena why she'd chosen to study euglenids, she told me that she actually started her career with diatoms but her professor recommended she change the studies from diatoms to euglenids. He said that a lot of people had been studying diatoms for centuries, but no one was doing research on euglenids. And because of the extensive studies, tens of thousands of diatom species had been described in literature, some of which had been wrongly described.

Diatoms are single-celled algae, and they possess something quite astonishing and beautiful: a cell wall made of silicon dioxide, which makes them literally living glass! They pull the dissolved silica out of the water and build their gorgeous cell walls with the skill of glass artists. The glass cell walls are called frustules. Frustules come in many different shapes and sizes, and there are tens of thousands of species of diatom, each different from the other. The difference is sometimes subtle but sometimes so remarkable that they look like they could belong to a totally different group of organisms. The word diatom means "cut in half", because the frustule is formed by two halves that look like the two pieces of a petri dish fitting together. Diatoms are also responsible for at least 20 per cent of the oxygen generated each year – most likely more than the Amazon rainforest. The oxygen diatoms release is produced in the same way as it is

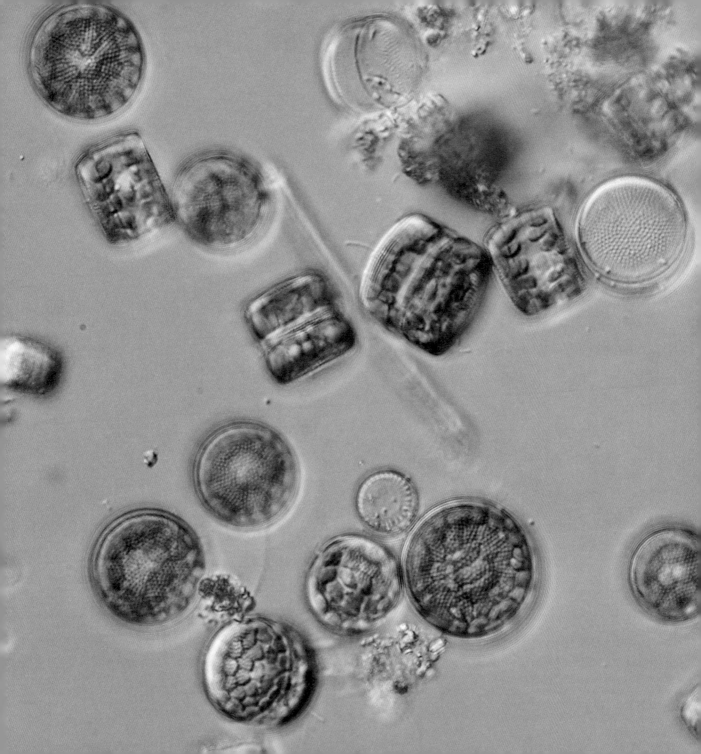

by other algae: through photosynthesis; which means carbon dioxide and water are utilized by light energy to create food and oxygen. But an accessory pigment, fucoxanthin, masks the other chlorophyll pigments, so diatom cells look golden instead of the accustomed green colour of most photosynthetic organisms. Diatom frustules are often beautiful shapes with pores and slits, which allow diatoms to secrete mucilage or waste. These ornaments of the frustules are especially breathtaking when the diatoms are dead, decomposed and have left their empty shells behind. Because the frustule pores and slits provide the most accurate way of identification, except for molecular work, scientists often wash diatoms in acid solutions. Acid eats up all the organic matter inside and outside of the diatom cells, leaving the silica frustules untouched and easy to identify.

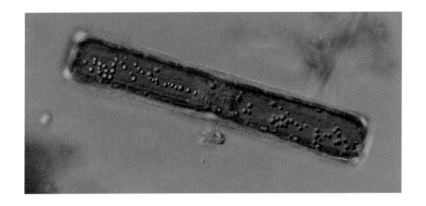

ABOVE:
Pinnularia
with oil drops,
120 microns.

The frustules of dead diatoms fall to the bottom of water like a constant rain, where they have accumulated for thousands, and even millions, of years. These deposits form something called diatomite or diatomaceous earth. Diatomaceous earth deposits can be metres thick. The first deposit that was discovered in Lüneburg Heath, Germany, was mined from 1863 to 1996, and the bands were up to 25m thick. Imagine the number of diatom frustules needed to create such formations!

Diatomaceous earth has been used in many applications, even by Alfred Nobel when he used diatomaceous earth to stabilize nitroglycerin and subsequently patented it as "dynamite". Some other uses of diatomite are less dangerous to handle. Diatomaceous earth is added to toothpaste for its mild abrasive properties, used in filter-making, cat litter production, used as a food additive and as a pest control agent. When powdered diatomaceous earth comes into contact with bugs, it absorbs the oil on their exoskeleton that prevents the insect from drying up from water loss, resulting in the death of the insect.

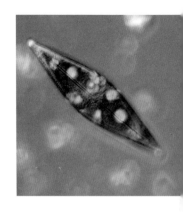

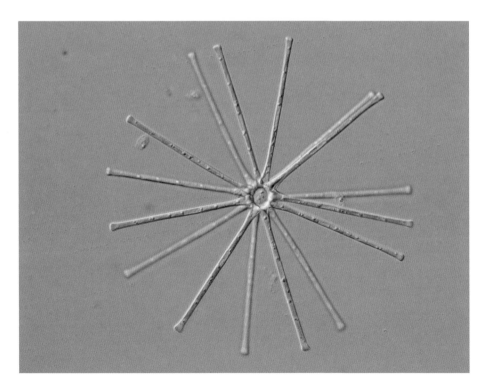

ABOVE:
Navicula details
on frustule,
70 microns.

LEFT:
Asterionella,
240 microns.

Asterionella and *Bacillaria paxillifer* – **blooming colonies**

Some diatom species form gorgeous colonies. *Asterionella* is one of these species. The number of cells in a colony varies, but a colony of *Asterionella* always forms an enchanting asterisk shape. Colonies don't actively move in the water but are carried by the current. I often find blooming *Asterionella* colonies from a river that runs through the city, and the *Asterionella* blooms are always accompanied by ciliates that specialize in eating diatoms. *Asterionella* don't form colonies just to look like cute little stars; I observed many times that ciliates cannot consume *Asterionella* cells that are attached to each other, but they slurp stray cells up easily, which indicates that the colony formation of the *Asterionella* is one of the ways that they evolved to avoid predators.

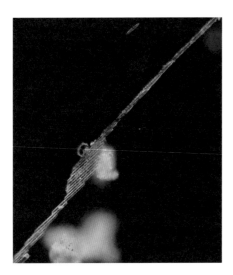
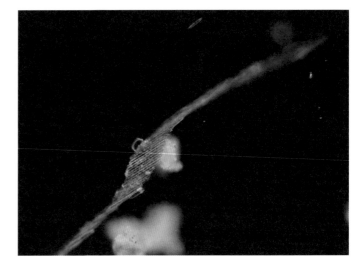

Another colony-forming diatom species is *Bacillaria paxillifer*, or, to use its old name, *Bacillaria paradoxa*. It was one of the first diatoms to be described in 1782 by Otto Friedrich Müller, who was utterly confounded by their movement. As he watched them he wasn't sure if he was seeing a single motile animal or a colony of extending organisms, and hence named them after this paradoxical motility (*B. paradoxa*). The colony moves like an extension ladder; each cell slides on to the one next to it, then extends and contracts. First, they look like a rectangular-shaped colony, then the cells start to move and the whole rectangle opens up and stretches out until the colony is only one-cell wide and centimetres long! Each cell just smoothly glides on the adjacent one without flagella or cilia! Today the locomotion of it is, still, quite enigmatic.

BELOW AND OPPOSITE: *Bacillaria paradoxa.*

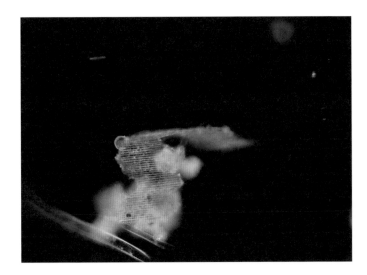

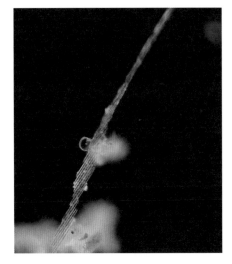

Golden-Algae *Synura* –
beautiful leaves and trees

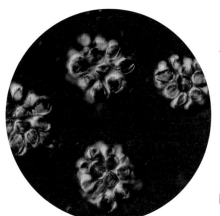

ABOVE:
Synura colonies,
40 microns.

OPPOSITE:
Golden-algae
Uroglena
colony,
200 microns.

A group of microorganisms appears in great numbers every spring, letting me know that the winter is over and the warm days are ahead. This organism is called *Synura*, and when it becomes incredibly abundant, it releases an odorous substance into the water. I can often tell that *Synura* are forming dense blooms before I actually sample the pond by relying on my nose rather than my microscope. The smell is pungent and hard to describe.

Synura is a colonial golden algae. They look like microscopic tumbleweeds because of the spherical colonies and their rolling swimming style. They are quite common in freshwater environments, but when they create blooms, a drop of water can contain thousands of colonies. *Synura* colonies contain many individual cells; the number in a colony changes, but the shape and the way they connect to each other stay the same. The tear-shaped cells are attached to each other at their back, and they often form a tightly packed sphere. Each of the individual cells has two tiny whip-like flagella, and the flagella extend out from the colony. Tens of these cells in the colony beat their flagella together, causing the colony to roll in the water, clumsily but gracefully.

The cells in the colony can sense light, so the colonies swim toward lit areas. It works for them because they use sunlight to produce food for themselves through photosynthesis, but this is also the reason I avoid collecting water from the blooms; when I put a drop of water with blooming *Synura* onto a slide, they quickly swim into my field of

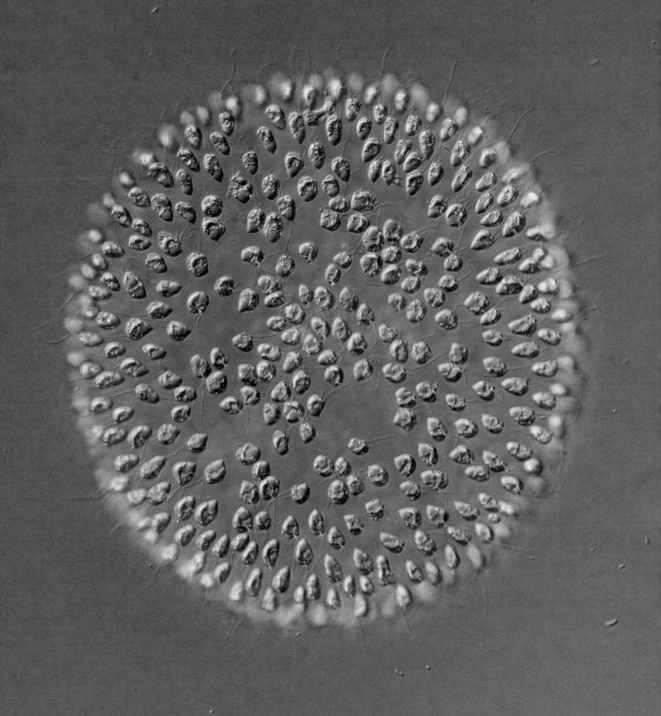

view because of the small circle that my microscope's light source creates on the slide. It's really pleasing at first, but then I cannot look at any other organisms on the slide because, wherever I look, all the *Synura* follow the lit circle and quickly blanket anything in that area.

There are many species of *Synura*, which are distinguishable from one another through their silica scales. These scales are like leaves covering *Synura* cells; they look gorgeous under an electron microscope. And there are over 1,000 species of other golden algae. The golden colour of these algae mainly comes from a pigment called fucoxanthin in the algae's chloroplasts.

Some of these algae prefer a solitary life, like the gorgeous *Mallomonas.* These were one of the first organisms I saw under my new differential interference microscope (I will explain more about this on page 160). *Mallomonas* have silica scales too but these are much bigger than the ones *Synura* have, and I can actually see them: they cover the whole cell like fish scales. So beautifully detailed, but that's not all; *Mallomonas* have silica bristles and spines that extend out from the cells, and they can control the way these bristles move. Like porcupines, they flare the spikes up or flatten them. I'm not sure why they have them, but it is most likely to protect themselves from predators.

Another genus of golden algae is *Dinobryon*. They are some of my favourite organisms. Countless times I have spoken out loud to myself when I have seen a *Dinobryon* colony and said, "Wow. This is beautiful!" The genus *Dinobryon* contains over 30 species. As you can see in the picture, *Dinobryon* species form tiny cellulose vase-like cases for themselves, and form colonies: every cell is inside a vase, with all the vases attached to each other, branching out like a tree.

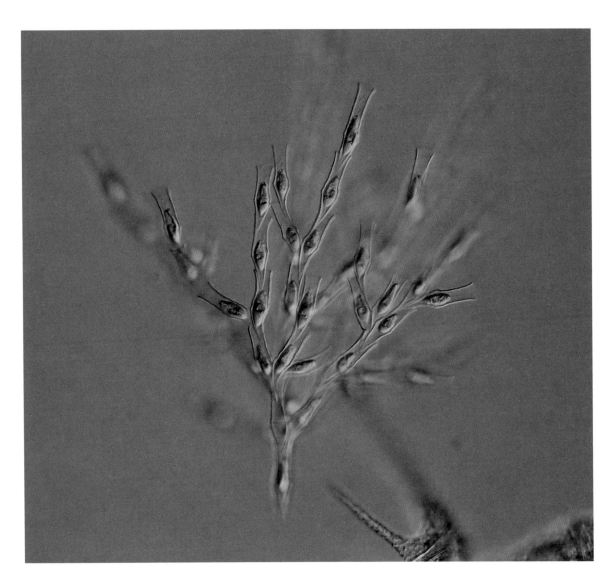

ABOVE: *Dinobryon* colony, 200 microns.

Spirogyra – **look a little closer**

I was lost in life until I found myself in pond scum.

This sentence is my motto, and do you know why? Even though it looks revolting to the naked eye, pond scum is so freaking beautiful under a microscope. You've probably seen green scum floating on ponds in a city park and thought it was pretty gross, or didn't think much about it at all. Yet that green scum is mostly a filamentous algae called Spirogyra, *also known as "water silk". Their name comes from the spiral shape of their green chloroplasts.* Spirogyra *filaments are around 50 microns in diameter, but they can be a couple of centimetres in length. The algae start growing at the bottom of shallow ponds. They produce oxygen gas through photosynthesis, and the bubbles get stuck between the growing tangled filaments of the algae, causing them to float to the surface of the water eventually. The floating algae mass doesn't look good at all until you put it under a microscope, but once you gaze into the algae with a microscope, your whole view about the pond scum changes. It makes you wonder where else you might find beauty if you change your perspective.*

ABOVE: *Spirogyra*, 50 microns in diameter.

Pediastrum – strength in numbers

In the microscopic world, the tiniest changes in your size might help you to survive all the predators around you. To increase their size, some algae such as *Pediastrum* can form quite weird colonies. They form flattened colonies that look like green ninja stars, consisting of 2, 4, 8, 16, 32, 64 and 128 cells. The number of the cells in the colonies is determined by the species, so while some species have 64-celled colonies, some others have 32. Nature loves maths!

The cells that are located at the outer part of the colony usually have a slightly different shape from the inner cells; they can have tiny spikes, or little hook-like parts to prevent algae-eaters from getting a good grip on them. All this collaboration is effective. *Pediastrum* are quite successful at surviving. In some of my sample jars, they are the most abundant organisms even after months of sitting on my windowsill.

OPPOSITE: *Pediastrum*, 100 microns.

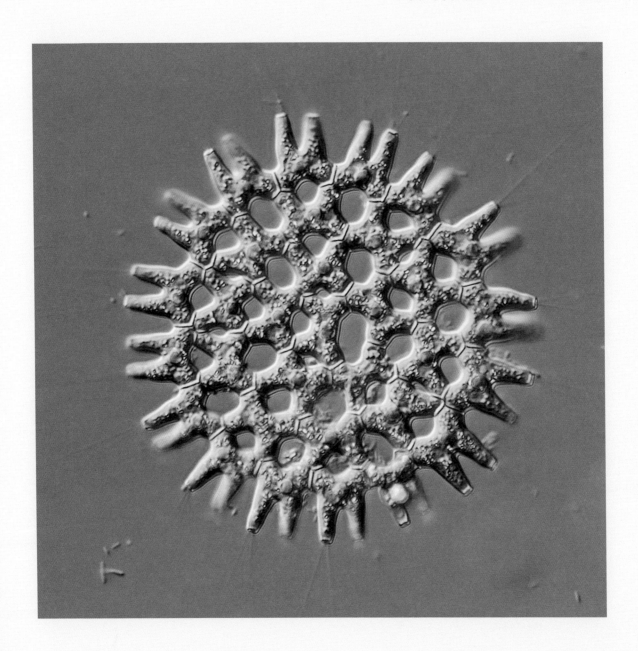

Ciliates – **hairy creatures**

One of my favourite groups of single-celled eukaryotes is the ciliates; they are surprising organisms because they are actually quite hairy! Their name comes from the thousands of tiny hair-like structures called the cilia on their cells. They form one of the most diverse groups of microorganisms, with around 10,000 species described so far, although the actual number that exists is way more than that. Ciliates are estimated to have originated over 2 billion years ago; that's a lot of time to evolve into different groups, and that's why there are ciliates more genetically different from each other than I am from a banana. They vary significantly in size too: one can be just a couple of microns long, (remember that 1mm is 1,000 microns), while another can be a couple of millimetres long. Once I even saw a worm-like ciliate, *Spirostomum,* that exceeded a centimetre in length!

Ciliates have two notable characteristics. The first one is that at some point of their life cycle they possess hair-like cilia on their cell surface. The number of cilia can change. Some species are extra hairy, while some only have cilia when they are juvenile and lose them altogether in their adulthood. Ciliates can use the cilia in locomotion by beating them to move, for food capture or for sensory purposes. The second characteristic is that ciliates have two types of nuclei in the same cell: a micronucleus and a macronucleus. The micronucleus is used in mating between two partners in the same species, and the macronucleus controls the cell metabolism.

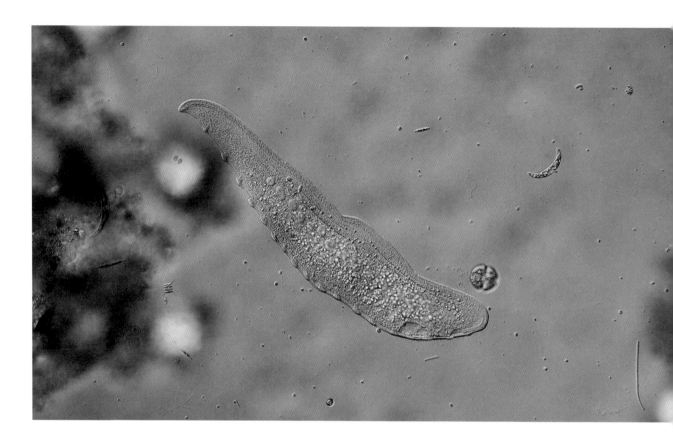

Ciliates reproduce by cell division: they create clones of themselves. But there is a way for ciliates to replenish their gene pool. It's called conjugation. This is where two individuals of the same species literally glue their mouths together and swap micronuclei to create gene variations. It's simply a kiss that makes you a whole new person!

ABOVE:
Ciliate
Loxophyllum,
700 microns.

A mysterious ciliate

After sampling a tiny pond in the middle of a forest, I found a strange-looking ciliate. Its cell was rather flat, with a tail-like extension coming out from the rear part of the cell. I had never seen anything like this before. It looked like a bumper car, with the rod-like tail that connects the car to the electricity mesh above. I tried to identify it but couldn't find anything helpful. The identification process gets easier in time, as you start to see details inside and on the cells that give away what kind of organism you are looking at. Eventually, I figured that it was most likely in the genus Bryophyllum, *but I couldn't find anything on the species of the organism despite its characteristic tail! I contacted a specialist, sending them a detailed video of the organisms I had found. Even though I emphasized that I had found around 30 cells, not just one cell, and that they all have the same tail, I was told that the cell in the video might be a damaged one, and not a proper representation of the species. I took this as a good sign: what I had found was clearly rare, perhaps even undescribed. I decided to seek an answer from a really old source: Alfred Kahl.*

Kahl was born in Germany in 1877 and died in 1946. He was a school teacher until he discovered his passion for microorganisms. He published 1,800 pages of studies, described 17 new ciliate families, 57 genera, and about 700 new species, in just nine years. Nine years! It's also fascinating that he got into ciliates when his daughter was studying them. As he described it: "The very interesting literature and preparations my daughter Lucia brought home fascinated me, as a dedicated biologist, and created the desire to study this field more deeply. . . Thus, I enthusiastically commenced literature reading and investigation of the small water bodies in my surroundings at the beginning of the year 1924. Within nine months, I got a rather solid knowledge in drawing and identifying many species."[1] When I read this while looking for more information about this scientist Kahl that I so often came across, it felt like I truly understood his fascination about the microscopic world. He published his first work in 1926, a 241-page book on a certain groups of ciliates. Over the next nine years, he kept publishing, including a four-volume study of free-living ciliates he finished in 1935. I own all four volumes of this study, and it's the most

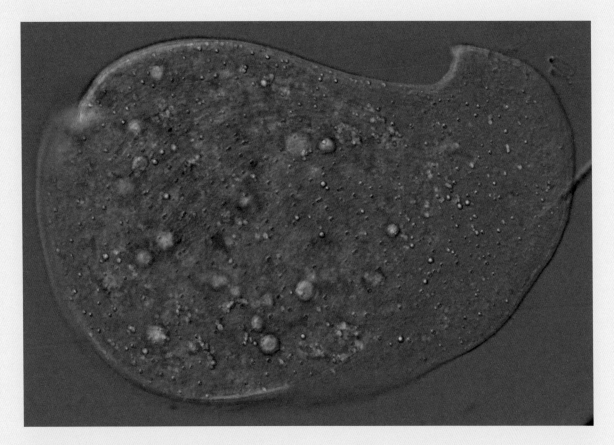

ABOVE: Mysterious *Bryophyllum*, 180 microns.

remarkable work I've seen on ciliates. Kahl combined his own studies and discoveries with previous studies and created this huge work; there are drawings of almost every single ciliate known during his time. Kahl stopped publishing after completing this work in 1935, and no one knows why. But it does not mean that he stopped using a microscope during that time; he most likely didn't. In the early 1940s Kahl produced the first part of his next four-volume study of microbes, which he never got to finish. During the wartime the

second volume was lost and the rest was never completed. He died in November 1946, cause of death unknown, and no one knows what happened.

Almost a century later, it felt poignant that I was seeking guidance from his four-volume study, and that in there was the ciliate I found in the pond, or at least something similar to it. Kahl shows two similar ciliates in his book, Bryophyllum armatum and Bryophyllum lieberkuhni. These two species show the tail, similar to the one I found on mine, but the shape of their macronucleus is different, as well as the location of the contractile vacuoles. These are the keys for morphologically identifying species. It supported my initial thought that I was looking at something that wasn't described before, and I decided to investigate this further, but the first thing I needed to do was get more of these ciliates. They were in each of the samples from that pond, but keeping them at home was a bit tricky. They were disappearing from my sample jars and bottles in less than a week after the collection. It's common for some "picky" organisms to vanish from a sample after some time, as their native habitat provides more stable conditions for them. The

pond I collected the water from is a rather small pond, but still it contains tens of thousands of litres of water, and when I take a litre of it in a bottle, the temperature, dissolved oxygen, the pH and every other parameter changes so much faster than they would in the pond. So the bigger the sample, the better the chances of survival for everything.

It was a bit of a conundrum. I wished there was a way of bringing more pond water into my flat. Then I thought maybe I could create a fish tank, which would have no fish but quite a bit of pond water and sediment in it. I decided to fill a 60-litre tank with pond water, and it worked quite well! My friend Luke and I went to the pond, collected sediment and water in big plastic containers, and carried it all the way from the forest to a place where we could call a taxi. The taxi driver thought we were carrying gasoline; he never would have guessed that we were actually carrying pond water back home! My arms were sore for a week after carrying all that water through the forest, but it was worth it! Now things were surviving for so long in the tank that I had an almost unlimited opportunity to find my mysterious organisms whenever I wanted. And later I invented something that

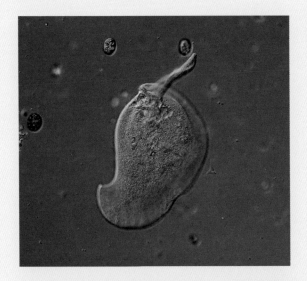

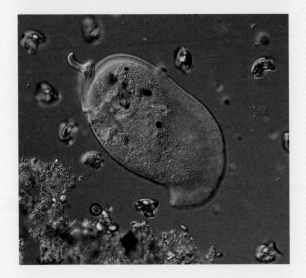

ABOVE: Mysterious *Bryophyllum*, 200 microns.

I can use to observe the tank without disturbing the microbes and I was able to record a couple of my new tailed ciliates in their natural state.

I also wanted to do some molecular work on them so I could compare it with the database of genes from that group of ciliates. I talked to Professor Bozena about the molecular work I wanted to do on this ciliate, and she gave me the green light. So now I am preparing to find out more about this mysterious ciliate. While I still have the population of them in my tank, I have collected some cells and washed them in clean water drops on the slide by pipetting them in and out, again and again, with new, clean drops. This helped me get rid of any other organisms that were accidentally in the drop. Once I thought they were clean enough, I put them in tiny Eppendorf tubes and stored them in a freezer in the lab at –82°C, so they don't denature. When I am ready to do the genomic work, I can use these prepared cells!

I need to learn a lot more before finishing this project, but I think I have enough enthusiasm to fuel me. It's been just three years since I identified my first microorganism, and my enthusiasm is shining brighter than ever today.

Stentors – **blue whales of the microcosmos**

When Warsaw froze over during winter, I was worried how the cold would affect my sampling, but I went to the pond in the park with a screwdriver in my backpack. Barely managing to break the ice with it, I collected a tube of something resembling a horrific mud soup, but after two days on my windowsill, the tube turned bluish. I couldn't believe my eyes; my sample was full of *Stentor coeruleus*, a member of my favourite single-celled genus, the *Stentors*. They are one of the biggest organisms I find in freshwater habitats. When I spotted the *Stentor coeruleus* for the first time, it occurred to me that I was looking at a tiny version of a blue whale.

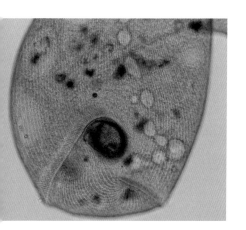

ABOVE, OPPOSITE AND OVERLEAF: *Stentor coeruleus.*

Why a blue whale? As well as being very big compared to the other organisms around it, *Stentor coeruleus* are a vivid bluish-green colour. This colour comes from a unique pigment called stentorin. Although it is unclear why *Stentor coeruleus* have these pigments, the stentorin is believed to be used for light-sensing and protection from predators. It has also been said a couple of times in literature that *Stentor coeruleus* ejects all of its stentorin like a squid to deter predators; the blue cloud of the ejected stentorin causes predatory single-celled organisms to pull back.

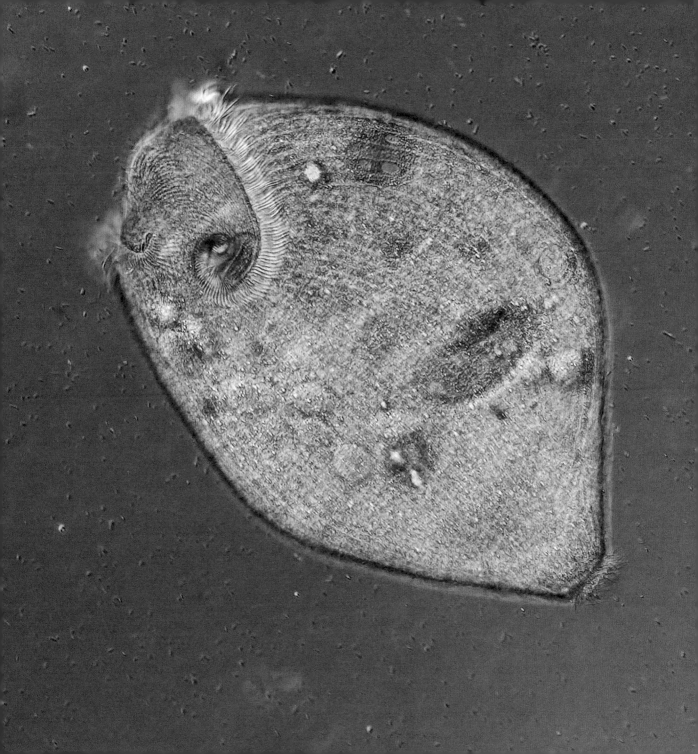

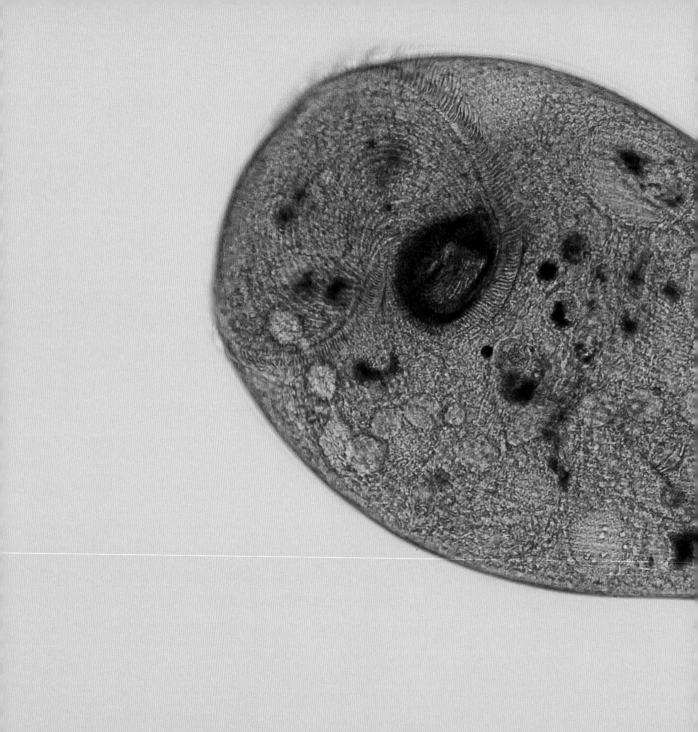

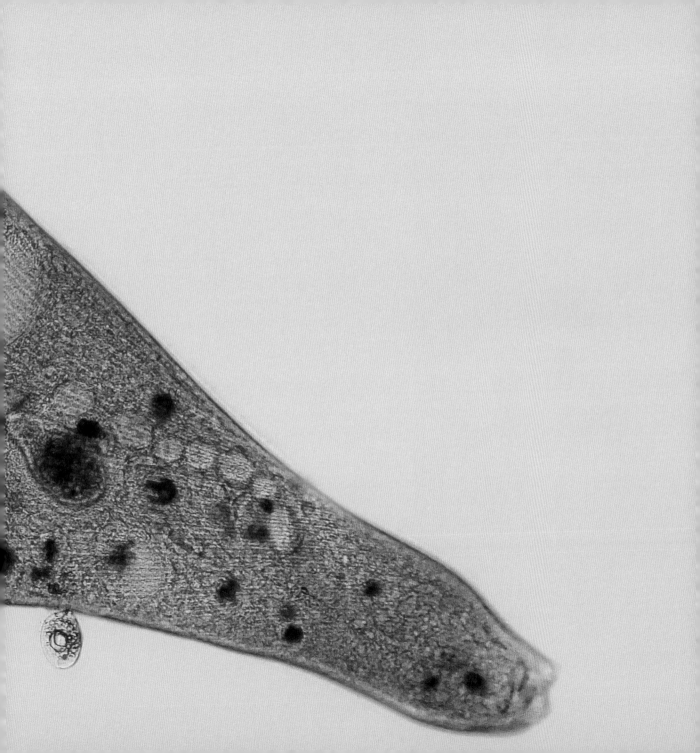

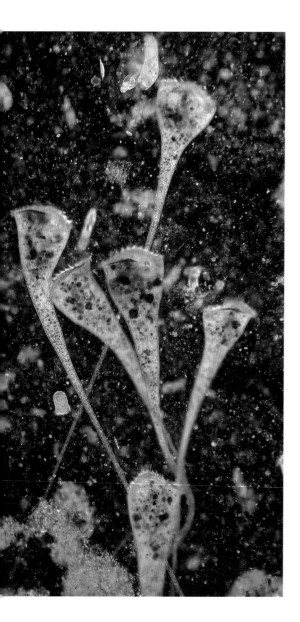

The author of one of the papers says that this indicates that the cloud contains a factor that induces backward swimming in the predator. I have tried to record this for so many hours, but so far I haven't managed to capture it. However, I have seen a *Stentor coeruleus* right after it ejected its pigments, swimming like a transparent ghost.

Stentor coeruleus are really the gentle giants of the ponds. I found some individuals as large as rice grains; I could easily see them without a microscope or a magnifying glass! There are 19 species of *Stentors* described so far, and all the species can attach themselves to submerged leaves, aquatic plants or even to some aquatic animals! In one case, I found a snail with a green shell when I was sampling and thought it was interesting enough to check under the microscope, so I brought the snail back to my place. Looking at the green scum on it under the microscope, I was amazed to find *Stentor polymorphus* – hundreds of them were hitchhiking on the snail's shell. When *Stentors* attach themselves, they take the shape of a trumpet, from which their name was derived. In this form, they beat the hair-like cilia around their mouth to create a water

LEFT: *Stentor coeruleus.*

current that brings bacteria, algae or anything else in the water into their mouth. Again, just like the blue whales of the macrocosmos, these microscopic giants feed on much smaller organisms. Yet they occasionally ingest big organisms too, and sometimes even each other!

I managed to set a *Stentor coeruleus* culture from the cells I collected under the ice. It was all wonderful. At one point I had so many cells they were covering everything in and on the jar. Then after a couple of months, things got a bit complicated. My *Stentors* started to eat each other. I recorded them partially eating what were most likely their clones, but I was never able to record a whole cell getting swallowed by a bigger cell. What I was able to see was many cells swimming around with other *Stentors* being digested inside them. A scientist named Vance Tartar researched *Stentors* in the 1950s, and he explains in his book *The Biology of Stentor* that cannibalism is most likely disturbed by the light of the microscope and that's why no one has ever recorded it, including himself.

Stentors are picky eaters, even though some have a taste for their relatives. Scientists feed them

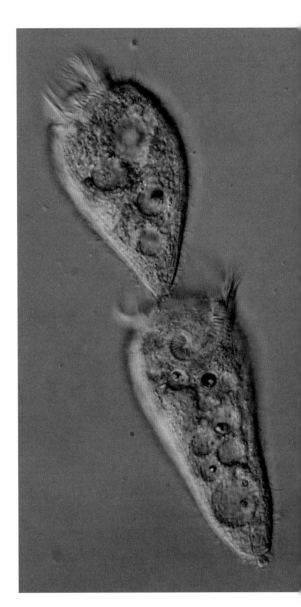

RIGHT: *Stentor igneus* during cell division, 140 microns.

with tiny pipettes. They love eating certain species of algae but reject others. And they almost always turned away tiny glass pieces scientists tried to trick them into eating. When they don't want to eat something, they simply reverse the beating of the cilia and push the unwanted food away.

Stentor coeruleus was well studied at the beginning of the 20th century, but later the interest in them subsided. Scientists did all sorts of weird experiments on them. They discovered that if two *Stentor* cells are cut through and quickly pressed together, the cells can be fused and will remain joined, regardless of the species of *Stentor*. For instance, you can create a cell that is half *Stentor coeruleus* and half *Stentor polymorphus*! Scientists removed cell nuclei, minced cells together, exposed them to chemicals, did micro-surgery on them to cut certain parts of the cells. . . These studies sound like horror movies but in most of the cases the organisms were able to survive the torture.

Stentor coeruleus is most famous for its regenerative abilities. If a *Stentor coeruleus* cell is cut in half, each half will regenerate into a normal-looking cell at half the size of the uncut cell. After healing and reconstructing its missing parts, these half-sized cells will grow to the normal cell size over time. Even if the cell is cut into a hundred pieces, each fragment will generate into a normal-looking cell eventually. For regeneration to happen, the cut piece must contain at least a part of the macronucleus and a piece of the cell membrane. The macronucleus of *Stentor coeruleus* is visible even under low magnification. It has a specific bead-like look and extends along the whole cell. It is highly polyploid, meaning that even a fraction of the macronucleus will contain thousands of copies of the entire genome of *Stentor coeruleus*

for regeneration. Even a tiny fragment less than 1/100 of *Stentor coeruleus* can build itself back. I have never cut a *Stentor coeruleus* cell on purpose, but accidents often happen when I put a coverslip on a drop of water. *Stentor coeruleus* cells can get stuck between some pieces of dirt and tear apart. I see the pieces regenerate back to a healthy individual in just two days! Fascinating, isn't it?

BELOW:
Stentor polymorphus, 1,300 microns.

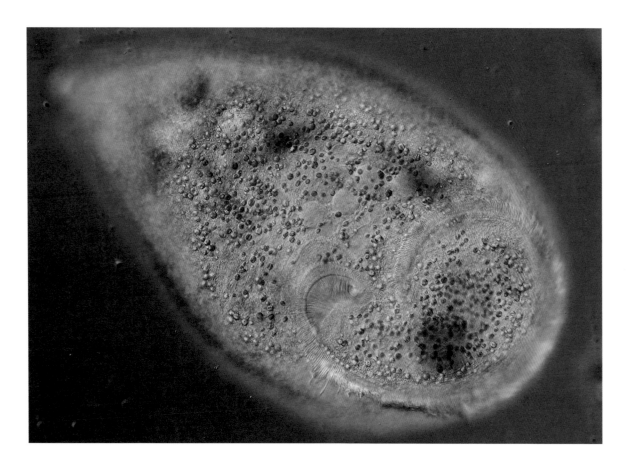

Stentor roeselii – decision-makers

I have also found a smaller species called *Stentor roeselii*. It's a colourless species with an uncommon trait for a single-celled organism: it shows simple decision-making behaviour! There is a century-old paper about *Stentor roeselii* by the famous American zoologist Herbert Spencer Jennings. Jennings injected carmine particles with a micropipette into the surroundings of the *Stentor roeselii* and observed its reaction to this unexpected cloud of red irritant. Jennings reported that the *Stentor* bends repeatedly in the opposite direction to avoid the irritant, but when Jennings continued to eject some more carmine particles into the water, the *Stentor* would reverse the beating pattern of its hair-like cilia to push the particles away from itself, just like when *Stentors* don't want to eat. If this action failed to disperse the carmine, the *Stentor* would contract fully to avoid the substance, and finally it would detach itself from the place it was attached to and swim away to find a nice, calm place somewhere else. It is quite remarkable that a single-celled organism is capable of this behaviour.

Scientists in the 1960s tried to conduct Jennings' experiment, but funnily enough they weren't able to find a *Stentor roeselii* and instead tried to repeat the experiment with a *Stentor coeruleus*. The results were neither satisfying nor conclusive, and the study was forgotten until Jeremy Gunawardena, Associate Professor of Systems Biology at Harvard Medical School, repeated the experiment and confirmed Jennings' century-old study! I was really proud that my own *Stentor* clips were used to visualize the study for the general audience!

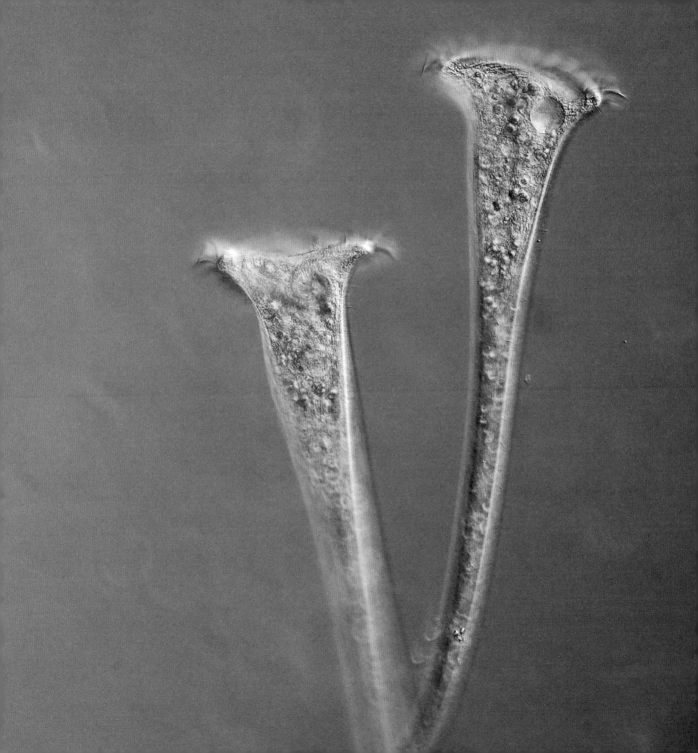

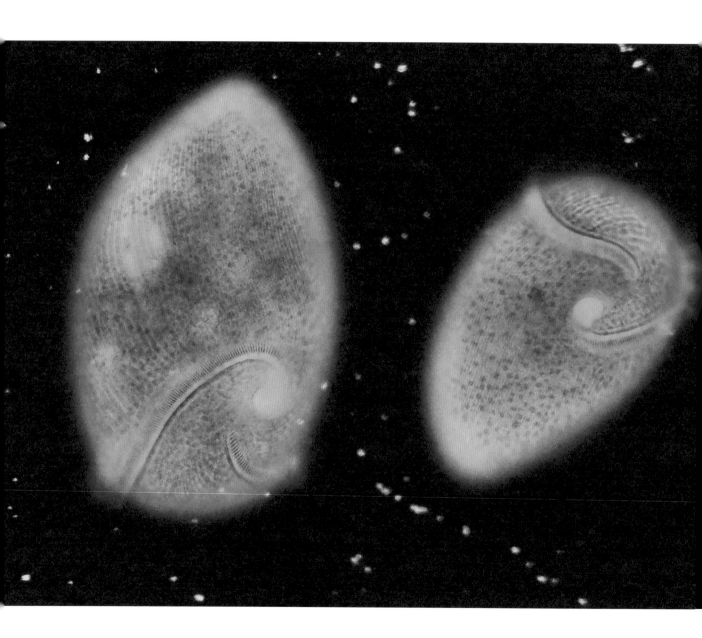

Stentor amethystinus – precious gems

Another species I spent two years looking for was *Stentor amethystinus*. This is a gorgeous pigmented *Stentor*, like *Stentor coeruleus,* but instead of the bluish-green pigments, *Stentor amethystinus* have purplish pigment granules. They are so beautiful, and they have green algae living and breathing out oxygen inside them while producing sugar through photosynthesis. Algae are tiny and often grazed on by many other microorganisms, but if you hide inside the biggest cell around you, your chances of getting eaten are lowered quite drastically! (The snail-hitchhiking *Stentor polymorphus* I mentioned earlier actually have the same algal endosymbionts but because the *S. polymorphus* have no pigments they just look green to the naked eye.) The algae use sunlight and produce sugar for themselves but also share some of the sugar with the *Stentor amethystinus*. I found these beauties only from one location, and I tried to set a culture but failed. However, I recorded them for hours and hours!

There are other gloriously coloured *Stentor* around the world. *Stentor loricatus* have only been reported attached to leaves in a small stream in New Zealand, and have never been found anywhere else on Earth. And another species was found only once in South America in a place that was later destroyed by human activity. *Stentor baicalius* have sea-green pigmentation and are most likely an endemic species to Lake Baikal in Russia. No wonder I am so impressed by microscopic life: even one genus of microbe was enough to blow my mind, and there are millions of others. It's not like watching a documentary on TV. It is like being Indiana Jones and exploring and discovering the secrets of life.

ABOVE AND OPPOSITE: *Stentor amethystinus*, 1,000 microns.

Paramecium – **friends with benefits**

One of the most popular microorganisms, if not the most popular one, is the slipper-like *Paramecium*. Over the last couple of centuries, scientists and enthusiasts have studied *Paramecium* extensively. It is one of the first two ciliates, alongside *Tetrahymena*, to have its whole genome completely mapped. *Paramecium* mainly feeds on bacteria, so it's quite easy to culture at home. It quickly reproduces through cell division, and it tends to gather in my jars right under the water surface like a white cloud.

Paramecium can have parasites as described at the beginning of the book, but it can also have some harmless organisms inside its cell, like the alga *Chlorella*. Some other pond residents benefit from this collaboration temporarily by engulfing algae cells and letting them live and photosynthesize inside their body, but there is one species of *Paramecium* that has a special bond with these algae. *Paramecium bursaria* almost always carries hundreds of algal cells from genus *Chlorella* in its cytoplasm, and these algal symbionts are continuously inherited from generation to generation. This means that during cell division *Paramecium bursaria* splits into two and creates two "daughter cells". Each of the daughter cells carry half of the algae that were inside the "mother cell". The algae later go through cell division too, and they pack up the daughter cells until they are full of round green algae.

Scientists managed to create algae-free *Paramecium bursaria* in laboratory conditions by culturing the organisms in total darkness or by exposing the organisms to certain herbicides that kill the algae but don't harm *Paramecium*. These algae-free *Paramecium bursaria* can

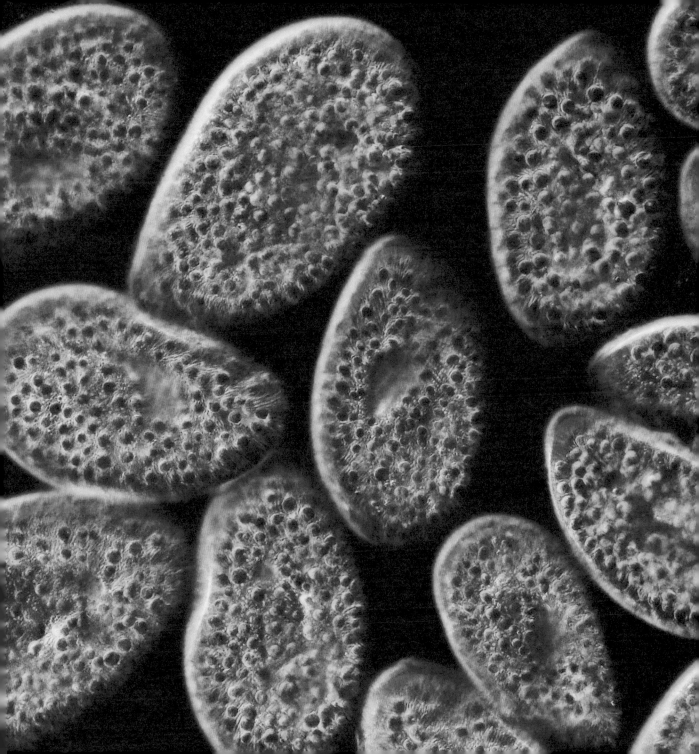

later reabsorb the algae if the algae are added into the *Paramecium* culture. In one of the experiments, algae-free *Paramecium bursaria* were starved, and they were only able to live for a couple of weeks, while *Paramecium bursaria* with algae survived for three months in lit conditions without any additional food source provided to them. This clearly demonstrates the benefits of having these algal endosymbionts. Algae photosynthesize inside the *Paramecium bursaria*'s transparent "belly", sharing some of the products of photosynthesis with their host. In exchange, *Paramecium bursaria* provides protection from microscopic grazers who love eating some juicy algae. But *Paramecium bursaria* does not only protect algae from algae-eaters but also protects them from viral infections. When they are inside the host *Paramecium*, algae don't get infected by chloroviruses that target them. These viruses can be devastating to *Chlorella* populations in water bodies. When algae are inside the *Paramecium*, chloroviruses cannot pass through the *Paramecium*'s defence and cannot infect the algae. However, when the algae are released from *Paramecium*, or the *Paramecium bursaria* gets damaged by a predator, algae are readily infected and show symptoms. Scientists are not sure how this happens, but it's believed that the viruses attach themselves to the surface of *Paramecium bursaria* and wait for algae to leave the host somehow. Quite sneaky!

RIGHT: *Paramecium bursaria*, 140 microns.

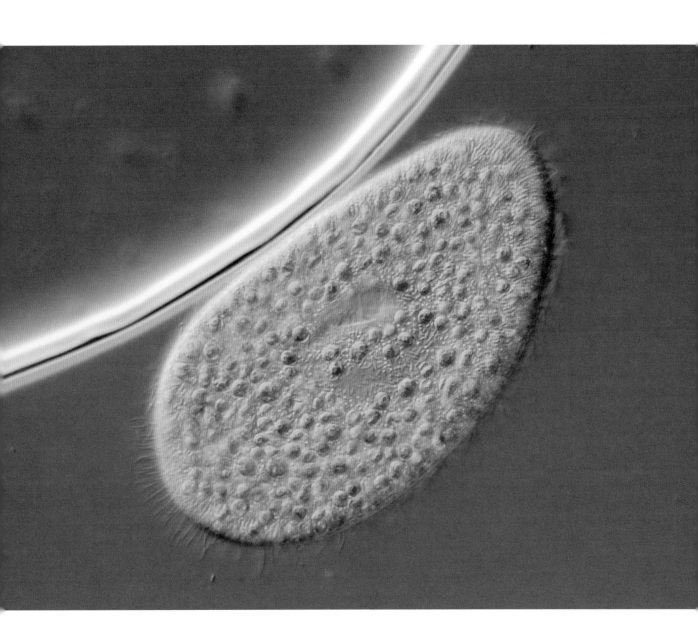

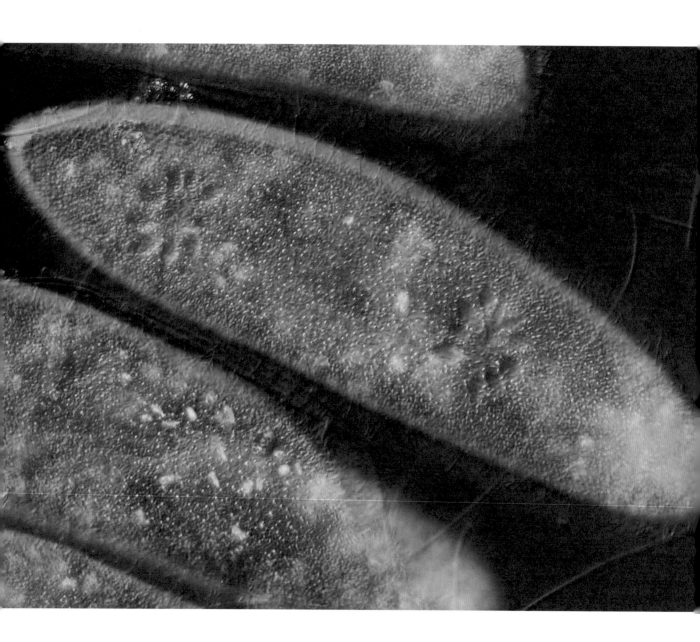

Contractile vacuoles of *Paramecium* – lifesaving pumps

Freshwater single-celled organisms constantly have to contend with something called osmotic pressure. Single-celled organisms are covered with a membrane, and inside this membrane there is a gel-like fluid called the cytoplasm which contains a lot of dissolved substances, more than the surrounding water contains. Concentration of these dissolved substances inside the cell is different from the surrounding water and they are separated by the cell membrane, which only allows certain things to pass through it passively, and water is one of these things that can pass through the cell membrane effortlessly. This imbalance between the concentrations causes water to fill the cell to attain equilibrium, which means that water constantly flows from the environment into the single-celled organisms.

The organisms have adapted to this problem by evolving microscopic pumps, called contractile vacuoles, in their cells. These handy little pumps accumulate the water, the contractile vacuole swells, and later on it discharges the water out of the cell through a pore and then the pore closes when the water has been discharged. This process happens again and again, all the time. The pumps have to work non-stop or the cells will swell until they explode and die.

OPPOSITE:
Paramecium,
180 microns.

Nassula – **colour-changing polka dots**

Nassula are such beautiful ciliates. Some species can have gorgeous, colourful polka-dotted bubbles in them, and the way these bubbles are formed is truly remarkable.

In order to explain the formation of these colourful bubbles, I should talk about something quite fundamental in eukaryotic cells: microtubules. Microtubules are hollow cylinders that are major components of each and every eukaryotic cell, including those that make up us. They have many functions in cells, from giving shape to the cell to playing a part in mitosis, intracellular transport and cell motility. In *Nassula*'s case, microtubules form its complex feeding apparatus, called the nasse or cyrtos. The nasse is made up of a bunch of rods, and these rods are composed of closely packed microtubules.

Nassula use the nasse to slurp up filamentous cyanobacteria, like *Oscillatoria* filaments. First they need to locate *Oscillatoria*. From my observations I believe that *Nassula* find them simply by following the chemical cues of the mucilage excreted by *Oscillatoria*. *Oscillatoria* secrete this substance from some tiny pores on the cells to glide in the water, and the substance leaves some trails on the microscope slide. Many times I have watched *Nassula* act like there is an *Oscillatoria* filament at a precise location, trying to find something that is not there any more. This made me believe that they are actually able to sense that there is mucilage on that location, and because the mucilage directly originated from the filament, locating the mucilage often means dinner time for *Nassula*.

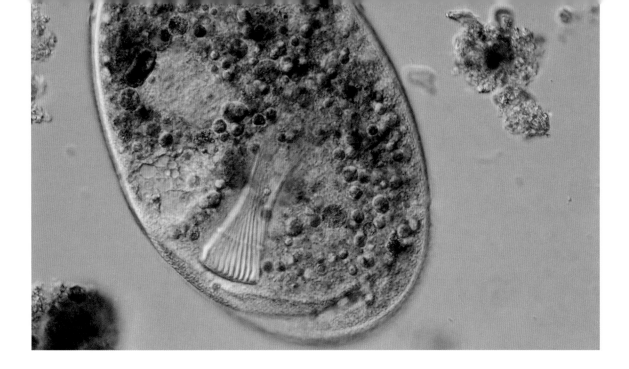

Once a *Nassula* locates a filament, which can be a couple of centimetres long, the *Nassula* swims back and forth along the filament and finds one of the tips. And then the slurping starts. *Nassula* takes the filament into its cell through the complex feeding apparatus, breaking it into pieces if it's too long. During this process, *Nassula* wraps the food into a membrane and forms a bubble-like food vacuole. It forms food vacuoles again and again while eating, and its cell quickly fills up with them. The *Oscillatoria* are a blue-greenish colour, but when *Nassula* flushes the food vacuoles with digestive enzymes, the green turns into many other colours during the digestion process. The newly created food vacuoles are still green, but the older ones can be pink, purple, blue, yellow, and all these colours fill up the *Nassula* and make it look polka-dotted. *Nassula* digests the content of the food vacuoles in under 30 minutes, acquiring all the nutrients it can, then excretes the remains.

ABOVE:
Nassula,
400 microns.

Lacrymaria olor – **a tiny killer swan**

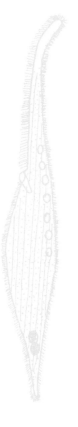

Lacrymaria olor is a delicate-looking single-celled organism with a unique hunting skill: it can extend its "neck" up to eight times longer than its body length. The name *Lacrymaria olor* is quite poetic; it means "tears of a swan" in Latin, perfectly describing both the tear-shaped body and long, swan-like neck. *Lacrymaria olor* is hard to find. I rarely see them in my samples when I collect the floating algae on the surface of ponds and never find more than just a couple of cells at a time. And because they're so fascinating to watch and quite rare to catch, I always enjoy seeing them! *Lacrymaria olor* hides in debris and dirt on the slide and extends its neck in and out to get the tip of its neck, the head, in touch with prey. The neck is extremely flexible. It pokes up and down, goes left and right. It bends around the substrate, rapidly darting forward to stretch out and pull back in a second. It is simply astonishing.

The head of the *Lacrymaria olor* is armed with many harpoon-like toxin-ejecting organelles known as "extrusomes", and when they touch their prey, the extrusomes are fired. If the prey is small, it is paralysed or dies instantly, but if it's a much larger organism than *Lacrymaria olor*, it loses a chunk of its body to this vicious hunter. Many times I have watched a big fella losing half of its cell to this seemingly fragile, much smaller organism. That is actually how I know *Lacrymaria olor* is living on my prepared slides before even seeing them, because I spot the damaged and regenerated single-celled organisms swimming around after battle.

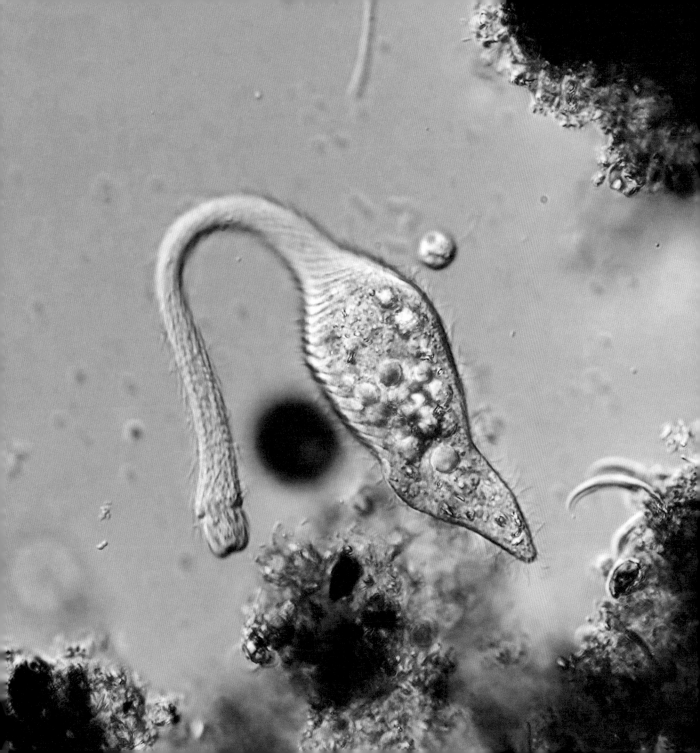

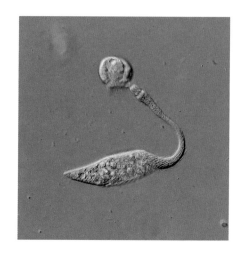

Lacrymaria olor's cell mouth is at the tip of the neck and it can stretch wide to swallow large pieces. Whatever is swallowed slowly slides inside the thin neck to the body and gets digested there. When I first found a couple of them on a slide, I was very eager to observe them extending their necks, but after just a couple of minutes of observation they started to become less active. Their necks started to dart across shorter distances and eventually retracted into the body and stayed like that. I thought I was harming them. Months later, when I started to put my slides in my humidity chamber rather than discarding them, I found some more *Lacrymaria olor*.

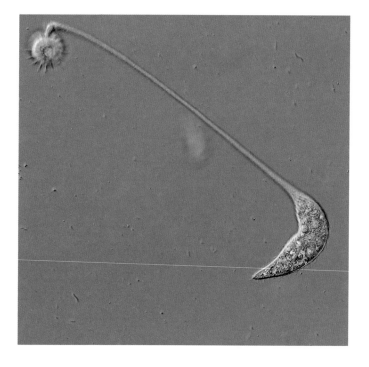

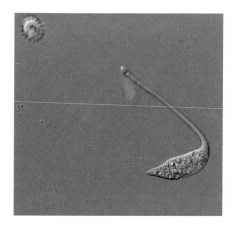

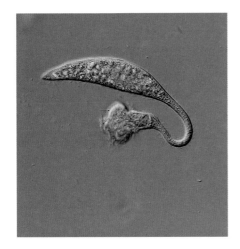

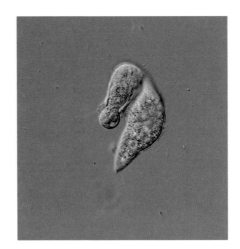

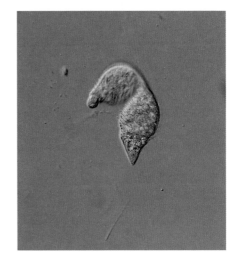

Again they took this weird form, retracting their necks and staying still, after about ten minutes, I couldn't make sense of it. I worried I was killing them by accident, and so I returned the slide to the humidity chamber and checked it the next day, hoping to see some other organisms, but it was full of *Lacrymaria olor*! They had not just come back to life but also appeared to be reproducing! As I observed them for a longer period of time, I noticed that they stayed active for about ten minutes, poking around with their necks, then they retracted their necks and stayed inactive for another ten minutes, as I'd seen them do before, and then they become active again! I realized they are much more resilient than I had given them credit for.

OPPOSITE AND ABOVE:
Lacrymaria hunting.

Actinobolina – **picky eaters**

Actinobolina is a ciliate I've found only three times over the last three years. It's quite a rare microorganism. When I found it for the first time, I didn't know what it was, so I missed the opportunity to observe it in detail. A year later I found another, but before I could get excited about my finding, the cell burst open and died. When I found it for the third time, I was prepared to keep it alive, which I managed to do for almost a week on a prepared slide in the humidity chamber.

What makes *Actinobolina* interesting is not the scarcity of it among microorganisms but the way it hunts. When it's swimming, *Actinobolina* looks like a regular ciliate: a roundish body with a bunch of hair-like cilia surrounding it. Things get a bit weird when *Actinobolina* stops: many long tentacle-like structures come out of its body, and it turns into a single-celled sea urchin. Each tentacle is armed with toxin-ejecting structures. When it extends its tentacles, *Actinobolina* stays still and waits until the prey touches the tentacles. When that happens, *Actinobolina* kills the prey, then positions the unlucky victim in front of its cell mouth by moving the tentacles, and swallows it. It can retract the tentacles in seconds and swim away to find a cosier place to set another trap.

OPPOSITE: *Actinobolina* tentacles, 120 microns.

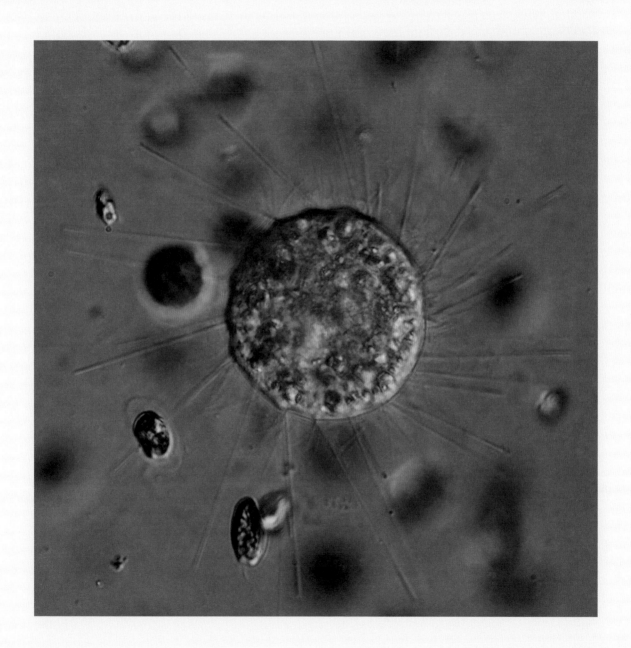

Actinobolina is fascinating to me because it seems to like choosing what to kill. I watched it for hours and hours over the week that I managed to keep it alive. My slide was overcrowded with many other organisms, but *Actinobolina* only fed on another single-celled organism called *Halteria*. When anything else touched the tentacles, they escaped unharmed. But whenever a *Halteria* came into contact with the tentacles, it quickly got killed and ingested. No one knows how *Actinobolina* can choose its prey, but there are many things about this rare ciliate that are mysterious, like the way it forms tentacles. *Actinobolina* extends its tentacles with some complex cell structures

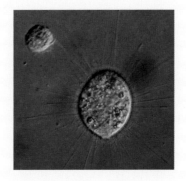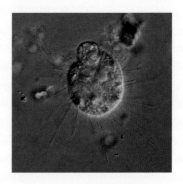

called microtubules. Each and every eukaryotic cell has microtubules – they support the cell structure and distribute matter in the cell – but in *Actinobolina*'s case, they also help to create extensions that push the tentacles out of the cell in mere seconds. As is often the case in the microscopic world, we still don't know how that happens.

ABOVE AND OPPOSITE: *Actinobolina* hunting.

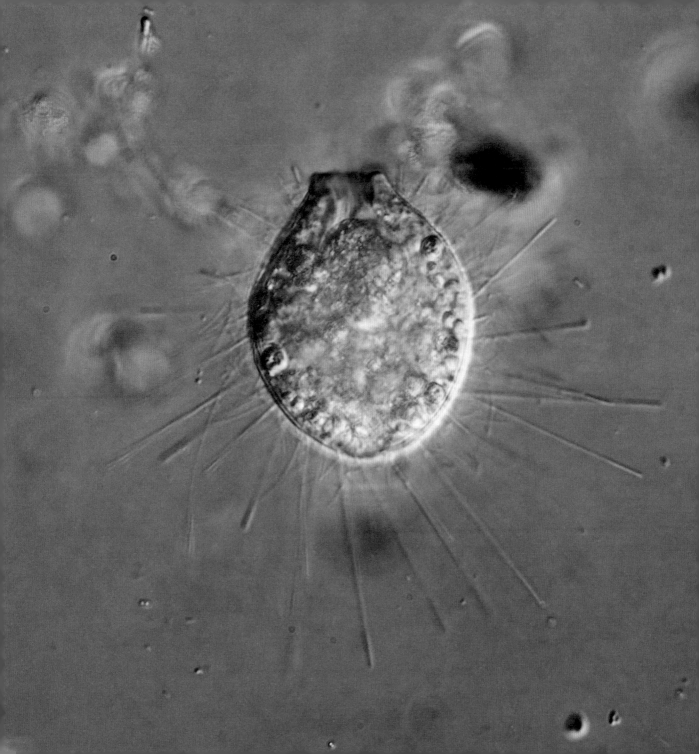

Loxodes – **navigating by crystals**

Loxodes is the only freshwater genus of a class of ciliates called Karyorelictea. *Loxodes* prefer to live in sand and sediment. They are quite picky when it comes to the dissolved oxygen in the water, seeking an environment with reduced oxygen-level conditions, just a couple of centimetres above the anoxic layer where there is no oxygen. The amount of oxygen gets lower and lower with increased depth because the water at the bottom of water bodies has no direct contact with the surface, where the oxygen gas dissolves into the water to saturate it. In addition, decomposing plant matter or any other kind of organic matter in the water will have sunk to the bottom, using up any available oxygen quite quickly. So, if you were a microorganism who wants to live right above the sediment layer, you would need to know which way is up and which way is down.

BELOW AND OPPOSITE: *Loxodes*, 140 microns.

 Loxodes can detect the Earth's gravity for this purpose in the most elegant way, with the help of a special organelle called the Müller's vesicle. It looks like a tiny sphere with a single dot in it (see picture, right,

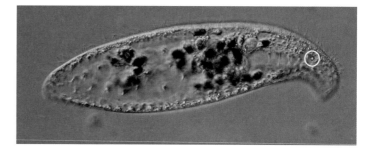

with the Müller's vesicle circled). The vesicle is a barium salt crystal wrapped in a membrane in *Loxodes*' cytoplasm. The number of the vesicles varies from species to species, and can even differ among the individuals in the same species, but all the Müller's vesicles work in the same way. Gravity continuously pulls the barium crystal toward the centre of Earth, and the pull lets the ciliate know where the bottom of the water is, so it can swim to find its preferred habitat.

I wanted to discover more about Karyorelictea. Even though there are over 130 species in this class, most inhabit marine habitats. I was stuck in a city far away from the nearest sea, so I wasn't able to find anything but the *Loxodes* species. I visited the Baltic Sea a couple of times in search of interesting microbes, but I found nothing from the class Karyorelictea. Then I came up with an idea.

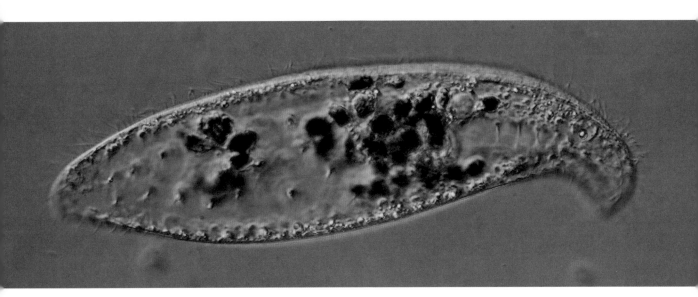

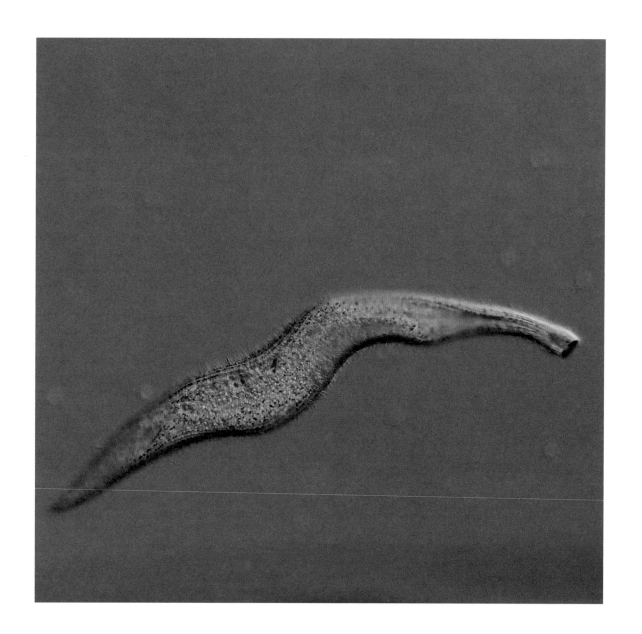

Whenever I went to the mall in the city centre, I always noticed a fish tank that looked perfect. One time I realized there was actually a biofilm growing on the glass of the fish tank. The presence of the biofilm meant that the aquarium was in bad shape if you consider the health of the coral and the fish that lived there, but biofilms are great places to look for some interesting microorganisms! So, one day I went to the mall, talked to a couple of workers there and managed to get myself some biofilm, sand and water from the fish tank, plus a pretty little starfish! I came back home, prepared a slide right away and put it under the microscope.

It was a sample full of many interesting things, but I was awestruck when I spotted something thin and slender swimming between the sand grains, over a millimetre in length. My first thought was that I was looking at a member of Karyorelictea, as they often have elongated worm-like bodies and live between sand grains. After a bit of research, I discovered that it was a species of *Tracheloraphis*, who also have similarly long bodies. Although I didn't find what I was looking for, this encounter ended up being equally fascinating. It isn't clear how *Tracheloraphis* originating from a marine habitat ended up in the tank. Some ciliates can form protective cysts that can survive drying up. However, the protective cysts in this class are unknown, which means that the first *Tracheloraphis* that came to the tank was alive and active, so it must have been collected from a marine habitat by someone. Maybe it had been in sand from a beach sold as "live sand" for fish tank enthusiasts, and it had travelled all the way to the supplier and then ended up in a fish tank in a mall, where it reproduced and created a population of *Tracheloraphis*. Well, life finds a way.

OPPOSITE:
Tracheloraphis,
1,500 microns.

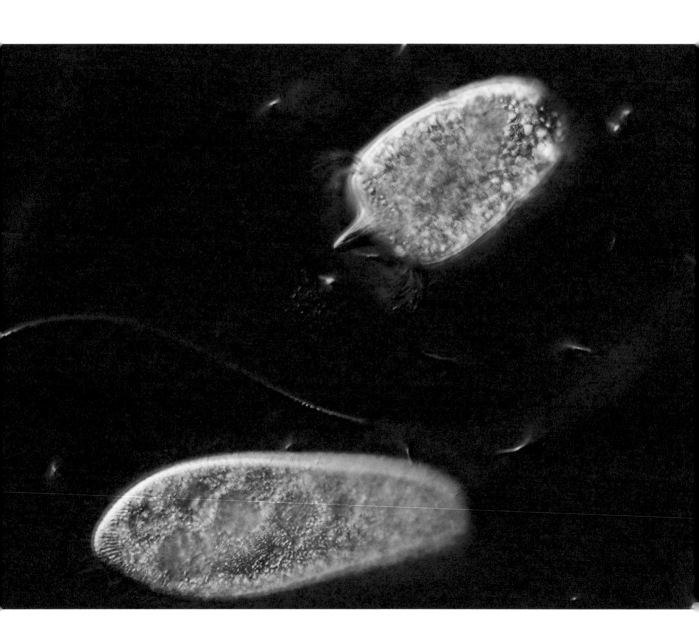

Didinium – **strategic hunter**

Didinium is a vicious hunter, but it looks more like okra than a predator! It has a chubby cell body with two rows of hair-like cilia encircling it, and there is a tiny cell extension called the proboscis. The proboscis is armed with toxin-ejecting toxicysts; these are tiny hypodermic needles that are fired upon contact, and *Didinium* doesn't hesitate to use them on its favourite prey: *Paramecia*.

When I found a *Didinium* for the first time, it was from a pond I had been sampling regularly for over two years, and I didn't expect to find the organism there. I was recording a tiny alga on the microscope slide with a high magnification objective, when a super agile organism entered my field of view and then left it almost immediately. I changed the magnification to a lower one and found the organism again. It was so fast, but I recognized the shape and the two encircling rows of cilia on it, and I understood that I had found my first *Didinium*.

BELOW AND OPPOSITE: *Didinium*, 140 microns.

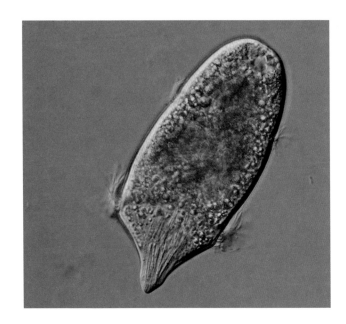

Next I saw that a *Paramecium* was in the vicinity of the *Didinium*, and I quickly hit the record button on my camera. Five seconds later *Didinium* killed the *Paramecium* viciously. Even though I had read about the way *Didinium* hunts, I couldn't believe my eyes!

Didinium hunts with a specific strategy. When there is enough water between the microscope slide and the coverslip, you can be lucky enough to observe it. *Didinium* moves in the water in spirals. If it hits something blocking its way, it backs up quickly and changes its swimming direction. Its deadly proboscis leads the way during swimming, and if the proboscis touches a *Paramecium*, it instantly

 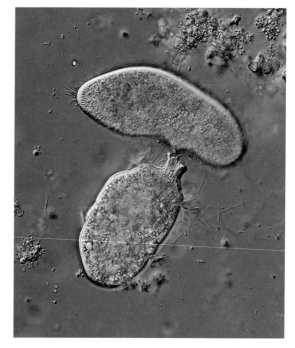

ejects its toxin, immobilizing the prey. The deadly event ends as *Didinium* stretches itself wide and swallows the prey whole.

That's quite a scene. *Didinium* can capture and engulf a *Paramecium* six times its size. It can even capture and ingest two conjugating Paramecia, or one during cell division.

Right after ingesting a large *Paramecium*, *Didinium* loses its agility and stays rather stationary. The digestion process is quite fast. After just 30 minutes there is not much left inside *Didinium*, and it gets back to hunting down more *Paramecium*. There are reports that *Didinia* have even died after eating a huge meal. A victim of gluttony.

OPPOSITE AND BELOW: *Didinium* hunting.

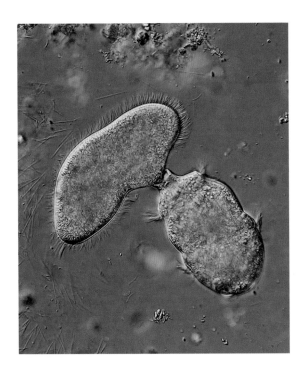
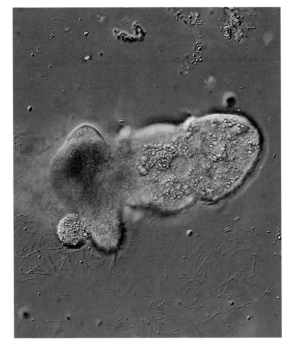

Dileptus – **mutant creations**

Dileptus is another vicious single-celled hunter from the microworld. It has an elephant trunk-like structure, called the proboscis, which it swipes in the water from one side to the other, hoping to touch a prey organism. *Dileptus* rotates the proboscis before each swipe so the inner part of the proboscis faces the swiping direction. The reason for this peculiar behaviour is that the inner side of the proboscis is armed with many tiny harpoon-like structures called toxicysts, so *Dileptus* wants these harpoons to come into contact with something delicious. When they finally touch the prey, the harpoons are fired, penetrating the prey and releasing toxins into the prey's body, killing or paralysing it, so the *Dileptus* can open its cell mouth, which is located where the proboscis connects to the rest of the body, and swallow its victim. You can see the ready-to-fire harpoons on the proboscis; they look like tiny lines. Maybe you can spot them better if you imagine the proboscis like a ruler, so the harpoons are like the little lines on a ruler that mark every millimetre.

The *Dileptus* species has caused some taxonomical problems for scientists, and after some detailed research some of the species moved into another genera called Pseudomonalicaryon, but they are all referred to under the umbrella term dileptids. I am not sure about the

species of the dileptids I find, because a proper identification requires the location and counting of macronucleus nodes; these hunters are often stuffed with contents in their cells so that it makes everything quite hard to spot and count!

Dileptus feeds on many things, sometimes on single-celled organisms like itself and sometimes on multicellular organisms. It amazes me every time I see a single-celled organism swallowing a microscopic animal with its thousands of cells, organs and even with simple brains. There is one old study that investigated whether *Dileptus* fed on planarians[2]. They ended up developing monstrous individuals over one millimetre in length! The whole study is quite weird and

BELOW:
Dileptus,
300 microns.

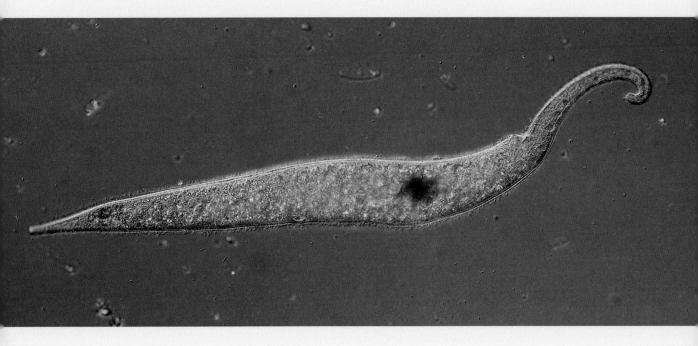

sounds like a horror story for the poor worms. The planarians were cut into small pieces (which is, by the way, a process they can survive!) and then needled into a *Dileptus* culture. The *Dileptus* fed on the cut tissue of the worm. The remains of planarians changed every day, with freshly cut pieces being fed to the *Dileptus*, and after just 72 hours, monsters appeared. The giant *Dileptus* individuals were as long as 1,200 microns, and some had twisted bodies. In addition to this, because of the prolonged intense feeding, they began reproducing rapidly to create more *Dileptus*.

Another weird thing about this study is that the researchers found out that one to three individuals out of 45 *Dileptus* in well-fed cultures had a strange vacuole at the centre of their cells. After isolating these strange individuals, the central vacuole kept enlarging until the individual looked like a water-filled balloon with the trunk-like proboscis attached to it. After 48 hours of staying in this state, the individual collapsed into a blob, and the blob later developed its parts into individual *Dileptus,* more tails and trunks! These parts of the blob later cut themselves free, producing as many as seven small *Dileptus*! Some of these abnormally small *Dileptus* developed into normal, heathy-looking individuals. The research emphasized that none of these abnormal cells had been observed in cultures which had not been fed planarians.

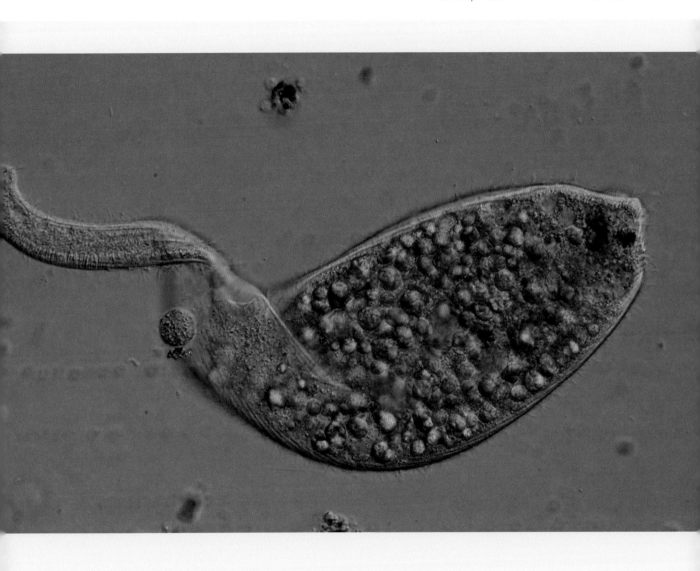

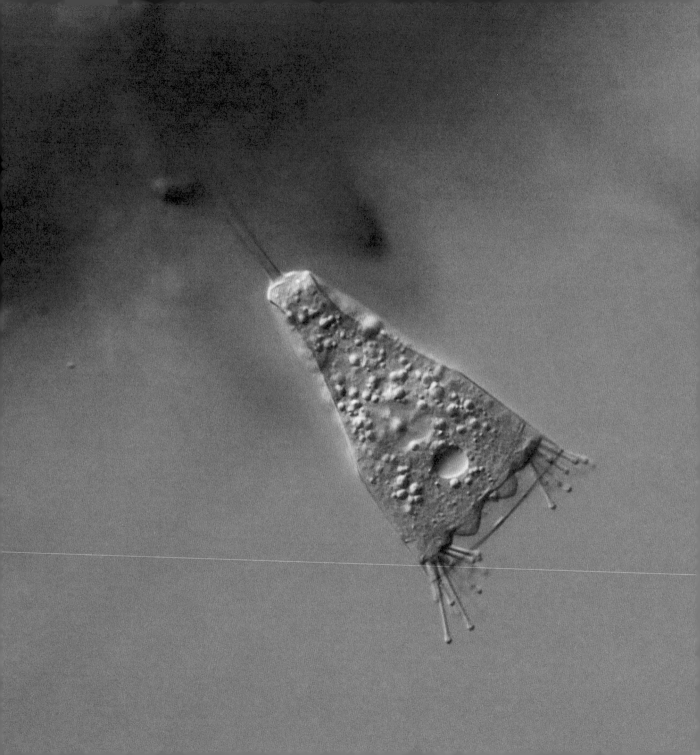

Suctorians – **tentacles with mouths**

One of the weirdest of the ciliate groups is the Suctorians. Although these are ciliates, they don't look like them at all. They don't have any cilia, or the familiar cell mouth of ciliates, but instead they have tentacles, each with a knob on the tip that attaches itself to prey. They look so different from the rest of the ciliates that even the legendary ciliate expert Alfred Kahl didn't include them in his studies (I talk more about Kahl on page 98). However, as strange as they look, Suctorians are indeed ciliates and have the hair-like cilia when they are young. But when these ciliated individuals find a spot they like and settle down, their shape and everything else about them changes. They grow tentacle-like structures, and when they reproduce they release ciliated swarmer cells to disperse into new areas.

ABOVE AND OPPOSITE: Suctorians, 120 microns.

I came across some Suctorians right after I started microscopy. I had a huge population of *Paramecium* in a jar, and one day I found them caught by what I thought were some microscopic sea urchins. After a bit of research, I figured out that they were in fact Suctorians feeding on my *Paramecium*. And because the *Paramecium* population was quite big, these predators increased in number quickly. I watched them devour *Paramecia*, one after another. When a *Paramecium*

brushes against one of Suctoria's tentacles, its cell is quickly pierced by the tentacle and held tight. Suctorians show something called polystomy; this means that their many tentacles are actually multiple little tube-like mouths that allow the Suctorian to slowly suck out the insides of its prey. Sometimes a single Suctorian is able to catch and eat multiple *Paramecia*. A horrible way to go!

Suctorians also feed on other ciliates. Sometimes Suctorians can be much smaller than their prey, and so they are described as parasites. They can attach to their prey and burrow their way into the cytoplasm. And even then, some Suctorians can get even smaller Suctorian parasites!

Another weirdness about them is that they don't have cytoprocts. In other words, they don't have cell-butts to excrete waste. Other ciliates have a vacuole that connects to a pore on the cell surface to excrete waste material. Food vacuoles with waste material fuse to this excretion vacuole, and later the pore opens up to excrete its contents. Because of the missing cytoproct, waste accumulates in Suctorians' cytoplasm, and a study shows that over-feeding a Suctorian shortens its lifespan, most likely due to the accumulated waste in its cell.

OPPOSITE: Suctorian, 70 microns.

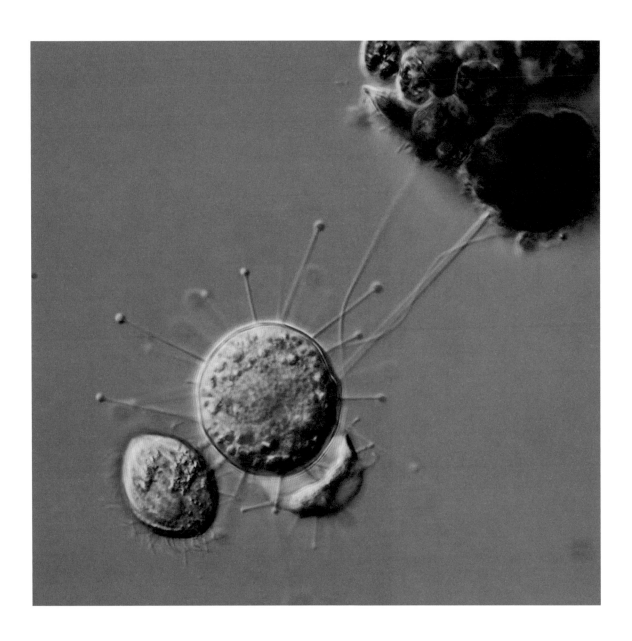

Vorticella and other peritrich ciliates – **lightning-speed reactions**

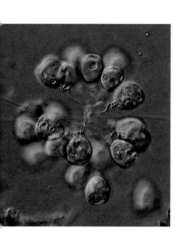

Microscopy wouldn't be what it is today without Antonie van Leeuwenhoek. He was a fabric trader in Delft, Holland, who developed an interest in lens-making. He had no higher education, but he learnt how to make perfect lenses, which he used to magnify things up to 350 times. It took a century for someone else to achieve that magnification. Van Leeuwenhoek was the one who discovered bacteria, sperm cells, blood cells and many things, including the tiny ciliate *Vorticella*, which he mentioned in a letter in 1676.

Vorticella are bell-shaped ciliates with some attachment issues. They like to produce string-like stalks that allow them to attach themselves to anything in the water. If they like where they are, they quickly multiply and form huge communities.

It all starts when a motile form of a *Vorticella*, called a teletroch, swims and finds a place to settle. It forms a long stalk that is glued to the place where the cell wants to stay. The *Vorticella* takes a couple of hours to finish forming the stalk, and once it's done, the stalk functions like a microscopic spring. Its thread-like structure, called the spasmoneme, contracts very quickly if the organism is disturbed somehow, making this bell-shaped microbe one of the fastest moving organisms in proportion to its size. It's like you going up three flights of stairs in 10 milliseconds. For reference: it takes 100 milliseconds to blink. *Vorticella* have been doing these light speed jumps for a long time; a wonderful fossil find shows a 200 million-year-old bell-shaped ciliate with a contractile stalk, just like *Vorticella*.

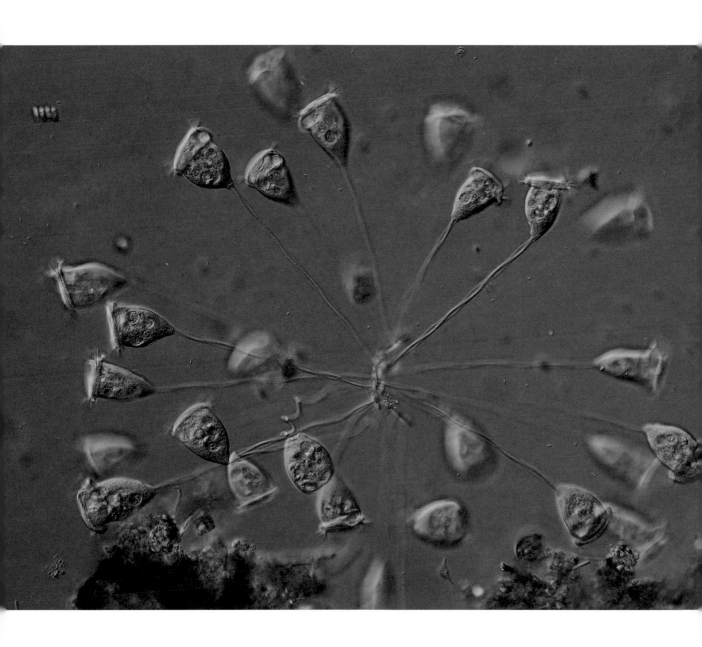

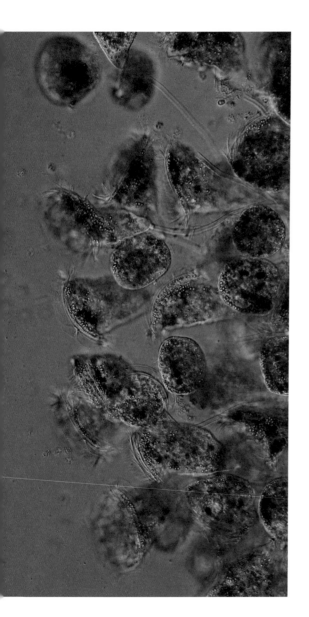

This wonderful organism has other interesting abilities. *Vorticella* are able to create a water current by beating the specialized cilia around their cell mouths, which brings food particles and smaller organisms into their mouths, where they swallow and digest them. I have seen microscopic animals covered with *Vorticella*, head to toe, in some cases literally. Sometimes, I've seen a number of *Vorticella* attached to aquatic organisms, like mosquito larvae! The infected larvae eventually drown because the *Vorticella* cells limit their movement. One study showed that a *Vorticella* infection reduced the emergence of adult mosquitos by 90 per cent, suggesting *Vorticella* could be used in mosquito biocontrol programmes[3].

Vorticella doesn't form true colonies, meaning that *Vorticella* cells are not connected at all. If there are many of them in one place, it means that they just like that location, and forming these communities may help them filter water more efficiently. *Vorticella* is part of a group of ciliates called peritrich ciliates. I find members of this group quite often, and even though *Vorticella* doesn't form colonies, some other peritrich ciliates do. I think my

LEFT: *Campanella* colony, 200 microns.

favourite is another common member of ponds, *Carchesium*. This ciliate forms beautiful colonies that look like bouquets of flowers where the flowers are individual cells on a long stem-like stalk. The formation of the colony starts similarly to *Vorticella*'s attachment on a substrate: first it settles down and forms a long stalk, sometimes even as long as a couple of millimetres, and then the organisms on the stalk divide many times to form other members of the colony, and the other members divide too, forming a giant colony.

Carchesium colonies have the contractile spasmoneme too, so they contract when they are disturbed in a similar way to *Vorticella*. However, the spasmoneme isn't continuous through the colony, and each member can contract individually. There is another colonial peritrich called *Zoothamnium,* which forms quite similar colonies to *Carchesium,* and does have a continuous spasmoneme through the whole colony. So, even if a single member is disturbed or startled, the whole colony ends up contracting, which can be amazing to see. But if you blink, you'd miss the whole thing!

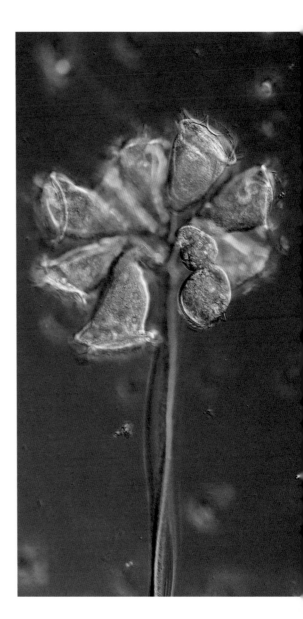

RIGHT: *Carchesium,* 600 microns.

Blepharisma – endings and beginnings

On Christmas Eve of 2018, I was feeling really lonely. I was far away from everyone, my friends and family. If being alone wasn't enough, I didn't have any money either, not even for proper food. I was eating only plain pasta and apples. The whole thing was depressing. As usual, I decided to check my microscope and find solace in the microscopic world. I prepared a slide, and found a pink ciliate called Blepharisma. This was a relatively unusual sighting for me; I had only found them on a couple of occasions before. They are really beautiful, I thought, with their pinkish colour and gentle swimming style. While I was admiring it swimming on my slide, the cell started to slowly melt away, leaving a trail of bits of itself behind. I had a strong impression that it wanted to live, and was swimming away from whatever was harming it. At some point the cell membrane put itself together, and I thought that it would survive, but then it dissolved into nothingness. I teared up; all the stress I felt during Christmas time, all that loneliness, finally overwhelmed me. It struck me that life was really delicate and precious like the tiny, pink cell who had just disintegrated in front of my eyes.

Blepharisma's pinkish colour comes from a pigment called, unsurprisingly, blepharismin. The pigment provides protection for the cells. When Blepharisma is threatened by a toxicyst-bearing predator, it releases this pigment from its cell, which kills the predator. Blepharisma are photophobic, meaning that they don't like the light, and intense light can even kill them.

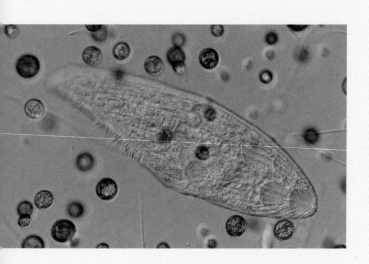

LEFT: *Blepharisma,* 220 microns.

OPPOSITE: Two *Blepharisma* during conjugation.

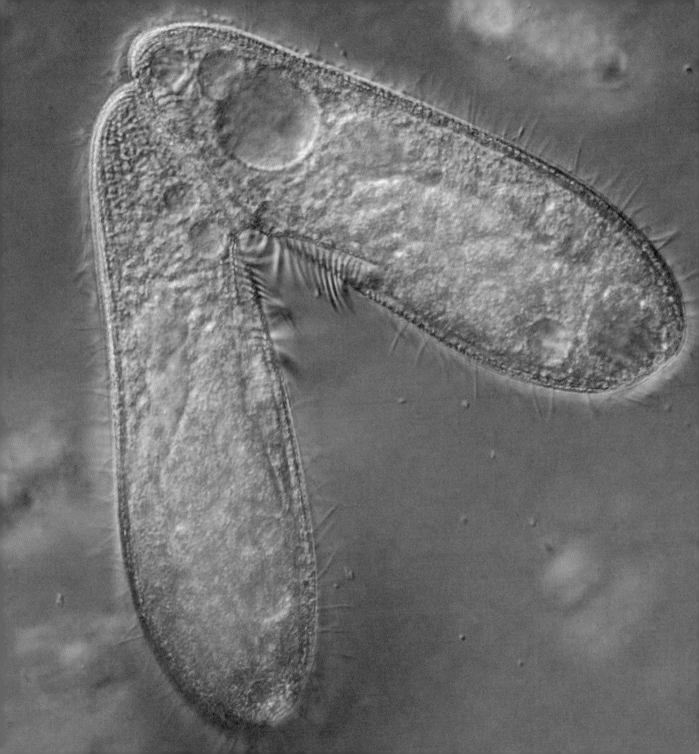

When they swim into a lit area, or the light intensity of the microscope suddenly changes, the pigments release hydrogen ions. These ions transfer to the cytoplasm, causing electrical potential changes in the plasma membrane, which change the beating of hair-like cilia to reverse the swimming direction. And when the pigments are exposed to oxygen and intense light, Blepharisma *dies due to necrosis: the cell membrane gets damaged, swells and "explodes", spilling out its cytoplasm. I believe this is what had happened to the one I watched dying.*

I recorded the whole thing. It was pretty quick, all happening in less than two minutes. I uploaded the video to YouTube and it went viral. The video got over 3 million views. It was all over the internet. People made memes about it, and I had to turn off email notifications on my YouTube channel. My dying single-celled organism was famous!

One night I received an email from a person I had admired for a very long time. It was Hank Green, the creator of SciShow and many other YouTube channels that I had been watching for years! I was so excited to see his name, I skimmed through the email, took a

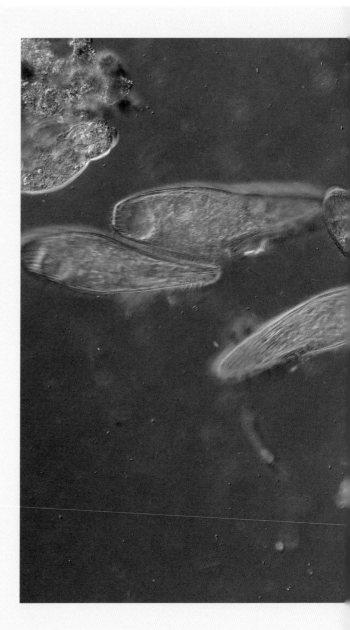

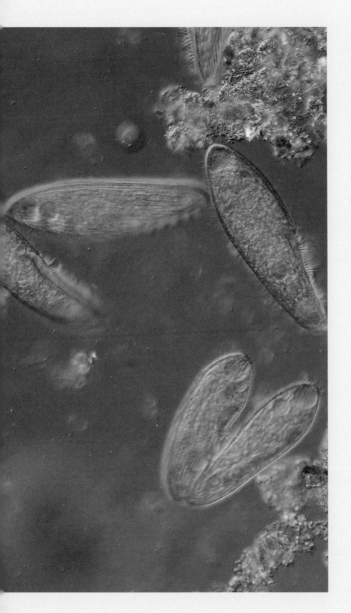

LEFT: *Blepharisma.*

screenshot of it and sent it to my best friend. He was also a big fan of Hank Green, and he responded to me, "MERLIN'S PANTS!"

Hank and I exchanged a couple of emails, had some online meetings, formed a team including our producer Matt and scriptwriter Deboki. Hank was our narrator and executive producer, and I handled the microscopy and microbe part. We started our YouTube channel "Journey to the Microcosmos". It became many people's favourite show really quickly. I think many microbes, such as Stentors and Blepharisma, were not known to this many people in human history before, and finally microbes were gaining the recognition they deserved!

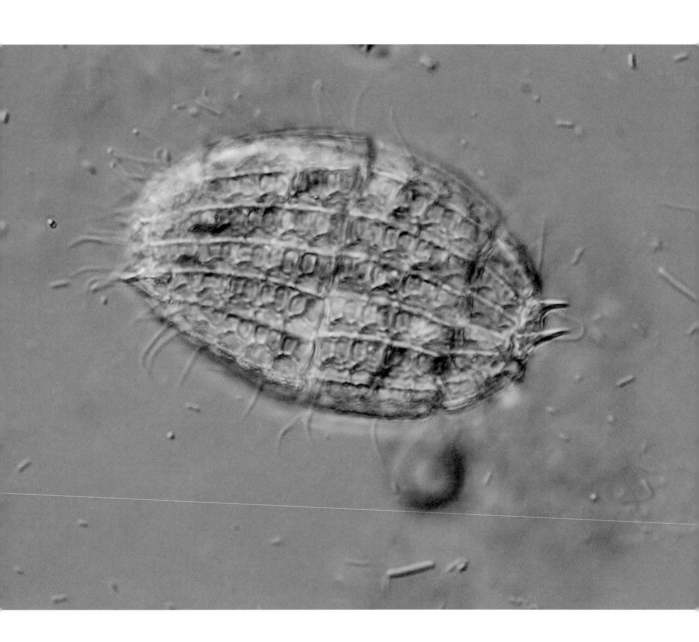

Coleps – **little sharks**

Some ciliates are attracted to dying or already dead organisms, and they feed on them. They are called histophagous ciliates, and they can sense death from a distance and swim toward it. It's quite fascinating that these organisms act like little sharks smelling a drop of blood in the water from kilometres away. They show chemotaxis, which in simple terms means that they can track certain chemical cues in the water to find their food. *Coleps* is one of these ciliates. Whenever there is an injured organism on a slide, all of the *Coleps* present swim toward it. The prey could be a dying *Paramecium* or a broken algal filament, or it could be tissue from a much bigger organism, like a dead fish in the water. *Coleps* find their way to their victim and feast on the organism. There is even a report of them killing the fry (recently hatched baby fish) of some species of aquarium fish. While I haven't seen them killing a fish, yet, I have witnessed tens of them devouring a dying worm.

ABOVE:
Coleps eating a dead rotifer.

OPPOSITE:
Coleps,
40 microns.

Ophryoglena –
a strange life cycle

I often find some other histophagous ciliates from the pond in the park close to my flat, but I couldn't identify them for three years! They didn't give away many clues about their true identity and they seemed to disappear from my slides after a day or two. When I got my new microscope, it allowed me to see the microbes in more detail, and that's when I spotted a clue as to what they could be; what I saw was like a comma punctuation, right next to the ciliate's mouth. This mysterious thing I saw turned out to be what is called the Organelle of Lieberkühn because it was first noticed by a scientist named Lieberkühn in 1856. This is an enigmatic, crystalline organelle which looks like a watch-glass, and it's sometimes called the watch-glass organelle. (I had to google to see what a watch-glass actually was!) However, seeing the watch-glass organelle made me certain that I was looking at a ciliate called *Ophryoglena,* who likes to eat dead things! No one knows what purpose this watch-glass organelle has, but it's the key to identifying *Ophryoglena*.

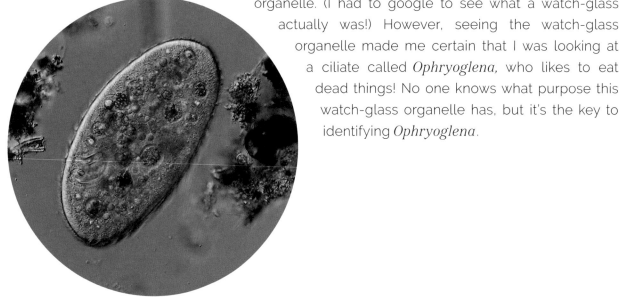

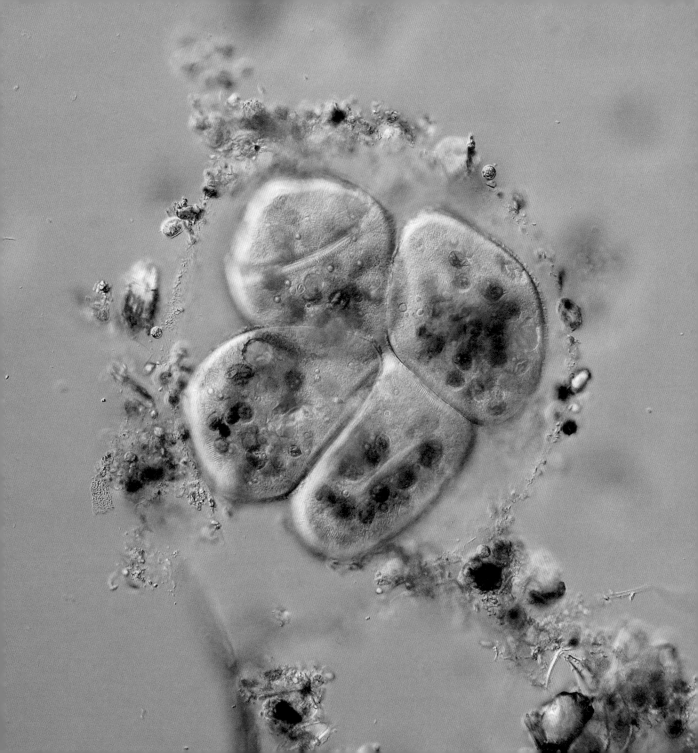

By identifying them correctly, I also managed to solve the mystery of the strange disappearance of them from my slides. Some ciliates like *Ophryoglena, Prorodon* and the extremely hard to spell *Ichthyophthirius* pass through distinct developmental stages during their complex life cycles. They completely change their shape, size and motility. Even the same individuals can end up looking different. Very different, in fact.

Ophryoglena goes through five different stages of reproduction, called theront, trophont, protomont, tomont and tomites; quite weird names, but the stages are even weirder. The theront moves quite fast. It covers over ten times its body length per second, and it has only one job to do: find food. The theront's body is "empty" because the organism in this stage is actually starving and there are no food vacuoles inside its cell. But once it locates the food, it eats quickly and its cytoplasm becomes full of spherical food vacuoles, doubling the theront's size, and now it's called a trophont. The trophont slows down to a protomont. The protomont just cruises slowly around for a couple of hours after eating, and then turns into a rather stationary form, a tomont. The tomont secretes a sticky material and slowly rotates inside it, and after a couple of hours, it divides to create two daughter cells. Then these two divide again and create two daughter cells each. Now there are four *Ophryoglena* tomites. The tomites develop into theronts, and the cycle continues!

RIGHT: *Ophryoglena* theront eating a crushed ostracod, 300 microns.

DIC microscopy – **a whole new level of detail**

When I first started doing microscopy, I saw some microorganism photos and videos in such detail that they almost looked unreal. Later I learnt that they were recorded with a special technique called Differential Interference Contrast (DIC) microscopy. When I googled it I saw that these microscopes were way beyond my budget. I was using a $160 microscope, and the DIC microscopes were $20,000. There was no way of getting one. I didn't have money most of the time, even for food. How on earth would I be able to get such an expensive thing? Then, two and a half years later, I got one! I started a crowdfunding campaign: almost 200 people chipped in; my friend Sebastian, who always loved my work, lent me some money; and I added some into the pile and got myself a DIC microscope!

It took eight weeks for the microscope to arrive, and even after it arrived I had to wait one more day for an engineer to come and put the whole thing together. Of course, I didn't plan on sleeping that night, so I went to one of my favourite ponds to collect a sample. I came

ABOVE: *Mallomonas* through the previous microscope.

back home and prepared many slides and put them in the humidity chamber so I would have some nice, fresh slides to view as soon as the engineer was done with assembling the 25kg behemoth. I was so excited that night. I felt like I was in a dream.

At 9am the engineer arrived and took a good three and a half hours to put everything together. Even before he left I put one of the slides I had prepared the previous night under the scope and saw something I knew very well, a golden alga, Mallomonas, *(which I mentioned on page 90). I knew that this alga had scales*

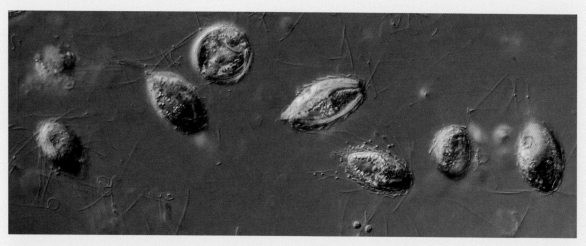

ABOVE: *Mallomonas* through the DIC microscope.

on its cell surface, but I had never been able to see them with my own eyes before. The thing I was looking at was so familiar yet so different. Over the countless hours I spent looking at it, I had never seen such detail. I realized that I would have to find and see everything I had found before. Tears ran down my cheeks. I hid it from the engineer, but that moment of realization that I would be seeing all the microorganisms in incredible detail was so precious to me.

Until I got the DIC microscope, the result of my work was mainly based on my microscopy skills. Microscopy is an art, and people often assumed I had quite expensive equipment when really I was using a $160 microscope. But after getting the new microscope, I was armed with a DIC system and great microscope objectives (lenses that gather and focus the light in a microscope for the base magnification), and skills that I had acquired while battling to make my videos better with limited equipment. From this point on, creating content felt different; now I felt like I was actually creating something that was going to be influential for a long time.

Amoeboids – **a kind of movement**

The term "amoeba" is used for describing a bunch of groups of single-celled organisms which are not closely related and most of the time have nothing in common except the way they move and feed. This shared way of moving is called amoeboid movement, where the organisms navigate and feed by changing their cell shape and extending their cytoplasm temporarily back and forth. Any group that shows the amoeboid motion is considered to be an amoeboid.

Amoeboid organisms live everywhere around us, and there are around 15,000 described species. They are found in all types of habitats, in freshwater and marine environments, deep seas, in moist places like soil and moss, and a tiny portion of the existing species are parasitic and pathogenic to other organisms.

Amoeboid cells can change their shape as they wish, allowing them to extend parts of themselves into features called pseudopodia. "Pseudopodia" is Latin for "false feet", and these extensions are used for moving and hunting. The cytoplasm of an amoeba can easily change from a fluid state into a solid state and back again. When an amoeba moves, liquid cytoplasm flows throughout the centre – it looks like an avalanche. The cytoplasm is often full of swallowed organisms, bits and pieces of sand and even some crystals, and they all tumble with the flowing cytoplasm. When the cytoplasm reaches the tip and the sides, it becomes more of a solid gel and stations the amoeba to the location.

Amoebas create these extensions in all directions to trap prey in between them. Once the prey organism is surrounded by pseudopodia,

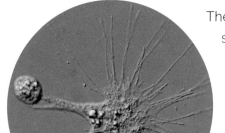

ABOVE:
Amoeba,
180 microns.

OPPOSITE:
Amoeba,
1,400 microns.

the amoeba simply wraps up the pseudopodia and fuses them together while taking the food into its cytoplasm, and in a matter of seconds there is a food vacuole formed inside the amoeba with the swallowed organism. The prey stays alive until the digestive enzymes melt it away.

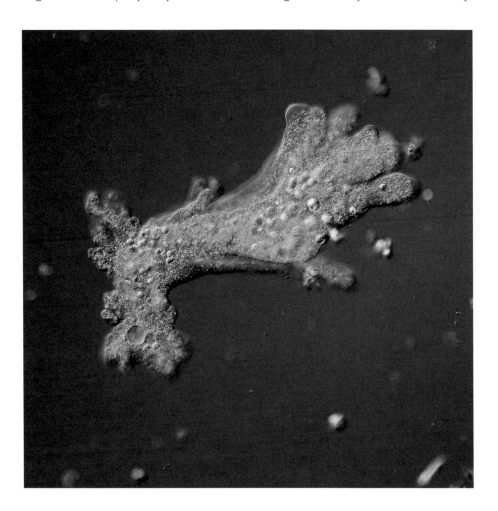

Vampyrella –
little vampires!

One of my favourite amoebas comes with a gorgeous and quite an appropriate name, *Vampyrella*. They got their name from their reddish colour and ability to suck algal cells. *Vampyrella* often feed on filamentous green algae, fungi and cyanobacteria filaments. They are spherical while searching for food, with thin pseudopodia extended out in all directions from their body; the *Vampyrella* walk on substrate by moving these tiny feet until they find their victims.

I have watched *Vampyrella* slurping filamentous green algae *Spirogyra* cells. It's a remarkable scene! First, a *Vampyrella* releases some enzymes that melt the cell wall of the algae, and then *Vampyrella* sucks out all the cytoplasm content of the algae, leaving an empty cell of alga with a hole on it. Once the amoeba eats enough, it forms a perfect little circle called a digestive cyst and stays immobile until it digests the food it has eaten. Later, the vampire will become active again to find more algae to suckle on.

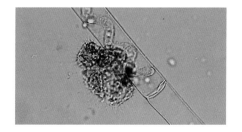
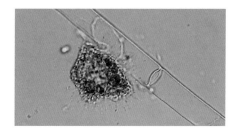

RIGHT: *Vampyrella* in the process of eating, 60 microns.

Pelomyxa –
colossal amoebas

Pelomyxa are colossal methane-producing amoeba that can grow up to 5mm in length and live at the bottom sediment of freshwater habitats, where the dissolved oxygen is limited or nonexistent. *Pelomyxa* have some bacteria and archaea endosymbionts; these organisms live inside the giant, and both the endosymbionts and the host amoeba benefit from this relationship. *Pelomyxa* are really hard to recognize. They look just like debris on the slide, and they are almost opaque because of the sand grains and many other things inside their cytoplasm. They also move incredibly slowly. The biggest *Pelomyxa* I found is the one in the photo. I had to stitch 12 photos together to put this giant in one frame. In reality, it is around 4mm in length!

ABOVE: *Pelomyxa*, 4,000 microns.

Naegleria fowleri – **the brain-eaters**

One time, after collecting sediment samples from a pond, I left the container in direct sunlight, and after a week I decided to check it. I thought because the sample was getting quite hot during the day and almost all of the water had evaporated, the heat might have killed everything in there. But when I looked at a drop under the microscope, I found many flagellated amoeba. These organisms showed the amoeboid motion with irregular body shapes and have whip-like flagella. They resembled the infamous brain-eating amoeba *Naegleria fowleri* to me, which also shows a period in its life cycle where it is flagellated amoeba, and they are heat-loving.

Although *Naegleria* is a common organism, during hot days it can increase in number in ponds and rivers and cause a horrific but quite rare infection. *Naegleria fowleri* infects people by entering into the body through the nose when people are swimming or diving, then it finds its way into the person's brain where it eats the brain tissue and reproduces. According to the Centers for Disease Control and Prevention (CDC), from 2010 to 2019, 34 infections caused by the brain-eating amoeba were reported in the USA.

ABOVE: *Naegleria* -like amoeba, 30 microns.

Testate amoebas – **shell-builders**

Some amoebas, called the testate amoebas, are tiny architects; they build shells or "tests" and live inside them to protect themselves from predators. There are a couple of different ways the little architects build their shells. One type of amoeba, *Arcella,* builds these beautiful shells from some building blocks that it secretes. The building blocks have a stunning honeycomb-like appearance under high magnification.

The colour of an *Arcella* shell changes throughout its life; when it's newly formed it looks quite transparent and colourless, but minerals like iron deposits inside the building blocks that form the shell transform the colour to yellow, orange and even to black. *Arcella*'s shells have an opening through which the organism extends its pseudopodia and crawls on the water surface to eat bacteria, algae and other tiny organisms. But how does it get to the surface with the weight that the shell puts on *Arcella*? Well, it has found a really clever way: it accumulates air bubbles inside its shell to float!

Another group of testate amoeba builds shells in a different way; they glue together pieces of material that are readily available in the environment. The genus *Difflugia* is remarkable at building shells. They collect tiny bits of rocks, sand grains, minerals and anything else they think good enough for them, and arrange them to create a shell. All the materials that are used for creating the shells are called xenosomes. The way *Difflugia* assemble and arrange xenosomes to create their shells is unique to that species. I cannot comprehend how each species knows what kind of shell they should be making and how they arrange hundreds of little pieces to form it.

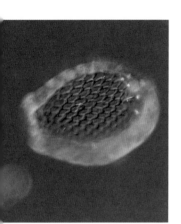

ABOVE:
Testate amoeba,
100 microns.

OPPOSITE:
Arcella,
200 microns.

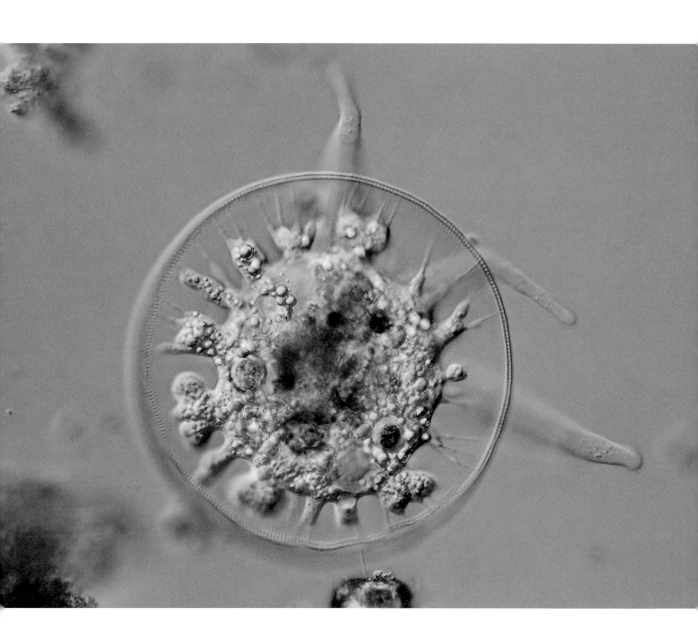

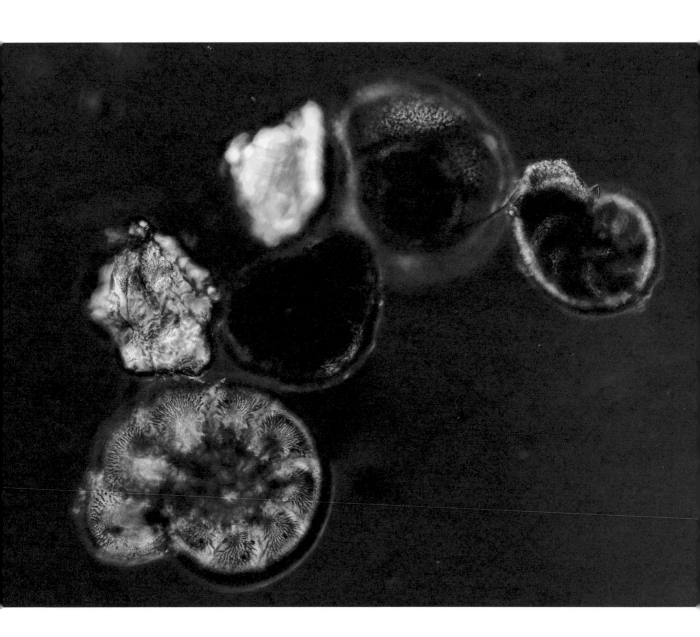

Foraminifera – **good luck charms**

Foraminifera look like molluscs, but they are actually amoeboid single-celled organisms with little shells. Through finding their fossils we know they've been around for over 500 million years, slowly but continuously changing, with new species appearing over time.

Their fossils got human attention before the age of modern science; the ancient Egyptians used limestones that contained foraminifera fossils in their buildings, and the Greek historian Herodotus mentioned seeing them in the blocks of the Great Pyramids in the fifth century BC. He called them nummulites, after the Latin word "nummulus", meaning "little coins".

I found my first Foraminifera in the Baltic Sea. I collected some sand in a big bottle from a beach and brought it back home, hoping to find some microorganisms. Yet the sample was mostly empty, and I left the bottle on my windowsill. A couple of months later, I saw a greenish algae growth on the surface of the sand and thought I'd better check it. I wasn't thinking that the green algae would be interesting but what comes to eat them might be! And to my surprise, my half-forgotten windowsill sample was full of Foraminiferas.

Foraminiferas, like all other amoeboid organisms, form cell extensions called pseudopodia, and in Foraminifera's case these pseudopodia are really thin and fast-moving networks. They look amazing when the organism decides to walk on the coverslip that sits on the water drop; when they do that there are no other substances that can block my view or scatter the light and reduce the resolution of the image that the microscope produces.

OPPOSITE: Foraminifera fossils.

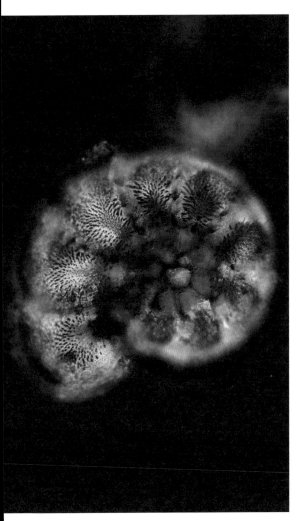

ABOVE: *Foraminifera* fossil, 140 microns.

Foraminifera use thin pseudopodia to move and capture food, as well as to construct their shells. These marvellous shells, or tests, are the houses of the organisms. The organisms extend their pseudopodia through a single, or in many cases multiple, opening in the shell houses, and when the organisms grow they add more rooms to the shell houses, making them look chambered.

The constitution of the shell depends on the species, but most of them are composed of calcium carbonate, and some others build a shell from sand grains cemented together, composed of organic material, and in one case opaline silica. There are over 4,000 living species, and many extinct species; all this richness of species creating such beautiful shell structures!

Foraminifera are separated into two types according to their lifestyle. One of the types is the benthic foraminifera; these live in the deep waters, their size ranging from a couple of hundred microns to a couple of centimetres. Some simpler forms were even reported living in the Challenger Deep, the deepest known point of the seabed on Earth – 10,896m deep. The Foraminifera found at this depth have organic shells rather than the common calcium carbonate shells. One study reported that at this depth the water is undersaturated

in calcium carbonate and therefore organisms that use calcium carbonate cannot exist there[4].

The other type of Foraminifera is the planktonic foraminifera; these organisms float freely in the water and are carried wherever the current takes them. Their shells are made of globular chambers to provide buoyancy so they can float rather than sink. They are much smaller than the benthic foraminifera, not exceeding 600 microns in diameter.

My girlfriend was visiting me from Virginia, USA, when the Covid-19 pandemic started. All flights were cancelled and we got trapped in Warsaw for two months together. But it turned out really well for us after all; we got engaged! Before my girlfriend – now my fiancée – came to Warsaw, she went to the coast and collected a jar of water and sand samples for me. This was one of the most unfortunate samples I have ever had: it leaked into my fiancée's luggage in the plane; then my cat, Sirius, tipped it over even before I could check it under the microscope; and then I did the same while trying to open my window! So this poor jar lost all the water it had and was just wet sand. I didn't think it would yield anything good but, once again, microorganisms surprised me! The sand was full of Foraminifera fossils. Even now, months later, I occasionally take some sand from the jar and check it under the microscope to find some Foraminifera.

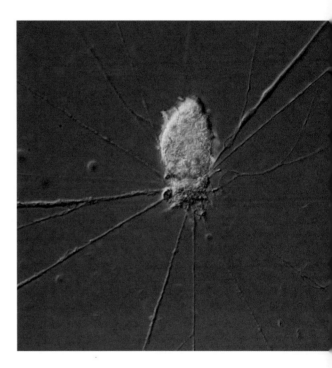

ABOVE:
Foraminifera,
120 microns.

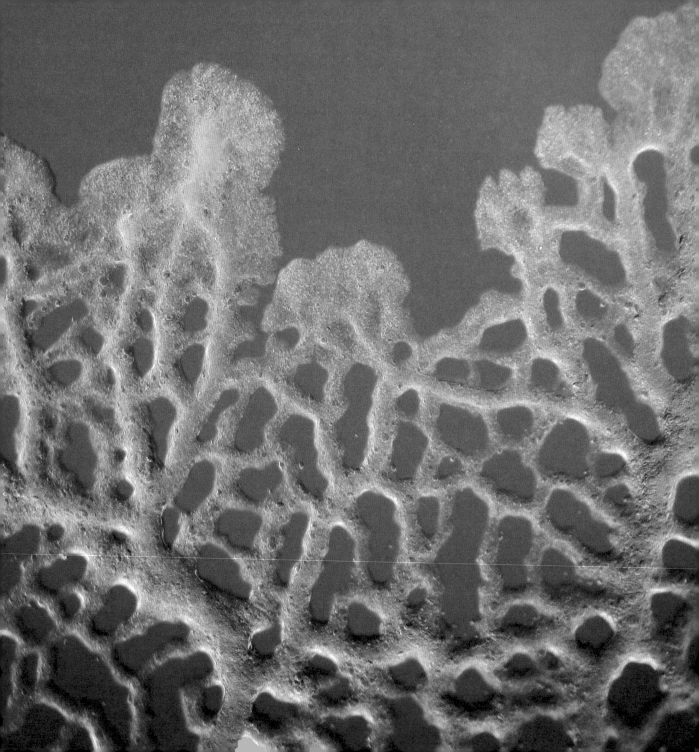

Myxomycetes – **the slime moulds**

OPPOSITE:
Slime mould.

Physarum polycephalum is a myxomycetes, or what is commonly known as "plasmodial slime mould". Myxomycetes have been classified as plants, animals or fungi since their discovery, but with the availability of the genomic work we now know they are amoebozoans. There are approximately 1,000 species of myxomycetes described, and even one commonly known as the "dog's vomit slime mould". Myxomycetes reproduce by spores. When the spores are released and moistened, they germinate to tiny amoeba-like organisms. Later some of these amoeba-like cells fuse to form a giant single-celled structure with multiple nuclei called plasmodium. These plasmodia are usually quite big, in the case of *Physarum polycephalum*. If the conditions are favourable, plasmodia of *Physarum* form complex networks that can even be tens of centimetres in diameter. They live on decaying organic matter, such as rotting logs and decomposing leaves of a forest canopy, and in my living room in petri dishes on nutrient agar.

I feed the bright-yellow plasmodia with oatmeal grains, and every time I add some more oatmeal to the dishes, the plasmodia form quite interesting and fast-moving networks. I place the dishes under the microscope to watch the plasmodia up close. It's not like watching a wild drop of pond water in which everything is trying to eat each other,

but plasmodia have their own beauty in the form of shuttle flow. This is where the cytoplasm of the plasmodium flows back and forth rhythmically. It's absolutely fascinating to watch. The cytoplasm carries a bunch of things in it, and for over a minute, everything flows in one direction. The cytoplasmic content tumbles and rumbles in the tiny roads the plasmodium creates. After a minute or so, the flow of the cytoplasm changes direction and everything tumbles back, and it happens again and again. Plasmodium moves in this way while forming new branches and connecting the existing ones, and when it finds some food, which are the oatmeal grains in my culture's case, it leaves only the shortest connections between the food sources.

Physarum polycephalum's ability to recognize the shortest way between food sources made it a model organism for many creative experiments. In one of these experiments, Japanese scientists made a map setup of Tokyo and 36 surrounding towns by putting oatmeal on the location of each town on the map and placing *Physarum* in the centre where Tokyo is[5]. After a couple of days, *Physarum* created a network that had striking similarities to the Tokyo subway system by choosing the most energy-efficient connections between the oatmeal grains. So smart for a single-celled being!

ABOVE: Slime mould.

Water moulds –
unexpected infestation

One winter I collected some samples from my regular spot, and I was checking them under the microscope. Nothing interesting was on the slide, and I had no idea I was about to observe something quite unusual, which would take me more than a year to identify.

It all started when I saw a water crustacean egg on the slide. The eggs were quite common. These eggs could survive in the water for quite a while before hatching, but this one looked like it was releasing something. First, I thought that I must have cracked the egg when I placed the coverslip on the drop and the egg's content was leaking out, but I decided to record and see what would happen. And I am so glad I did, because the thing that I captured on camera was extremely weird and mind-blowingly interesting.

The substance that was coming out of the egg was like a paste; it looked thick and gooey and it kept leaking, forming a ball of weirdness next to the egg, wrapped up inside something, like an envelope. After about ten minutes, the leaking stopped and the ball of leaked substance started to look like it was boiling. It was moving, churning, bubbling slightly. It looked unreal, something out of a sci-fi movie. But then it got even weirder. The boiling substance started to form tiny round things inside the envelope. I watched, my jaw on the ground, as the tiny things started to move individually; they were single-celled organisms! Hundreds of them inside the envelope, each having whip-like flagella, and the spherical envelope was keeping them inside and together, but they were moving individually, pushing and expanding the sphere. After

ten minutes, the envelope burst open and hundreds of tiny cells scattered into the water. I was shocked but I managed to record the whole thing!

This happened the winter I started microscopy, so it took me over a year to figure out what happened. It's still a bit uncertain, but I believe, and so do some specialists, that these were zoospores (which means a spore that can swim) of something called oomycetes; they are some of the most devastating parasites of plants. Oomycetes are also known as "water mould", although they are not actually moulds, not even related to fungi. They were classified as fungi for a long time because of the way they grow like branching fungi and reproduce by spores as fungi do, but fungi is more closely related to us than they are related to oomycetes. Molecular studies show that oomycetes are related to algae and plants.

A species of oomycetes caused the great potato famine of the 1840s in Ireland by infecting and killing all the potato plants in Ireland, which later resulted in a million deaths from starvation. The oomycetes in my sample were infecting water crustaceans called *Daphnia*, and the cells I saw being released were zoospores that were filling a spore case called a sporangium. Once the zoospores were released into the environment, they dispersed to infect more *Daphnia* and complete the cycle.

The unique unicellulars

Single-celled eukaryotes are fascinatingly diverse. Here I included a short introduction to some of my favourite groups, but there are so many more to discover. Even though these organisms are just composed of single cells, they are incredibly complex. The way they evolved enabled them to interact in an impressively clever way with a complicated environment, even when lacking a central processing system. Similarly to prokaryotes, they have environment-changing capabilities, such as creating new materials or compounds that are released into the soil, water and air; some of which are toxic, and some of which are essential to human life. Even though they served as building blocks for multicellular evolution, unicellular eukaryotes have proven themselves to be self-sufficient and capable of thriving in their own right.

As I discovered when I came across my mysterious ciliate mentioned earlier, the unicellular eukaryotes that have been described are only the tip of the iceberg of undiscovered organisms.

part three
multicellular eukaryotes

In a single drop of water, there are many tiny multicellular eukaryotes living alongside the single-celled prokaryotes and eukaryotes. As a result of multicellularity, these organisms have organs, including some familiar structures like eyes, legs, heart, guts and even some testes! They are quite complex organisms compared with their single-celled predecessors. They can have thousands of cells in their bodies, and these cells work on specialized functions. For example, for locomotion these organisms can use muscles that are composed of muscle cells. Having specialized cells allows organisms to be more complex in certain tasks. We humans are multicellular eukaryotes too, just not small enough to fit under the microscope, and maybe that makes humankind less interesting than microbes for me!

ABOVE AND PREVIOUS PAGE: *Aeolosoma,* 1,500 microns.

Nematode-catching fungi
hero and villain

I was sampling the pond in the park next to my place for years, at least a couple of times a week. Every sample yielded something new each time. However, there are some organisms that are so common that they feature in almost every slide. An example of a common creature is a nematode. There are actually 60 billion nematodes for each human on the Earth, so you see: extremely common! I do not enjoy looking at these worms that much, so I don't observe or record them often. In fact, there is something repellant about their slithering motion. Yet on one occasion, there was something about a nematode that caught my eye.

I fixed a slide that I had been keeping in my humidity chamber under my microscope and the first thing I saw was a dead nematode. Nothing interesting at all. But then I looked again, a little closer. I realized it appeared as though it had died after becoming entangled in a bunch of fungi hyphae (a fancy word for its branching filaments). Fungi appear on slides that have been in the humidity chamber because the humid conditions are just perfect for fungi spores to grow. Their complex hyphae branch up on the glass, like tiny roads and highways. Although this time it almost looked like the hyphae had choked the nematode. Suddenly I was reminded of a painting by my friend Kate. She draws

OPPOSITE:
Spores and hyphae.

mainly soil microbes, and almost two years ago she drew a nematode choked by a specific fungus that creates ring-like traps to capture nematodes and feed on them. It's called the nematode-trapping fungi, and I realized that I had actually witnessed a murder committed by that fungi, right on my slide.

LEFT:
Trapping rings,
30 microns.

OPPOSITE:
Caught
nematode.

The fungi that capture nematodes are called nematophagous fungi. There are a couple of different fungi that feed on nematodes, but the one that was growing on my slide was an *Arthrobotrys* species. Similar to carnivorous plants, *Arthrobotrys*' desire to trap nematodes comes from its nutritional requirement for nitrogen in nitrogen-limited habitats. It has to gather nitrogen compounds from other organisms in the soil where nitrogen is not freely available. The first nematode-trapping fungi to be discovered, *Arthrobotrys superba*, was described in 1839, but the scientists who described it didn't realize the fungi's predatory habit until 36 years later.

Arthrobotrys creates long networks to form ring-like traps for the nematodes. When nematodes move inside a ring or even just come into contact with the outer part of the rings, they become attached to the trap's surface. Under an electron microscope, the surface of the trap cells look like they are covered with a layer of fibrils (extremely fine and small fibres). If a nematode brushes against the trap, the fibrils become perpendicular to the nematode's body and the fungus pierces its body. The nematode slowly becomes less and less active and dies. The fungus starts to grow on and in the dead nematode by using the dead creature's nutrients. It's like a horror story.

Nematodes are a huge part of healthy soil, but out of almost 30,000 described species, half of them are parasitic to other organisms. They parasitize insects, animals including us humans, and plants. They cause billions of dollars-worth of damage annually to crops all over the world. So the nematode-trapping fungus is a candidate to be our hero protagonist, by saving us from losing our crops and keeping our livestock happy and healthy.

OPPOSITE TOP: Nematode caught in fungi traps, 3,000 microns.

OPPOSITE BELOW: Same nematode, one week later.

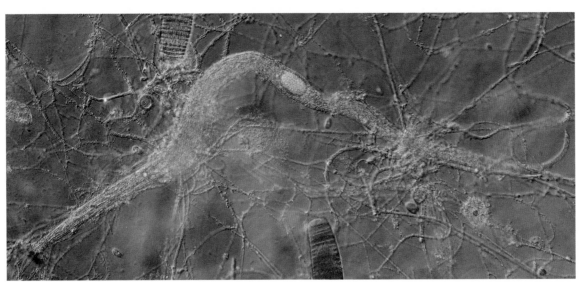

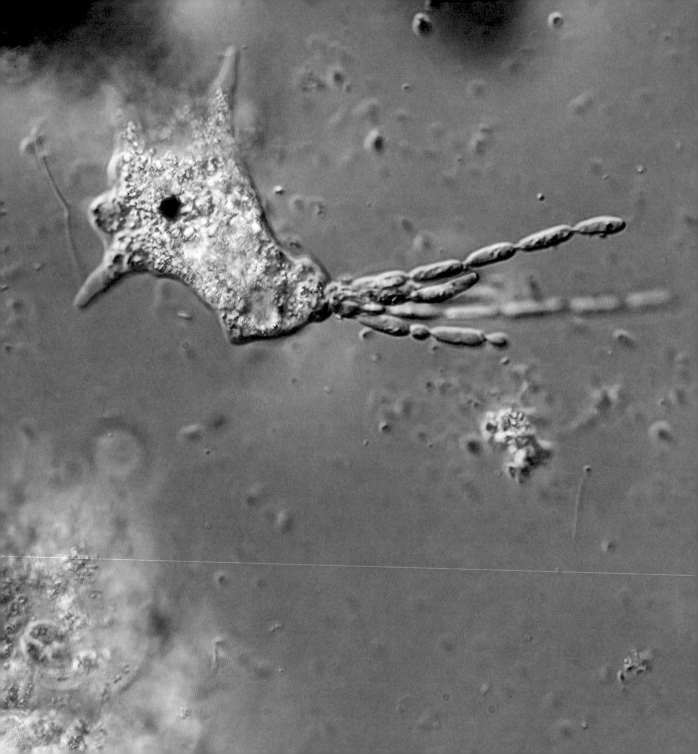

Amoebophilus simplex – **a deadly flower**

Some microscopic fungi can also infect single-celled organisms such as amoebas. The interactions between the host amoeba and fungi are not well understood because it's rare to find amoeba with fungal parasites. However, I managed to find a fungal parasite of amoebas, *Amoebophilus simplex*. So far, data scientists think *Amoebophilus simplex* targets only a group of amoebas called the *Mayorellid* amoebas, and it can even be species-specific, only infecting *Mayorella penardi.* The infection starts when an amoeba ingests a spore of the fungus. Later the spore forms something called an haustorium at the rear part of the amoeba. The haustorium is inside the amoeba's cell but it "flowers" through the cell membrane of the amoeba and creates chain-like new spores outside of the amoeba. When these new spores are released into the environment, they will infect new amoebas and will create more spores. To make things worse, a single amoeba can be infected with many spores and have more than one haustorium flowering on its cell. I have seen a bad case of infection where the amoeba had seven different infections. Because the haustoria

OPPOSITE AND BELOW: *Amoebophilus simplex*, 75 microns.

OPPOSITE:
Amoebophilus simplex, 100 microns.

are really close to each other inside the amoeba, it's hard to see each one of them but the tail-like spores give the multiple infections away.

On the same slide that I found the rare *Amoebophilus simplex* fungus infecting my amoebas, I also found a couple of giant amoebas. Some were longer than a millimetre in length and were clearly visible to the naked eye. These are actually pretty common and I find them often in my sediment samples, but because of my rare find of the amoebas with feather-like infectious spores, *Amoebophilus simplex,* I put the slide into my humidity chamber for further observation. (It sounds impressive when I call it a humidity chamber, but just to remind you, it's a Tupperware box with wet cotton balls in the bottom!) I didn't think anything would happen to those giant amoebas, and nothing did for the first week. I observed the *Amoebophilus simplex –* infected small amoebas crawling on the slide, alongside the giant, healthy amoebas. But after a week, I was casually checking the slide again to watch the infected ones, when I saw that one of the giant amoebas was stuffed with many spherical things. I thought they could be spore cases, which some organisms form to release spores, like oomycetes. These spheres were quite big, and there were so many of them inside the amoeba. Before I had some time to think further, something weird happened, again! (I think that's one of the reasons why I love microscopy and microbes. *Everything* is unusual, and weird things happen all the time. It feels unnatural if I *don't* see something strange on a slide once a while.) What happened was that the giant amoeba I was looking at started to discharge the spheres out of its cell. It was violent. If the amoeba could scream, I believe it would be screaming. The spheres tumbled out of the amoeba, ripping the

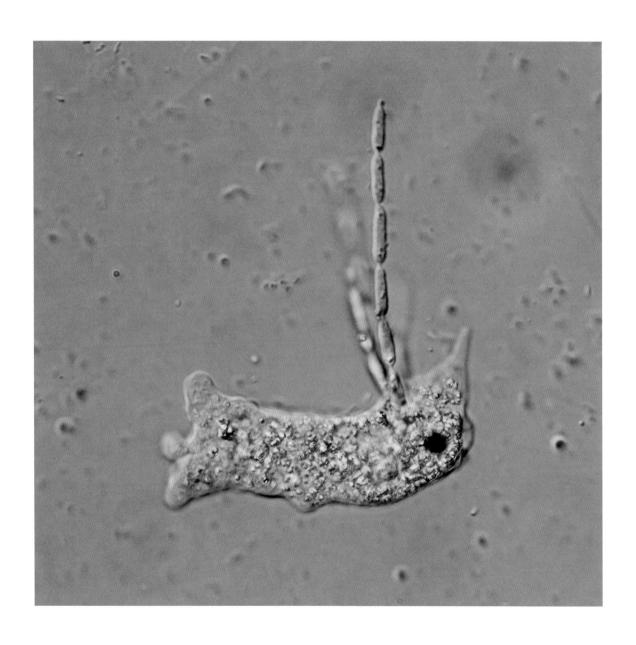

amoeba's cell membrane, spilling its cytoplasm out. One after another, the spheres came out of the amoeba. After five minutes there was no amoeba left, and the spheres lay there motionless. Just a couple of minutes later the spheres kind of dissolved and hundreds of spores were released. They were not actively swimming. They lay there motionless. The whole thing took only ten minutes, enough time for me to understand that I had witnessed something incredibly rare.

I saw one of the other giant amoebas on my slide and it, too, was full of spheres. And that one died in the same way. Then that evening I watched it happen to all the other giant amoebas on my slide. They all died in the same way. I am not sure about the species of the amoeba, and I wish I had paid more attention to them when they were healthy-looking, but I think they were *Amoeba proteus* as I often find this species from the same location. And I believe that the *Amoeba proteus*

BELOW:
Dying amoeba, 1,400 microns.

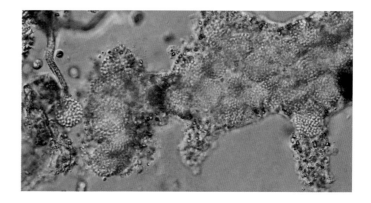

population on my slide was infected with a parasite that specifically targets *Amoeba proteus*, infects them, reproduces inside them and forms spore cases, killing amoeba to release the spores into the environment to infect more *Amoeba proteus.* It's brutal.

This happened when I was about to finish writing this book, and at the moment I am keeping the slide with the spores so that I can try to add the spores onto slides with some *Amoeba proteus*. Spores should survive for months before infecting anything. I want to see if the amoebas will get infected or not when I add the spores into the slide. If *Amoeba proteus* get infected, and all the other amoebas stay healthy, I will know that it was something that infects this certain species of amoeba. Species-specific infections are so interesting, and I would love to see the interactions between the host and the parasite.

BELOW:
Dying amoeba, 1,400 microns.

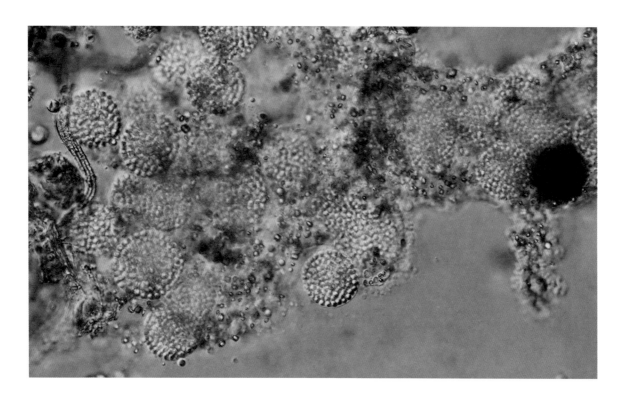

Daphnia –
helmet-wearing water fleas

ABOVE:
Chydorus,
140 microns.

OPPOSITE:
Daphnid,
600 microns.

As part of my daily work, I kidnap microbes from their natural habitats. However, I often get to save them too! Aquarium stores sell tiny living crustaceans as fish food. These poor animals are packed into tiny plastic bags and kept in a minifridge in the store. I go there once in a while and buy a bunch of these packaged animals and release them into my pond aquarium where they happily live until they get eaten by some *Hydras* (learn more about *Hydras* on page 210).

These rescued animals are called *Daphnia*, or water fleas. They are not related to fleas, but they are named this way because they "jump" while swimming. The water fleas, or *Cladocera*, are one of the largest groups of freshwater crustaceans in terms of the number of species, containing over 600 species. Water fleas are found in all sorts of freshwater habitats, but they are especially common in shallow ponds and lakes with thick vegetation. These habitats hold so many individuals that they often block the tiny meshes on my plankton net and make my sampling trip extra difficult. The biggest genera in *Cladocera* is *Daphnia*, which includes over 100 species alone.

Daphnia have a transparent body covering called a carapace. Because the carapace is transparent, *Daphnia* are quite interesting to

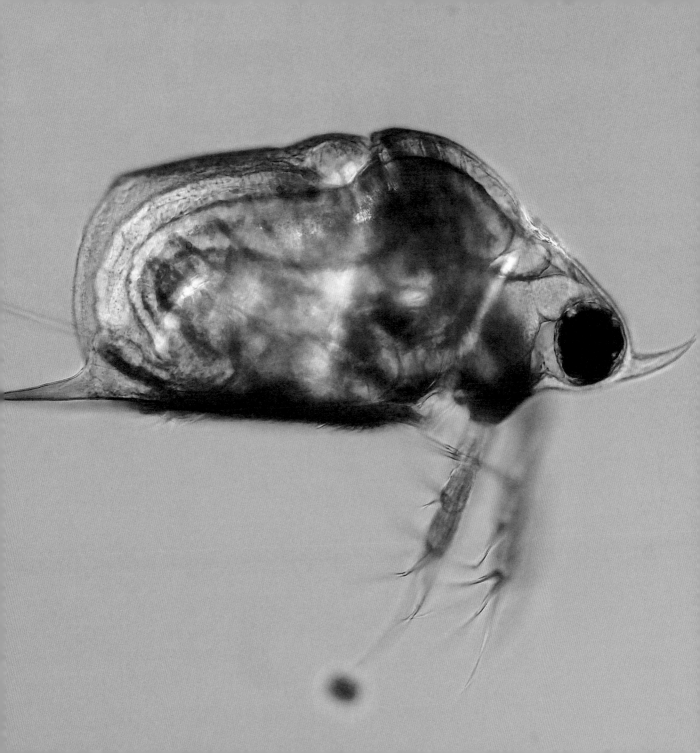

look at under the microscope. I can easily see *Daphnid*'s stomach, muscles and even its little beating heart. *Daphnid*'s heart beats about 200 times per minute, which is both interesting and kind of bonding to watch. With some small additions to the water *Daphnia* lives in, you can make its heart go faster or slower. If you add caffeine, its heart rate goes off the charts, and if you add alcohol, the heart rate drops down significantly.

Daphnid's life story is fascinating. Most of the year the *Daphnia* populations don't have males. All the individuals that jump and hop in the water are females; it's like a utopian society. The females produce eggs, which start developing without fertilization. Mothers carry the developing eggs inside their exoskeleton, and the eggs keep developing until they hatch inside the mothers and are released. All the new baby *Daphnia* are females until the autumn. Then males start to appear in *Daphnia* populations, and the females produce a different

LEFT: *Daphnid* eggs (dark-coloured circles), with *Daphnid* heart shown below. Height of image is 300 microns.

type of egg, called the winter egg. These eggs are fertilized by males and they are resistant to environmental stresses. Even after the mothers die, the eggs survive and wait for spring to develop and hatch into female *Daphnia*.

As they are simple animals, *Daphnia* don't have lungs or red blood cells. Humans have red blood cells that contain a protein called haemoglobin. The haemoglobin binds with oxygen inside the red blood cell. As the haemoglobin contains iron, it appears red. Whereas oxygen is transported to human cells via haemoglobin in our red blood cells, oxygen molecules are carried into the *Daphnid*'s body through diffusion. The haemoglobin proteins are outside of *Daphnia* cells and help carry oxygen to tissues. Normally, *Daphnia* don't need to have excessive amounts of haemoglobin, and the animals don't look reddish, but the *Daphnia* I rescue from the store all look bright red in colour. The reason for this is that the animals inside the sealed plastic packages

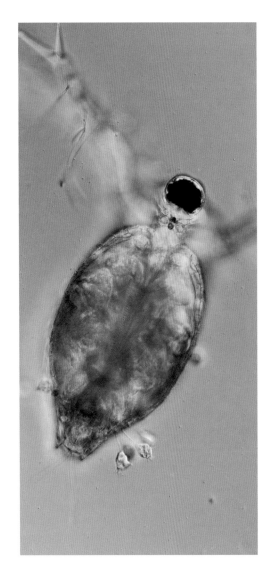

RIGHT: *Daphnid*, 1,500 microns long.

don't get enough oxygen and so they pump up their haemoglobin production in a desperate effort to get the limited oxygen more efficiently. Most of the time, it's really important for these animals to be less colourful. Many fish rely on vision when it comes to hunting, and bright-red Daphnia are easy meals.

After collecting samples I turn on the flashlight on my phone and inspect the sample to see how it looks with the naked eye. I can distinguish many cells just by seeing how the little living specks move. One time I was looking at my freshly collected sample when I saw something quite big reflecting the light and moving in a jerky fashion. I had never seen anything like that before. I put it under the microscope and saw that it was a *Daphnid* with a single giant eye and wing-like arms. I remember seeing a drawing of something like this in a book, but I couldn't remember the name. It only took me a minute to find it. It was called *Leptodora*, a cousin of *Daphnia*. It has only one giant eye. It cannot actually form images, but the tiny structures that look a bit like cake slices inside the eye, called ommatidia, make up visual subunits of the compound eye where the light information from the environment is converted into neural signals to the brain. This allows the organism to "see" the light.

They are horrifying hunters; when a *Leptodora* makes contact with a possible prey, its stomach area expands and opens up to catch the prey. *Leptodorae* love preying on *Daphnia*. They also eat so many other crustaceans, they keep their populations under control. The prey have developed some defences to keep themselves safe from the hunters. One example of this is found in a species of *Daphnia* called *Daphnia cucullata*. This species lives in ponds and lakes and it has a helmet-like

structure on its head. The size of the helmet changes seasonally. For instance, individuals have long helmets in summer while they have shorter helmets from autumn to spring. The helmet is used to protect the organism from predators like *Leptodora*. The most fascinating thing is that scientists can change the size of the helmet by adding "chemical cues" released from the organisms that eat *Daphnia*. These morphological changes offer extra protection from the predators and they happen selectively according to the presence of a certain predator. This means that the *Daphnia cucullata* change the shape of their helmet based on which organism is attempting to attack and eat them.

LEFT: *Leptodora*, 1,400 microns.

NEXT PAGE: *Daphnia cucullata*, 1,400 microns.

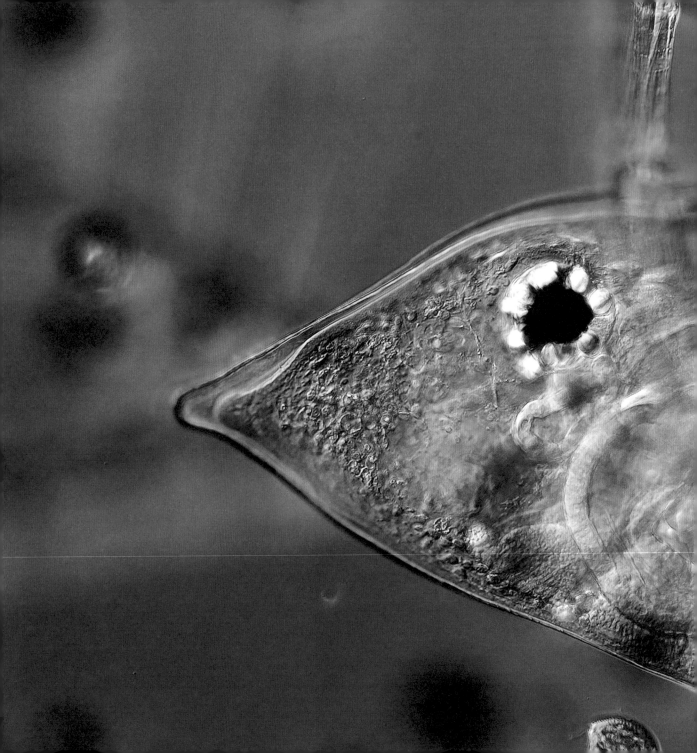

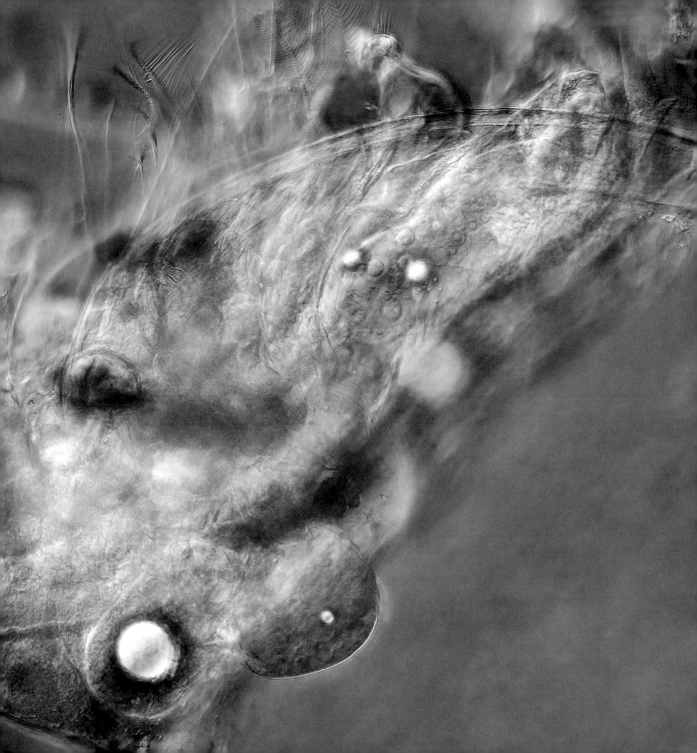

Gastrotrichs – **shy dragons**

ABOVE:
Gastrotrich with
an egg,
140 microns.

OPPOSITE:
Gastrotrich
head,
120 microns.

Gastrotrichs are fascinating microscopic animals. Commonly found in freshwater and marine habitats, there are around 800 species of gastrotrichs divided into two orders. They prefer to swim over the sediment layer and eat bacteria, algae and some other protists. For every square metre of sediment layer, there are estimated to be almost 100,000 individuals! gastrotrichs have hundreds of cells in their bodies but are often much smaller than anything single-celled around. Gastrotrichs can be as small as 80 microns, while a single-celled *Paramecium* is around 200 microns. Even though gastrotrichs are half the size of a *Paramecium*, they are much more complex; they have a simple brain, intestines, ovaries and even a bladder. Nature is good at making things in all sizes.

Gastrotrichs have hair-like cilia on their stomachs. The beating of these cilia lets gastrotrichs swim on the sediment in a gliding manner. The name "gastrotrich" comes from the cilia on their belly, meaning "hairy stomach", and gastrotrichs are commonly known as "hairybacks" in English. Yet it's quite hard to observe the undersides of gastrotrichs through the microscope because of the particular way they swim; they almost always swim facing down! Gastrotrich backs are covered with scales and spines, giving them a dragon-like appearance. Gastrotrichs are easy to startle. When I'm recording them I need to be extra careful

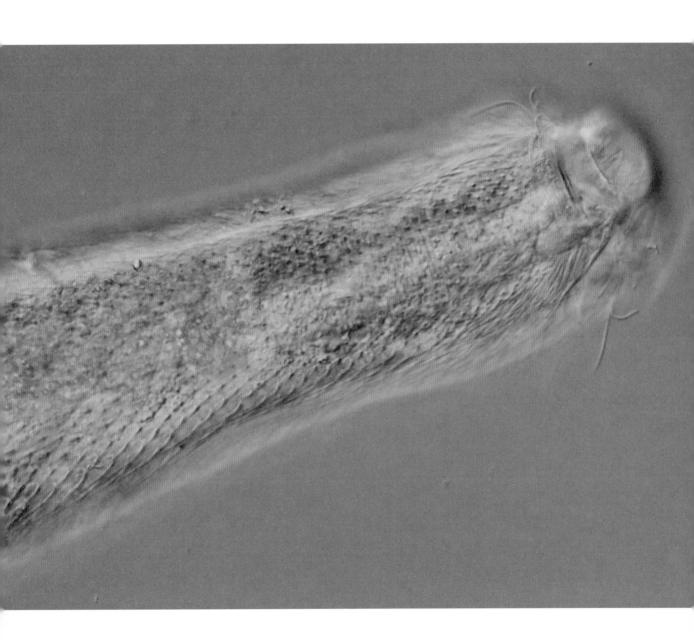

not to cause any vibrations that can shake the microscope. Their heads are covered with sensory organelles that look like cat whiskers. With these sensory structures a gastrotrich can sense even the slightest movement in the water so it can avoid predators. In its couple of weeks of life, a gastrotrich will lay numerous eggs. I have seen gastrotrichs laying eggs: they carry a giant egg in their stomach until the egg tears through the body like in a horror movie! The body can close itself up afterwards and the egg may hatch or stay dormant for a while if the conditions are not good enough for it.

Gastrotrichs demonstrate something called eutely, meaning that they are hatched from eggs with a fixed number of cells, and that number doesn't change throughout their life. Cell division stops once the embryo develops in the eggs. The animal gets bigger in adulthood because the cells get bigger volumetrically, but they don't divide. For example, if a certain species of gastrotrich has 1,002 cells in its body after hatching, every single individual of that species all around the world at any time in its life cycle will have 1,002 cells.

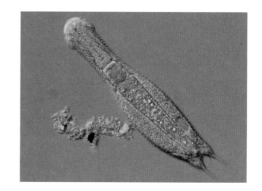

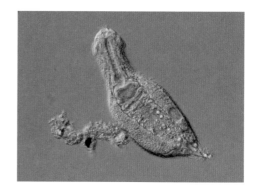

ABOVE AND OPPOSITE: Gastrotrich poops, 120 microns.

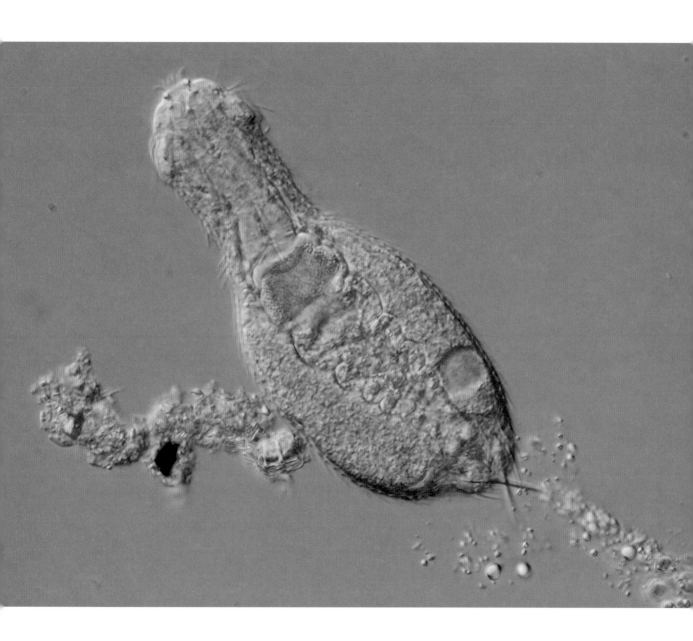

Hydra – **immortal tentacles**

Hydras are freshwater relatives of jellyfish and sea anemones. *Hydras* attach themselves to submerged surfaces and extend their tentacles out to hunt. I am really glad that they are not large animals; imagining a pond where a *Hydra* with 2m long tentacles lives is terrifying to me!

There are a couple of dozen *Hydra* species widely distributed in all continents except Antarctica. This wide distribution may be a result of *Hydra*'s early appearance in the history of life, even before the continents we know today separated from each other in the Mesozoic era. The study of *Hydra* fauna in Madagascar is quite interesting because of the island's geological formation; Madagascar has been isolated for over 100 million years. This condition led to the evolution of many species that can only be found in Madagascar. However, the fact that *Hydras* living on the island are very similar to the ones living on other continents indicates that *Hydra*'s evolution was quite slow and rather ancient, and that they haven't changed much since they were cut off from the main continent.

Hydra extends its tentacles to increase the chance of them coming into contact with an unlucky organism. The tentacles have stinging

OPPOSITE: *Hydra*. Width of image is 1,000 microns.

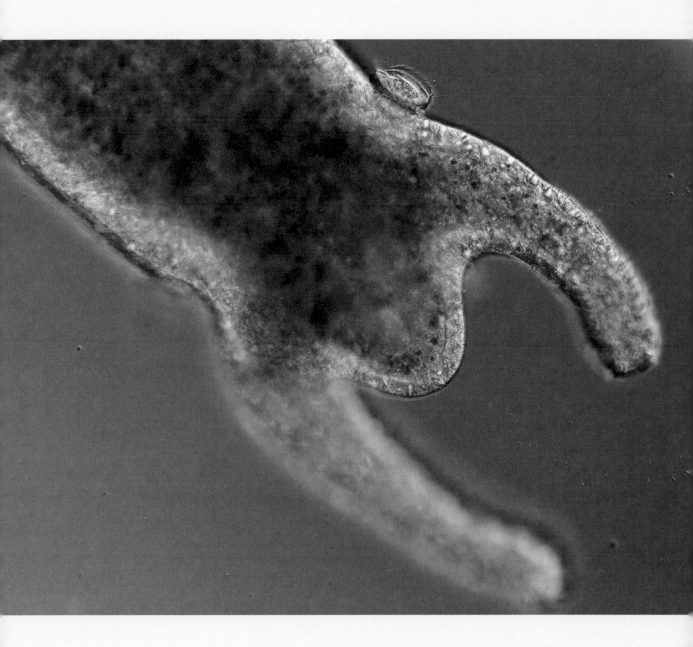

cells similar to those of a jellyfish. The stinging cells look like tiny amphoras, and inside each amphora a coiled hypodermic needle waits to be fired on contact with an immense power. *Hydras* have thousands of these arsenals on their tentacles. There are a couple of different stinging cells on *Hydras*; some inject toxins into prey to immobilize it and others help *Hydra* to hold the prey tightly while it slowly swallows it through its mouth at the centre of the tentacles. I have watched them eat *Daphnia* and other crustaceans many times. It's a fast process, often taking less than a minute. First, a prey touches the *Hydra*'s tentacles and the mechanical stimulus triggers the stinging cells. The needles pierce the prey and at this point *Hydra* wraps other tentacles around the prey and contracts them, both bringing the prey closer to its mouth and stinging it more to prevent it from escaping. Then it opens its mouth, or rather pushes the prey into its mouth, and swallows. After *Hydra* swallows its prey, it digests it and later poops it out. But because *Hydras* have a simple body plan, they do not have an anus, so they poop through their mouth. Do you kiss your mother with that mouth, *Hydra*?

OPPOSITE: *Hydra*, 1,000 microns.

Hydra got its name from the nine-headed mythological creature that can grow two new heads when one is cut off. Just like the mythical sea monster, *Hydras* are able to regrow their missing parts, which is a really handy trait if you have numerous thin tentacles that you may lose. Yet what fascinates me the most about *Hydras*, besides their super cool name, is that they don't age at all and seem to have an unlimited lifespan due to the self-renewing ability of their stem cells. As other animals age, some of their cell functions stop working properly and the organism is not able to repair everything; the older it gets, the greater the chance of death. However, that's not the case with *Hydras*. There is no decrease in fertility over time, and *Hydras* can demonstrate unlimited growth of clones. This is why *Hydras* are considered biologically immortal, but that doesn't mean they don't die; *Hydras* are quite sensitive to environmental changes. I never managed to keep one alive in a small jar longer than a couple of days. Oxygen depletion and temperature change kill them quite quickly. Thankfully, when I set up my pond tank, some brown *Hydras* appeared in it, and their number quickly increased and then stabilized.

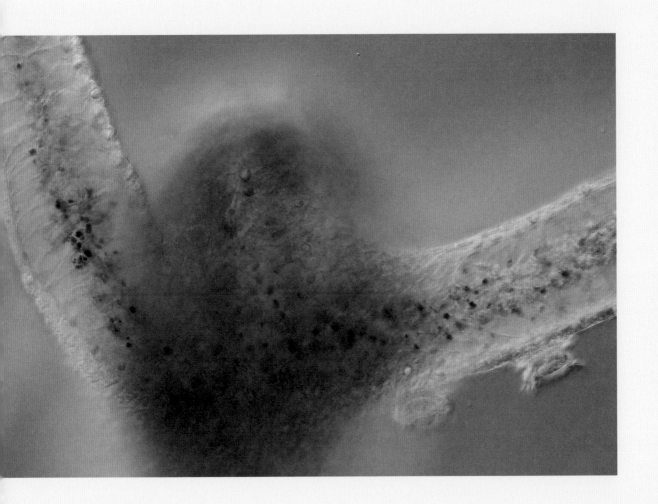

ABOVE: *Hydra.* Width of image is 1,500 microns.

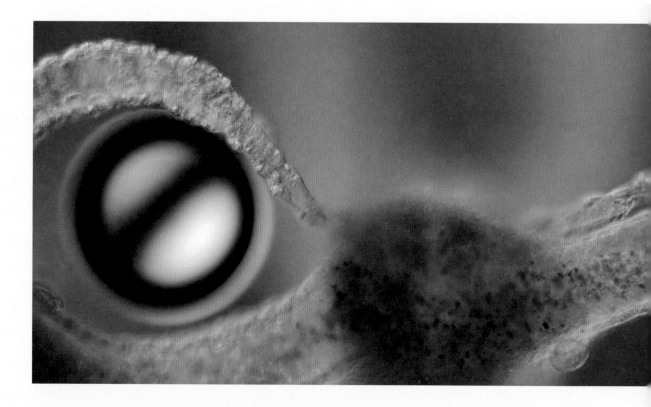

There is another species of *Hydra* that is green and much smaller than the brown ones I often find. This species is called *Hydra viridissima* and it gets its colour from a species of unicellular green algae that live symbiotically inside *Hydra viridissima*. Green *Hydras* can survive without food for up to four months, while brown *Hydras* can only survive for a couple of weeks. However, as beautiful and hardy as it is, *Hydra viridissima* is quite hard to find in nature. I had never found one in my samples, so I found it strange when I was reading about them on the internet that people kept complaining about *Hydra* infestations in their

ABOVE:
Hydra. Width of image is 1,500 microns.

fish tanks. Then it occurred to me that some people in the city may have the green *Hydra* in their tank already. So I went to an aquarium store with a magnifying glass in my hand and *Hydra viridissima* in my head. I checked a couple of different tanks and couldn't see any, but then I checked a tank where they grow aquatic plants, and there they were! I could see them attached to the glass. They were tiny – just a couple of millimetres in length.

The tank was well-lit to boost the plant growth, which also helped *Hydra viridissima* to grow and reproduce in the tank. It was just perfect for them; while they lazily sat on the glass, the green algae in their body would produce sugar for them. I have to admit, it was awkward when I was looking at tanks with a magnifying glass, but then it got even more

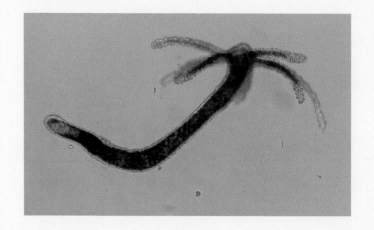

ABOVE: *Hydra viridissima*, 3,000 microns.

awkward when I told the store assistant to scrape the glass with the plants I wanted to buy. I got a plant and two moss balls. I came home with them in a plastic bag with some water and saw that there were some tiny snails crawling on the moss balls. I took a snail and put it under the microscope and was surprised by a green *Hydra* attached to the snail. It was too cute to be true! I recorded some clips of it, and when I watch those clips even now they put a smile on my face. My plan had worked, and I had found *Hydra viridissima* in an aquarium store in a shopping mall!

Rotifers – **waiting for better times**

ABOVE:
Collotheca,
250 microns.

OPPOSITE:
Conochilus
colony,
250 microns.

Rotifers are one of the most abundant animals on Earth, and you've probably never heard of them! They are most likely the unluckiest of all the animals I have seen. They are tiny – most of the time even smaller than medium-sized single-celled organisms – and they don't have crazy defences or tough skins, so they get bullied a lot! I have watched them get eaten by countless different single-celled organisms. Sometimes they were lucky and died quickly. Other times it took them so long to die it made me uneasy. In one case I watched a *Stentor coeruleus* swallow a rotifer and it stayed alive inside the giant single-celled organism for about 30 minutes. It wiggled and extended its body but couldn't find a way out and slowly died, most likely from the enzymes digesting it. I watched another rotifer caught by a *Heliozoan*; it was slowly wrapped and swallowed. The rotifer was apparently carrying an egg, and she managed to lay it while being eaten by the *Heliozoan*! Long story short, being a rotifer is tough and tragic.

Rotifers are animals. They are microscopic, as you might have guessed, and are found in every aquatic environment. From the moist soil in your garden to the pond in your favourite park to the pot plant on your windowsill: they are everywhere! They sustain the life of many

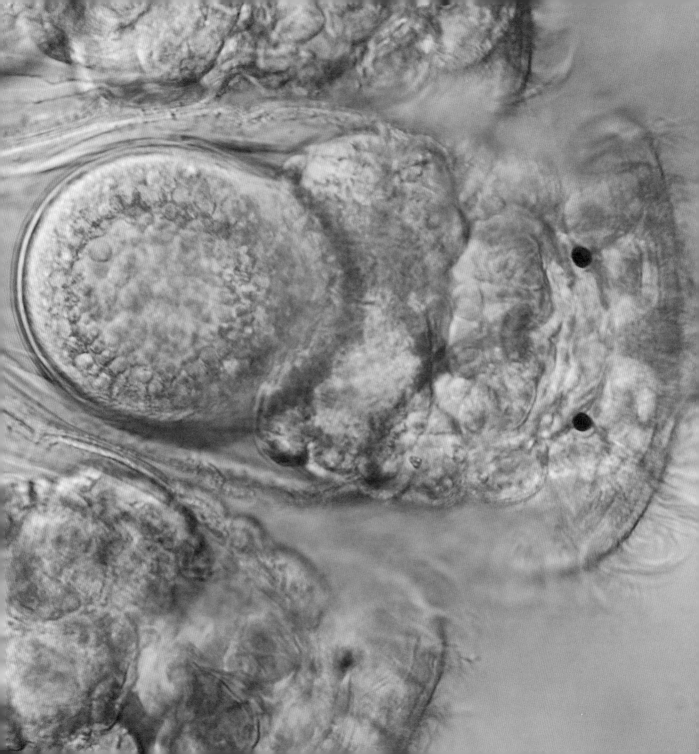

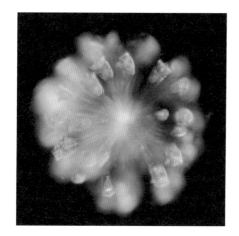

ABOVE: *Conochilus* colony,
700 microns.

OPPOSITE:
Conochilus colony, 800 microns.

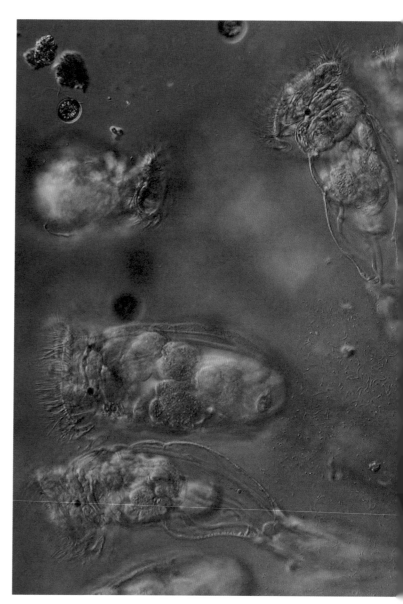

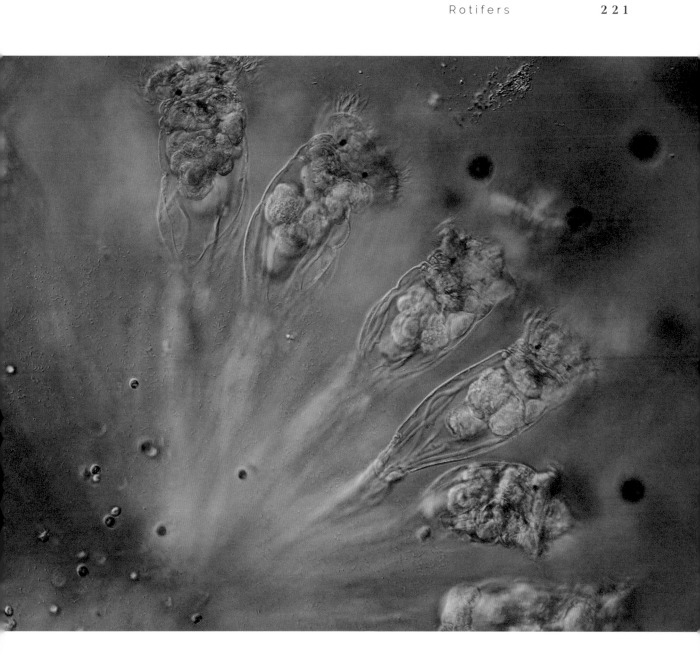

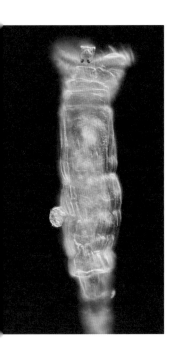

ABOVE:
Philodina,
700 microns.

OPPOSITE:
Philodina,
300 microns.

other organisms as a food source and they eat microscopic algae and bacteria voraciously until their transparent bellies get full and turn green. There are over 2,000 different species of rotifer and they come in all shapes and sizes. Most of the species are under a millimetre long. They have simple brains, stomachs, intestines, glands, eye spots and reproductive organs.

The general body plan of a rotifer consists of four basic regions: head, neck, body and the foot. Most of the species have "telescopic" bodies that can extend and contract, with the very end part of the rotifer referred to as its "toe". The toe of the rotifer contains glands that can secrete adhesive substances to attach rotifers to substances in the water while they keep eating! In most species the head carries a crown of hair-like cilia called the corona. This is where the rotifer name came from; it is derived from the Latin word meaning "wheel-bearer" as the rapid beating of the cilia at the corona looks like a rotating wheel. Imagine the confusion it caused among the first microscopists who witnessed this!

Do you think rotifer's morphology is strange? How they reproduce is even stranger. Some species of rotifers consist of only females. They produce daughters from unfertilized eggs by a type of asexual reproduction called parthenogenesis. Some species produce two kinds of eggs, which will develop by parthenogenesis; one kind

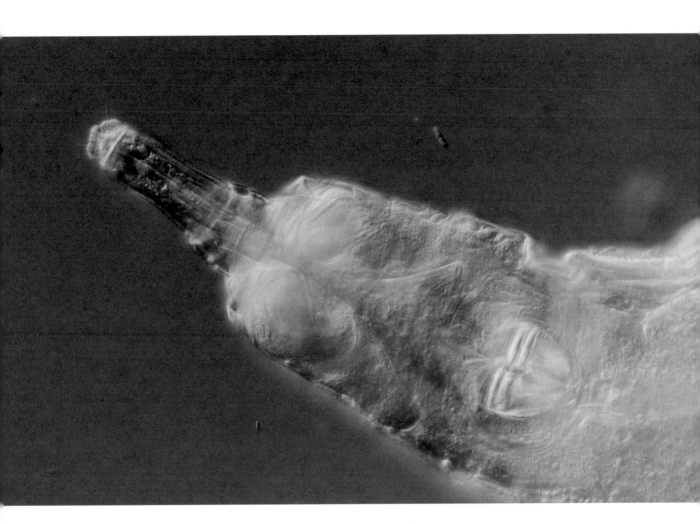

ABOVE: *Asplanchna* giving birth.

will hatch to produce only females and the other kind does something even stranger. This second kind only hatches males, but these males are hatched as degenerate individuals; they cannot even feed themselves! Their only duty is to fertilize eggs before they die of hunger. The eggs that are fertilized by the damaged males can survive environmental stresses such as water dry-ups, when the eggs will stay dormant until they reach water again and will hatch!

Some species are ovoviviparous. This may look like a made-up word but it means that an animal's egg hatches inside its body and later the hatched babies are released into the environment. One day I found a rotifer species in the genus called *Asplanchna*. The species in this genus can be large and they usually have quite transparent bodies. The *Asplanchna* I found had some wiggly things inside its body. They were baby *Asplanchna*! Ten minutes later, the mother *Asplanchna* gave birth to one of her babies. It was so interesting to see, but I felt bad about the babies and the mother being trapped under the coverslip so I washed the slide into my pond tank. It may sound strange that I sometimes feel connected to these organisms, but they changed my life and I care about them more than many other things in my life.

A thin film of water such as on mosses, lichens and soil, which are the most common habitats of rotifers, are not the most stable of environments. This water can evaporate and condense in daily and seasonal cycles. Some of the rotifer species have evolved to protect themselves in these unstable conditions with something called anhydrobiosis. When the water evaporates these rotifer species enter into a dormant state and become active again once the water returns. Anhydrobiosis is somewhat common among microscopic animals such as tardigrades and nematodes.

Even though they are microscopic and often ignored by us macro-animals and bullied by their single-celled neighbours, rotifers are charmingly bizarre animals. They are everywhere, minding their own business, living their happy life and turning themselves into inactive little balls when life gets tough, waiting for good days to return. Not so different from us after all.

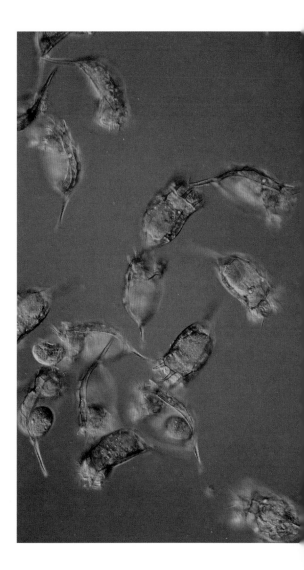

ABOVE: *Keratella,* 140 microns.

Tardigrades –
everyone's favourite water bear

ABOVE:
Two-day-old
tardigrades,
150 microns.

OPPOSITE:
Tardigrade,
600 microns.

Tardigrades. They are the most adorable things you can find under the microscope and their nicknames are even cuter: they are often called water bears or moss piglets. I love calling them water bears because they look like tiny little bears with their claws on each of their eight chubby legs. The name "tardigrade" was coined by an Italian scientist who was studying creatures he found from the sediment in gutters in the 1770s. He called the animal "il Tardigrado", the slow stepper. When he described them, he actually missed the last pair of legs the animal has and recorded them as six-legged, and even now, two centuries later, tardigrades are often misunderstood. It's believed that tardigrades can live under extreme conditions, or that they are immortal and virtually impossible to destroy. These beliefs are all wrong. Tardigrades are quite delicate animals. They can easily be killed.

The misunderstanding comes from the fact that some species of tardigrades can form stress-resistant structures called tuns. Some species do that by producing a sugar called trehalose, which forms a glass-like structure inside the animal's cells and protects the cells from various environmental stresses. Some other species don't form tuns, but instead can form something called cysts, which are different from tuns in appearance and function.

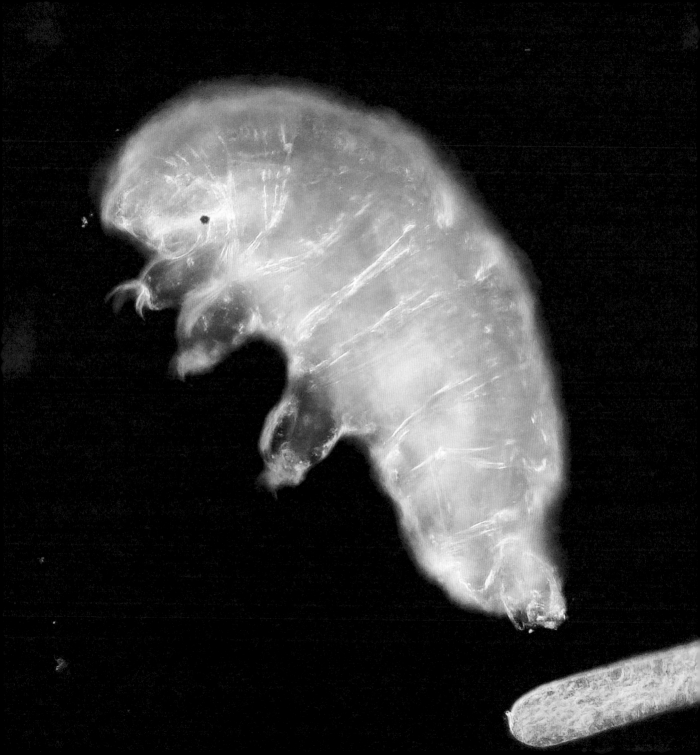

There are still some parts of tardigrade survival that we don't quite understand, but when some species are in their protective stage, they can survive drying up, they can endure pressures much higher than the bottom of the ocean and radiation that would be more than enough to kill a human, and extreme temperatures like 150°C/302°F and −200°C/−392°F. Their survival skills can also explain the distribution of tardigrades all over the world. Some tardigrade tuns can also fly, literally! A strong wind during a storm can carry the tuns into high altitudes, and then they will simply rain down on you or continue flying as an aerial plankton. Some tardigrade tuns were reported as common in raindrops after a storm in Greenland. So next time when you stick your tongue out in the rain, remember me!

OPPOSITE: Tardigrade trying to eat alga, 400 microns.

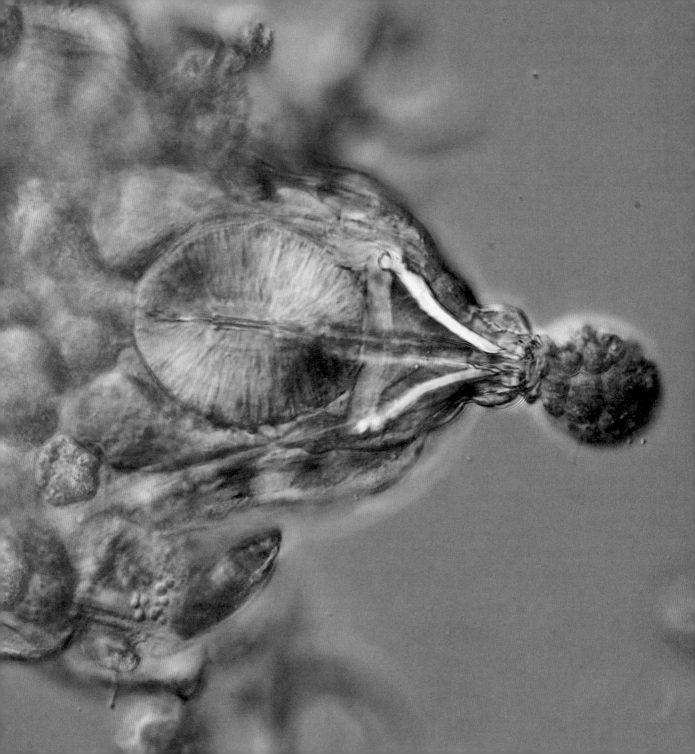

Terrestrial tardigrades – clever adaptations

Water bears have been around for quite a while; they most likely originated from the marine environment and later evolved to live in terrestrial environments and freshwater habitats. As you can expect from a microscopic soft-bodied animal, water bear fossils are extremely rare. Possible tardigrade fossils of four individuals were found in Middle Cambrian rocks from Siberia and were sized between 250 and 350 microns. They actually resemble today's tardigrades with the barrel-like body, four pairs of limbs with claws, and a mouth with some sensory organs around it. Another fossil, which is way more reliable, came from a sample of amber collected from New Jersey, USA. The fossil was so well-preserved, the specimen was put into the existing genus *Milnesium* as a new species, *Milnesium swolenskyi.* I find tardigrades in this genus quite often. It was thought that the genus only consisted of a single species for a long time, but now there are 38 known species in the genus. However, the most fascinating thing is that this genus of tardigrades called *Milnesium* existed 89.3 million years ago, and it separated from the other genera of tardigrades way before 89.3 million years ago.

I find *Milnesium* species from the moss that grows on the trees in front of my house. Just after it rains I get a jar and go out to scrape some moss and lichen from the trees. The reason I do

OPPOSITE:
Milnesium and *Ramazzottius.*

BELOW:
Ramazzottius in a tun, 150 microns.

this after rain is that *Milnesium* and some other tardigrades can survive drying up by forming a tun; when the animal is in the tun state it becomes quite resistant to environmental stresses. Tuns of some species can survive extreme situations. (However, not all tardigrades forms tuns, and certainly not all tuns of every species can survive all of the extremes I mention.) The reason why the tardigrades can live in temporarily wet environments, like the moss on the trees, is that they developed these physiological adaptations to survive a range of conditions. So when there is rain and the moss gets wet, the tardigrades in tuns quickly become active, feed, reproduce; and when the water starts to evaporate, they get back into their tuns again. When they are in tuns, they don't age and can wait for years to be active again. A couple of frozen tardigrades in a Japanese lab were brought back to life after 30 years, and there was also a report of a moss specimen in a museum yielding active tardigrades when it was rehydrated after 100 years, (although this is from a source that's not very reliable).

OPPOSITE: *Ramazzottius*, 240 microns.

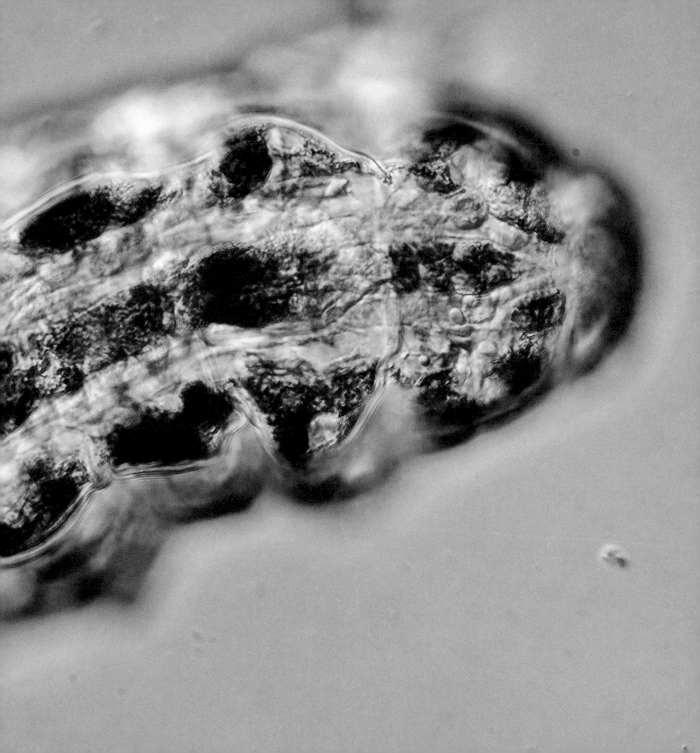

Milnesium tardigrades are rather more robust-looking than their relatives. They resemble crocodiles more than cute bears. And they are quite the apex predators. They eat algae, nematodes, some rotifers and even other tardigrades! A study reported that adult *Milnesium* actively search for prey[6]. When a rotifer was added into the *Milnesium* culture, they were swallowed whole by the tardigrades. It has even been reported that a single *Milnesium* swallowed 13 rotifers in just 17 minutes and then stopped eating even though the prey was still abundant in the culture.

The sexual reproduction of this species is not well-known, but we do know that females reproduce through parthenogenesis without needing fertilization. *Milnesium* lays 1–12 eggs into its shed cuticle (a half-shed exoskeleton), and the eggs hatch into babies in about a week. In the same study that observed *Milnesium* preying on rotifers, the lifespan of the tardigrades was recorded too. One individual remained alive for 58 days after hatching and laid 41 eggs in 5 separate events, but toward the end of the experiment the animal climbed out of the water and entered into tuns three times. The animal rehydrated two times, but because the observation was terminated when it formed the third tun, it wasn't observed afterwards.

ABOVE:
Milnesium,
300 microns.

OPPOSITE:
Milnesium,
700 microns.

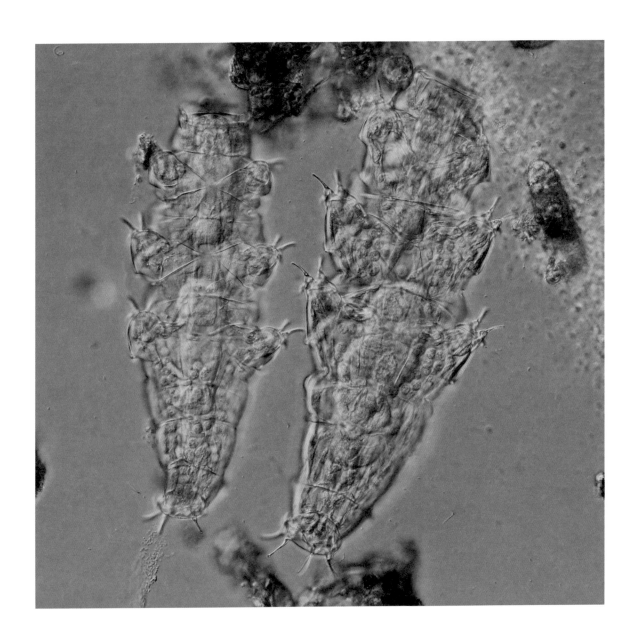

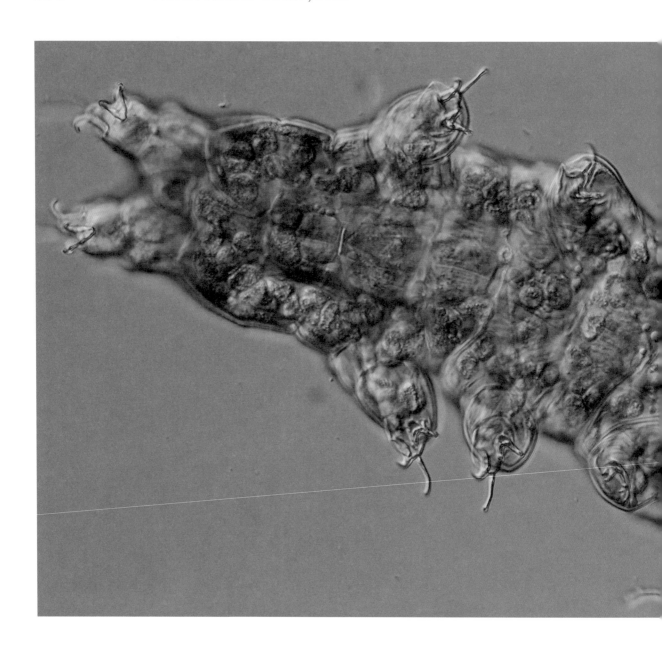

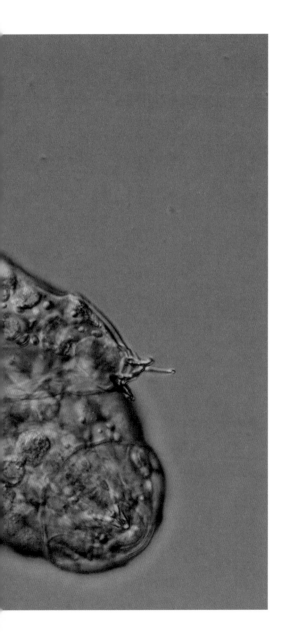

I find two genera of tardigrades in moss: one is the *Milnesium* and the other is *Ramazzottius*. The latter's genus name comes from an Italian tardigradologist (yep, that's a thing!), Giuseppe Ramazzotti. These tardigrades have reddish pigments on their cuticle. The pigmentation most likely protects them from the harmful UV light that comes from the sun. The body cavity fluid of these little redheads is filled with something called coelomocytes. Coelomocytes function as storage cells; they accumulate polysaccharides, proteins and lipids. In *Ramazzottius* species there are approximately 200 coelomocytes, but their number declines when the animal is starving. It's been reported that cell division occurs in storage cells, which questions whether tardigrades are truly eutelic (when an organism has a fixed number of cells its whole life) or not. A fascinating thing about the storage cells is that they can also function like immunity cells, protecting the animals from infections.

LEFT: *Ramazzottius*, 300 microns.

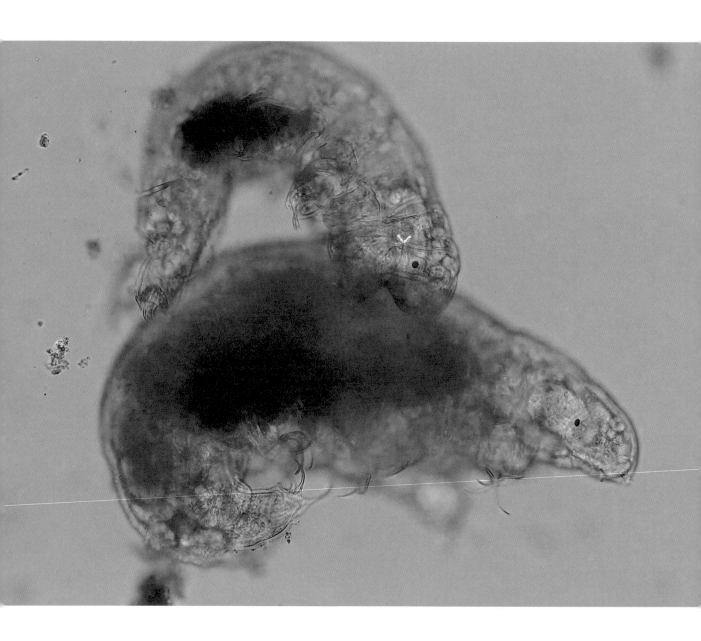

Tardigrade mating and babies

There is a river running across the whole city of Warsaw called the Vistula. At one point it was unfortunately one of the most polluted rivers in Europe, and I think it's still quite polluted. Some locals say it's not that bad any more because the beavers returned to the river, but from time to time I get an automated text message from the city warning us not to swim in the river and not to use the water from the river for anything. Despite all the pollution and the occasional wastewater-treatment plant spills, the river is one of my favourite places to sample, especially during the season when the river has a low level of water and muddy river banks appear.

The mud is a wonderful place for my little water bears, and every time I collect some samples from there, I find a lot of individuals waddling in the mud. After one particular sampling, I came back home with a kilogram of mud from the river and prepared a slide with it. The slide was full of water bears, their number so high I couldn't believe my eyes. There were around 30 individuals on the slide. I prepared a couple more slides, and on each one there were as many water bears as there had been on the first slide. I recorded them for a while and put the slides in the humidity chambers for later observations.

These slides became some of the longest-running water bear slides I have ever had. For over four months I observed the organisms there, and I witnessed some remarkable behaviour of water bears.

For example, one day I was checking one of these crowded slides again and I saw a water bear with another water bear on it. Looking more closely, I saw there were actually two smaller water bears on the big one. I couldn't understand what I was seeing but kept watching, and

OPPOSITE:
Mating
tardigrades.

then at some point, the big water bear rolled over and I was able to see her back. I gasped; there were eggs inside the female. These eggs are called oocytes and they were maturing inside the ovary of the female. They were not fertilized eggs yet. Then I realized that this behaviour could be a mating behaviour of water bears, and what I was watching was maybe a tardigrade threesome. I was shocked. Then things got even weirder; the female pooped all over the males and they were "wrestling" in it. These cute little water bears I adore so much apparently had a weird side. It made everything even more interesting for me, I think!

The female was being held tight by the two males for about 30 minutes, and then one of the males turned his back and left, but the

BELOW: Mother bear with eggs, 1,400 microns.

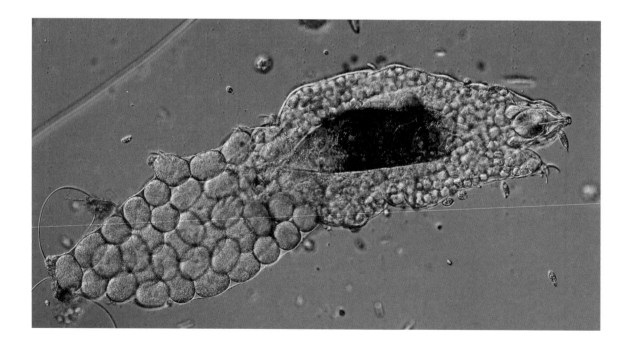

other one stayed clinging on to the female for an hour longer! It was one of the most ridiculous things I've seen through the microscope. The female was much bigger than the male and she was dragging him across the slide. The male was holding her tightly with his long claws and not letting her go. I started laughing at the expression the male had while his head was dragged along the glass; he looked so sad but determined with his pitch-black little eyes. It took a good, long hour before the male left the female. I wasn't able to observe it all in detail because the female kept walking into the sand and dirt on the slide, which blocked my view. I decided to check the other water bears on the slides I prepared and I was hoping to see some more action.

My water bears didn't let me down. For a week I watched them all having sex. Non-stop, 24/7. It always included a single female with oocytes in her ovary. I learned to differentiate between the males and the females. Based on my observations, males had a long, cylindrical thing under their cuticle. Months later I read that these were giant testes. Males were searching for the females with their ready-to-fertilize eggs, and they were quite fast in finding them.

I wanted to try to see how the males spot the females, so I fashioned a poking device; it was a kitty whisker (Sirius was kind enough to donate me one) superglued to a micropipette. I was able to squeeze the whisker through the slide and the coverslip and poke the mating water bears. I wanted to see if, when I separated the males from the females, the males would find their mates again. And they did! I felt a bit bad for shamelessly poking the mating couples until I separated them, but to my surprise it only took a couple of minutes for the males to find the female again. I think they were following some chemical

signals coming from the females, but I believe males don't release anything to attract females. The males were always the one in pursuit of a mate. While females calmly grazed on algae, males were running around like crazy chickens and hopping on females' backs and staying there for an hour and a half. No matter what I did, I couldn't observe the fertilization. According to a study on a different species of water bears, males ejaculate a couple of times during more than an hour-long mating, and the sperm find their way into the eggs and fertilize them[7].

I was becoming quite familiar with this species as I was observing them for so long. They lay eggs inside a cuticle so that they can carry their eggs in it as they move around. I had found water bears with the eggs like this before but had never managed to observe them hatching. And then, a couple of mothers on the slide laid eggs into the half-shed cuticle, and I decided that I would observe them until they hatched.

I kept checking the slides, even setting some alarms so I would wake up to check the mothers. On the fourth day, while I was going through one of the slides, I saw some of the eggs belonging to one mother had hatched already, and there were cute little babies inside the half-shed cuticle, and some eggs waiting and still unhatched. I started to record, hoping to catch the actual hatching of a water bear. I watched a couple of eggs hatching inside the half-shed cuticle, but because the mother water bear kept walking around and the half-shed cuticle was full of eggs and eggshells, I wasn't able to record the moment properly. Then I saw one stray egg, somehow knocked out of the half-shed cuticle and sitting on the slide. There was a developed embryo inside the egg. I could see it all; it was wiggling and repeatedly moving its piercing stylets in and out through its mouth. I was adding

some water through the side of the slide to keep it wet and, two hours later, the baby started to move its mouth faster and faster, and then the egg popped like a popcorn kernel!

The little baby came out of the egg slowly. Its belly was empty and it was so cute. It looked like a puppy. It started to walk around in search of algae. I kept recording until I saw that it could feed itself. I felt such strong emotions toward this little baby tardigrade. I had followed it around for four days inside the egg, and then I had watched it hatch and walk around. It was a microscopic pet who I never get to pet!

I kept the slides until all the other eggs that the other mothers were carrying had hatched. At one point, I had over 100 individual water bears on some of the slides. It was getting a bit crowded for them, and I didn't want to see them dying on my slides, so I washed the slides back into the sample container and wished them a good life there!

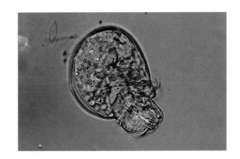

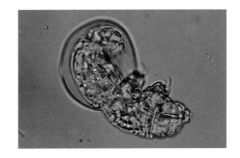

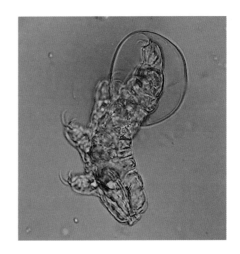

RIGHT: Hatching, 60 microns.

Meet Amelia the water bear

This is Amelia the water bear. I found Amelia in my bathroom in a giant fish tank filled up with pond water. I found her in the tank exactly a month after filling the tank with the water. Amelia, and hundreds of other water bears, had been living there the whole time, and I didn't know about them at all! I was adding milk to the tank to boost the number of organisms living there. Milk provides nutrients for bacteria and therefore to everything else that eats bacteria too. So milk increases the number of microorganisms in the tank. But two days before I found Amelia, I accidentally added too much milk, and too many nutrients in the water can increase the number of bacteria so much that they use up all the oxygen in the water. Usually it wouldn't bother me much, but then I discovered the huge population of water bears who had been living in the tank unnoticed for a month!

I was checking the glass walls of the tank with something I invented, which I called the BottleScope because I made it out of a plastic bottle and some microscope parts. It is quite useful. It looks like a telescope rather than a microscope, but I place one end of the BottleScope on the glass and I can magnify what I am seeing from 200 times to up to 500 times. I am free to move it to anywhere on the giant tank; in this way I turned my fish tank into a giant glass slide. I learnt so much about the lifestyle of the microbes without disturbing them or limiting them under a piece of glass. The BottleScope opened up such a new way of observing organisms. I was spending hours sitting in front of the fish tank and looking at things. Every day for a month I was gazing into the tank, and I thought I knew what was living there, more or less. I was able to identify most of the single-celled organisms there. I noticed that some of them prefer to be close to the surface of the water at night, and dive deeper during the day. I saw tiny snails hatching from their eggs, watched cyanobacteria filaments creeping on the glass. The microorganism populations were really dynamic; certain organisms dominated the tank for a period of time, and then something else became the dominant species. For instance, algae dominated the tank at first, turning the glass surface green, then the population of some tiny

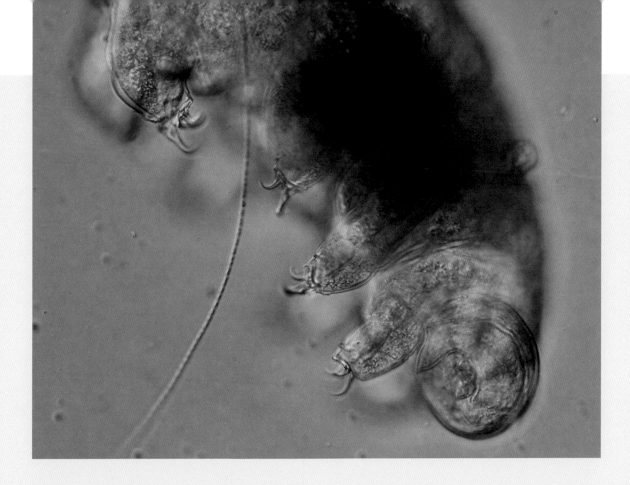

crustaceans that eat these algae boomed, and then tentacled Hydras started to appear and feed on the crustaceans. At one point there were hundreds of Hydras in the tank; they were covering the glass and waving their tentacles, constantly eating crustaceans.

The day after I accidentally added too much milk to my tank, I was checking it again with the BottleScope. On one side of the tank,

ABOVE: Amelia the water bear. Height of image is 600 microns.

there were literally hundreds and hundreds of water bears. They looked like they were stampeding each other, like little bricks forming a wall on the glass surface. And they weren't in good shape; they were not moving and they looked swollen. I knew this shape very well. Sometimes when I leave my slides with a

lot of bacterial activity, the water between the glass pieces loses all of its oxygen. The oxygen in the atmosphere generally diffuses into water through the water surface, but in a prepared slide there is almost no water surface in contact with the air, except the minuscule area on the edges. When the slides have no oxygen left, my water bears get swollen, extending their eight limbs and staying inactive. If after a couple of days the conditions don't improve, they die. The reason that they take this shape is to increase their body surface area, so more oxygen can enter their body. I can tell when they are dead, not just waiting for conditions to get better, because when they die, the inside of the animals gets overrun by bacteria in just a couple of hours.

When I see my water bears swollen on a slide, I just blow on the slide for a couple of minutes and that's enough to add some oxygen into the water. My water bears start to move right away! First their little feet start to move and then they take a couple of slow steps, and in an hour or two they are back to running on the slides, searching for delicious algae. When it came to the fish tank, I have an air bubble pump for these kinds of incidents. I turned it on to increase the dissolved oxygen in the water.

It took an hour before the water bears started to slowly move. And a couple of hours later, I was able to see them walking, so I left the pump running the whole night. When I woke up, I saw that there were almost no water bears left on the glass. They had just walked away toward the inner part of the tank's bottom.

With a tardigrade massacre avoided, I started to wonder why the water bears had been concentrated on that specific side of the tank. I was brushing my teeth while I concentrated on finding the answer, getting ready for bed, and I kept brushing. According to the smart toothbrush, I was brushing my teeth for 12 minutes 36 seconds! When I finally got the answer, I realized that I should stop brushing before my teeth wore down and dissolved completely in my mouth. The reason the water bears moved and formed a water bear wall on that side of the tank was because it was the furthest point from where I poured the milk into the tank. The highest concentration of biological activities stimulated by the milk slowly spread out from that spot, gradually consuming the oxygen available, and my water bears were sensing the less oxygenated area on one side and walking toward the more

oxygenated area on the other side, until they all ended up on the glass wall!

Later I wanted to identify the species of these water bears and record some videos of them, so I checked the tank with the BottleScope and found a couple of water bears still walking on that side of the tank. I dipped a long glass pipette into the tank and collected some of the sediment from the side of the tank. When I checked the sediment under the microscope, I found Amelia running on the slide. She was really cute and she had a friend – another water bear, but this one had lots of bacteria right under its exoskeleton. I don't know what kind of bacteria they were, but there were so many of them, tens of thousands of them! The water bear continued to behave as if it was quite healthy; it kept walking and grazing on the algae. I am still not sure why it had all those bacteria. I believe tardigrades do have bacterial endosymbionts but never in this high number. It might have been due to the oxygen-limited conditions the water bear had previously been exposed to. Until I get a fluorescent microscope and start staining the bacteria, I cannot be sure what they are, but it was certainly an interesting find!

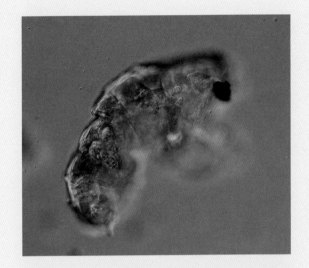

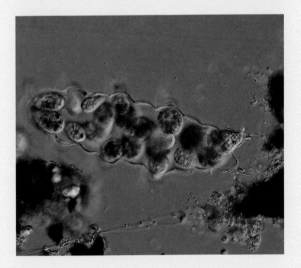

ABOVE: Dead tardigrade, 700 microns long, pictures taken 7 days apart.

Surviving is not living

Tardigrades can survive in their dormant stage, waiting for the better times to come. They can wait for years, even decades, but in this state their biological clock stops ticking. They are alive, but at the same time they are not living, just surviving. That's how I felt for a long time in life; not living, just surviving. Like a tardigrade, I rolled up into a ball to avoid environmental stresses, and I too survived some extreme conditions but I never felt like living when it was happening.

Then I found my biggest passion in the smallest form of life. I found solace in watching tardigrades being born on the glass microscope slide, waddling there, not knowing anything else but their tiny glass garden. I found similarities between them and me; I understood that life is about life, not about one species or individual. We are here for a short time, not just as individuals but as a species. One day, maybe in a thousand years or maybe in a million years, humans will become extinct, and everything we created will crumble to dust, then to molecules and atoms, and life will use that to make more life, and I think that's meaningful.

We are here for a short time, not just as individuals but as a species.

I've wanted to be a part of something for all my life: a functioning family, a group of people who I can hang out with every day in a coffee shop called Central Perk, or have a partner who I can fall madly in love with. All these thoughts made me feel like I was missing something, but then I started to observe microbes. I watched them being born, hatch, divide. I watched them live and die. Again and again, it felt like I witnessed thousands of lifespans, and after some time I realized that I was already a part of something quite special and wonderful, and it's called life.

NEXT PAGE: *Beggiatoa* filaments, each 5 microns wide.

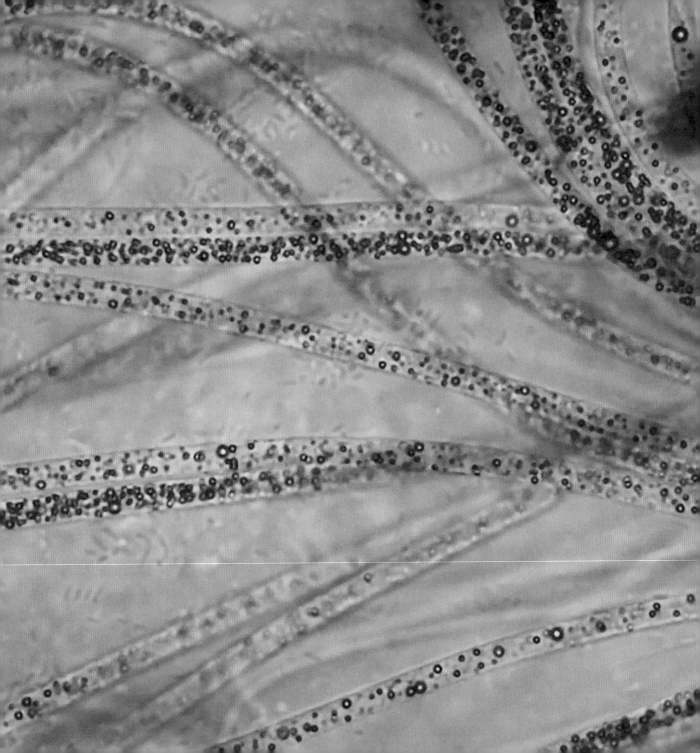

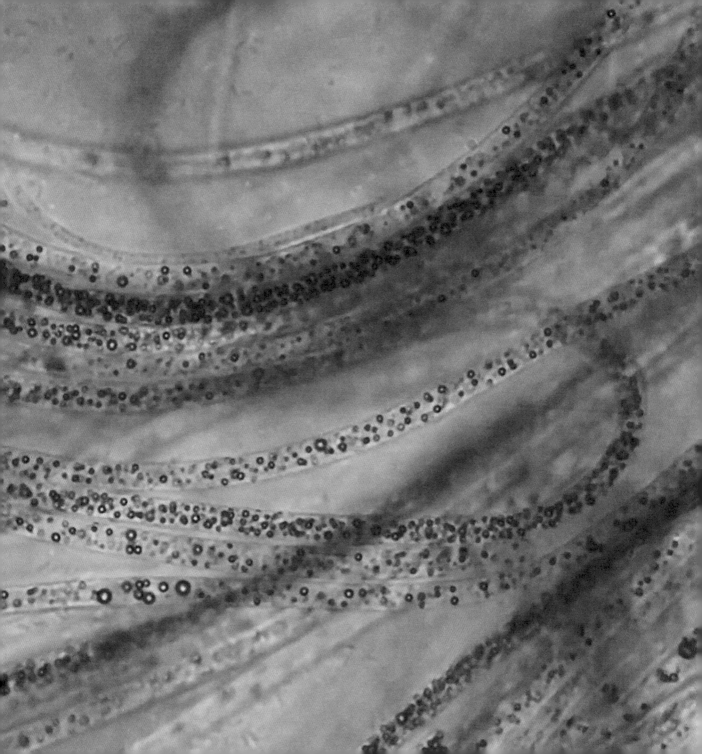

References

1. Wilhelm Foissner & F. Wenzel, "Life and legacy of an outstanding ciliate taxonomist, Alfred Kahl (1877–1946), including a facsimile of his forgotten monograph from 1943", *Acta Protozoologica*, Issue 43, 2004, pp. 3–69

2. John Janovy Jr., "Monsterism in *Dileptus* (Ciliata) Fed on Planarians (*Dugesia tigrina*)", *The Journal of Protozoology*, Volume 10, Issue 4, November 1963, pp. 428–430

3. Chandrashekhar Devidas Patil, Chandrakant Prakash Narkhede, Rahul Khushal Suryawanshi & Satish Vitthal Patil, "*Vorticella* sp: Prospective Mosquito Biocontrol Agent", *Journal of Arthropod-Borne Diseases*, 10(4), December 2016, pp. 602–604

4. Yuko Todo, Hiroshi Kitazato, Jun Hashimoto & Andrew J. Gooday, "Simple Foraminifera Flourish at the Ocean's Deepest Point", *Science*, Volume 307, Issue 5710, February 2005, pp. 689.

5. Toshiyuki Nakagaki, Hiroyasu Yamada & Ágota Tóth, "Maze-solving by an amoeboid organism", *Nature*, 407, 470, 28 September 2000

6. Atsushi C. Suzuki, "Life History of Milnesium tardigradum Doyère (Tardigrada) under a Rearing Environment", *Zoological Science*, 20(1), January 2003, pp. 49–57

7. Jana Bingemer, Karin Hohberg & Ralph O. Schill, "First detailed observations on tardigrade mating behaviour and some aspects of the life history of *Isohypsibius dastychi* Pilato, Bertolani & Binda 1982 (Tardigrada, Isohypsibiidae)", *Zoological Journal of the Linnean Society*, Volume 178, Issue 4, December 2016, pp. 856–862

Resources

Igor V. Dovgal, "Evolution, phylogeny and classification of Suctorea (Ciliophora)", *Protistology*. Volume 2, Number 4, 2002, pp. 194–270

Tom M. Fenchel, *Ecology of Protozoa* (Springer: 1987)

Gabriel Gutiérrez, Ludmila V. Chistyakova, Eduardo Villalobo, Alexei Y. Kostygov & Alexander O. Frolov, "Identification of *Pelomyxa palustris* Endosymbionts", *Protist*, Volume 168, Issue 4, August 2017, pp. 408–424

Ann Holbourn, Andrew S. Henderson & Norman MacLeod, *Atlas of Benthic Foraminifera* (Wiley-Blackwell: 2013)

Alfred Kahl, *Urtiere oder Protozoa I: Wimpertiere oder Ciliata*, Volumes 1, 2, 3 and 4 (Gustav Fischer Verlag: 1930–1935)

Hans-Werner Kuhlmann, "Life cycle dependent phototactic orientation in *Ophryoglena catenula*", *European Journal of Protistology*, Volume 29, Issue 3, 25 July 1993, pp. 344–352

De-Wei Li (Ed.), *Biology of Microfungi* (Springer: 2016)

Denis Lynn, *The Ciliated Protozoa* (Springer: 2008)

Denis H. Lynn, Martin Kolisko & William Bourland, "Phylogenomic Analysis of *Nassula variabilis* n. sp., *Furgasonia blochmanni*, and *Pseudomicrothorax dubius* Confirms a Nassophorean Clade", *Protist*, Volume 169, Issue 2, April 2018, pp. 108–189

Stephen Miller, "The Predatory Behavior of *Dileptus anser*", *The Journal of Protozoology*, Volume 15, Issue 2, May 1968, pp. 313–319

Mark A. Nienaber & Miriam Steinitz-Kannan, *A Guide to Cyanobacteria: Identification and Impact* (University Press of Kentucky: 2018)

J. A. Postuma, *Manual of Planktonic Foraminifera* (Elsevier Science: 1971)

G. Prescott, John Bamrick, Edward Cawley & Wm. Jaques, *How to Know the Freshwater Algae*, (McGraw-Hill Education: 1978)

Ralph O. Schill (Ed.), *Water Bears: The Biology of Tardigrades* (Springer: 2018)

John D. Wehr, Robert G. Sheath, J. Patrick Kociolek (Eds.), *Freshwater Algae of North America: Ecology and Classification, second edition* (Academic Press: 2015)

George Chandler Whipple (Ed.), *Fresh-Water Biology* (John Wiley & Sons Inc: 1959)

Ralph Wichterman, *The Biology of Paramecium* (Springer: 1986)

Ke-Qin Zhang & Kevin D. Hyde (Eds.), *Nematode-Trapping Fungi* (Springer: 2014)

Index

instagram.com/jam_and_germs/

youtube.com/JamsGerms